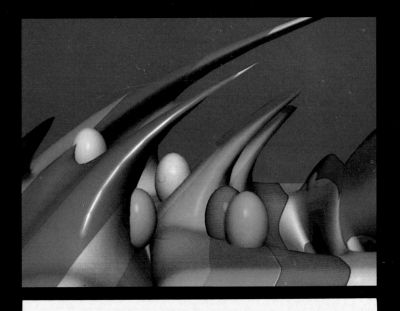

ART AND THE COMPUTER

Melvin L. Prueitt

Los Alamos National Laboratory

McGraw-Hill Book Company

New York St. Louis San Francisco Auckland
Bogotá Hamburg Johannesburg London
Madrid Mexico Montreal New Delhi Panama Paris São Paulo
Singapore Sydney Tokyo Toronto

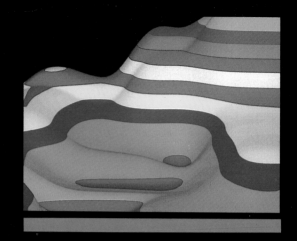

ART AND THE COMPUTER

1 2 3 4 5 6 7 8 9 0 K G P K G P 8 9 8 7 6 5 4

ISBN 0-07-050894-1 HC

ISBN 0-07-050899-2 SC

Melvin L. Prueitt's pictures were created at
the Los Alamos National Laboratory,
under the auspices of the U.S. Department of Energy.

This book was set in Futura Lite by Black Dot, Inc.
The editors were Debbie K. Dennis and Jonathan Palace;
the designer was Jo Jones;
the production supervisor was Charles Hess.
Kingsport Press, Inc., was printer and binder.

Library of Congress Cataloging in Publication Data

Prueitt, Melvin L.
Art and the computer.

Includes index.
1. Computer art. I. Title.
N7433.8.P7 1984 760 83-24818
ISBN 0-07-050894-1
ISBN 0-07-050899-2 (pbk.)

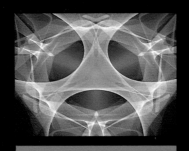

To
Susi,
Roger, Cynthia,
Daniel, Linda,
Stanley, and Shawn,
artists all.

CONTENTS

FOREWORD vi

PREFACE vii

INTRODUCTION viii

**PART ONE
THE SUBJECT**

From Computer to Human 3
From Human to Computer 4

Perspective 5
Shading 7
A Different Viewpoint 8

The Program 14
Creating Perspective Pictures 14
Hidden-Line and Hidden-Surface
 Removal 16
Shading and Shadowing 19
Ray Tracing 20
Anti-aliasing 22
Motion Pictures 23

Animation 26
Computer-Aided Design 27

 28
Home Computer Art 29
The Computer as Designer 29
The Computer Artist 30
Everlasting Art 30

Color Intervals 31
The Substance of Beauty 32
Visual Mystique 34
Computer as a Teacher 36
New Art Forms 37

Exploring the Images 38
A New Vision 38
Maintaining Appreciation 38
The Eye and Mind of the Beholder 39
The Future 40

**PART TWO
THE GALLERY**
Line Drawings 42

Perspective Mesh Plots 56
Symmetry 65
Asymmetry 77
Science 83
Topography 100
Erosion 106
Mathematics 114
Landscapes 125
Computer Caverns 137
Still Lifes 145
Computer Sculptures 151
Outer Space 163
Lighting Effects 173
Errors 185
Home Computers 191
Pictures from Japan 195
Realism 204
Patterns and Designs 211
Abstractions 220
Eye Pieces 228
Electronic Flowers 234

INDEXES 243
 Artist Index
 Subject Index

v

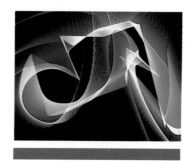

FOREWORD
Jennifer Mellen

As this book makes abundantly clear, the union of artist and computer has produced an art medium of unprecedented promise. These extraordinary pictures are the first evidence that a tool artists have been seeking for centuries is nearly within our grasp: here is a medium that can translate the artist's inner vision directly from the mind to paper or screen, eliminating forever the necessity for hand-eye coordination on the part of the artist. With the computer, everyone can "draw."

Most of the pictures in this book were made by an artist who has been applying his considerable gifts as a nuclear physicist to the complex task of teaching the computer how to turn numbers into pictures for almost twenty years. Hunched over a keyboard in what may be the cleanest artist's studio in history, Mel Prueitt has patiently and adroitly coaxed the computer to render the most intricate image on command, color it according to his wishes, add light and shade, rotate it to any perspective, and animate it if he chooses to watch one form evolve into another across his electronic canvas. In a dazzling display of technical virtuosity he has harnessed the vast number-crunching power of the computer and equipped it to produce fine art of almost surprising delicacy and grace, all at the touch of a few buttons on the computer's keyboard. In doing so, he has been among the pioneers of this first generation of computer artists. They have opened a new horizon for all the people Dr. Prueitt calls "passive" artists: those who think, as he once did, that because they cannot "draw" the worlds they imagine, they cannot be "artists." Until the computer came along, Mel Prueitt had no idea he could ever become an artist.

Art and the Computer documents the work of the few artists who have had the skill or the opportunity to use the skills of other pioneers in computer programming to experiment with this astonishing new art medium. Within the next decade or so millions of people will be able to use modified versions of the software that was used to produce the pictures in this book to explore their own artistic capabilities. As more and more artists have a chance to discover this revolutionary medium, the art world will have much to look forward to; for in unlocking the secrets of teaching the computer to do the artist's bidding, Dr. Prueitt has given us the equivalent of the "magic brush."

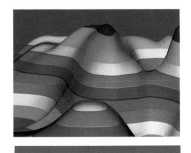

PREFACE

When the Renaissance dawned in Europe several centuries ago, there was no trumpeter to herald the beginning of the new age. There was no radio to spread the word and no television to show the brilliant new works of art. Most people were unaware that society was undergoing lasting change. The news spread slowly. Perhaps it has taken the intervening centuries for us to fully assess the impact of the Renaissance upon the human race.

Today another revolution is breaking upon the art world, and it may be as profound in the long run as the Renaissance. It is happening so fast that, in spite of globe-encircling communication networks, many people (even some in the art profession) are unaware of it. Computers, tied to sophisticated graphics equipment, are the bright new tools of artists, providing expanded capabilities for the creation of new art forms that would be difficult or impossible to produce by other means. Home computers are opening exciting possibilities to millions of people for the creation of colorful art.

This book provides a report on some of the fine works of art being produced by artists using computers. The novice and the art professional alike may study these pages to learn what is happening in this blossoming new field. The book contains pictures of historical significance from these pioneering days of computer-aided art. It also contains new artworks which the world has not seen.

Since the width of most of the pictures in this book is greater than the height, the book is published in the horizontal format. People are more accustomed to books that are taller than they are wide, but I believe we will see more horizontal books in the future, particularly in the art field. We love wide panoramas. Theaters present wide-screen motion pictures, and museums display broad dioramas. Even televi-sion screens are wider than they are tall. Most photographs do not fit comfortably in the vertical format pages. This and other horizontal books will help us to become more accustomed to a visually more stimulating way of displaying pictures.

The book is divided into two parts: "The Subject" and "The Gallery." The first part treats the subject of computer implementation as an art tool and contains sufficient computer graphics to illustrate the principles. The second part is a collection of some of the finest computer-generated art extant. The works are grouped into sections according to origin or type with a minimum of text, letting the images stand on their own merit.

ACKNOWLEDGMENTS
A book can be a work of art only with much hard work. The burden is made easier by the thoughtful help of others. For valuable sugges-tions on the manuscript, I am grateful to Charles Barnett, Karen and Robert Hotchkiss, Jennifer Mellen, Jeannette Mortensen, and Arthur Nichols. Very patient typing and text improvements were made by Mildred Baran, Barbara Forest, Charlotte Hobart, Maureen Klein, and Pearl Lucero. Other secretarial help was rendered by Beverly Mattys.

Vital contributions to the quality of the book were provided by the artists who made available the fruits of their work. Their names are given in the "artists" Index.

I am most grateful to Dr. Carl Sagan for taking time from his many important projects to review the manuscript and to write the Introduc-tion. Thanks to Jennifer Mellen for writing the Foreword.

Melvin L. Prueitt

INTRODUCTION
Carl Sagan

As an unmanned spacecraft approaches a planet or moon never before examined close up, its cameras take a rapid-fire succession of pictures which are stored for a moment on magnetic tape, radioed back to Earth, and then erased so that room is made for the next batch of pictures. In the last 20 years, more than 100,000 pictures of new worlds have been returned in this way to Earth. In each of them the exotic landscape or cloud form has been imaged as a kind of pointillist nightmare: something like 1 million separate dots have their position and brightness recorded; each is radioed individually back to Earth; and then the whole assembly of points is reconstructed by a computer. A straight line running from the top of the picture to the bottom is in fact composed of about 1,000 individual dots. But as you stand back a little from the picture, you cannot make them out individually. Because every one of the million picture elements has had its brightness individually recorded, we can ask the computer to enhance the contrast of the very darkest part of the picture, say, or to make all places in the picture which are even slightly blue a striking and saturated blue. We can bring out faint features and subtle colorations. We can measure the real brightness of each picture element. This computer processing enormously aids our understanding of what is in the image. Almost all the pictures returned to us from space, images that have revolutionized our knowledge of our neighbors in the solar system, have been such pointillist portraits, with a large computer as an essential intermediary.

Any work of art is ultimately pointillist. There are a large but finite number of atoms or molecules in a painting or sculpture. Color and brightness have no meaning on any finer scale. If you knew the position, reflectivity, and "color" of every small molecule in a work of art, you could, in principle, reconstruct as many identical copies as you wished, each of them equally an "original." In fact, the smallest object that the unaided human eye can see is about 0.1 millimeters across. A line 1 meter long, viewed close-up, will then have 100 centimeters/0.01 centimeters = 10,000 resolution elements in it. So a painting 1 meter by 1 meter in area, for example, is comprised of about $10,000 \times 10,000 = 100,000,000$ resolution elements, rather more than the pictures radioed back from the planets, but not absurdly so. Now, if a computer can generate such exquisite and informative pictures from information supplied to it by a spacecraft, why could it not produce comparably beautiful and instructive images if its only data source were a human being?

There is an indomitable urge to make art which can be found in every human culture. Ever since our ancestors finger painted in ochre

INTRODUCTION

on the walls of caves, the technology of art has been improving. Chisels, brushes, paints, canvas, pencils, pastels, forges, foundries, kilns, and cameras are all the products of technology. When our species wishes to make something beautiful, it first constructs tools.

Recently, a new tool—constituting a potential revolution in the future of art—has arrived: the electronic computer, able to store, access, and manipulate large amounts of data, large numbers of picture elements. The field is still in its earliest stages, but it already displays immense promise. In principle, computers can create works recognizably in the style of the old masters, as well as art of a kind never before imagined. The opportunities open to gifted artists who are also expert computer programmers are unlimited. However, this is, at least so far, an unusual combination—perhaps because the right hemisphere of the cerebral cortex is mainly responsible for the holistic conceptualizations essential for art, while the left hemisphere is primarily in charge of the analytic thinking necessary for computer programming. Communication between the two hemispheres, through a bundle of nerve fibers called the corpus callosum, is imperfect. At the same time, we have had a fair amount of practice in something very close to this mix of abilities: In 1637, René Descartes

invented analytic geometry in the *Discourse on Method;* it wonderfully connects every algebraic equation with a geometric figure, and vice versa. It is widely taught and, so far as I know, even widely understood by high school students. In another century, the sense of incongruity which many of us feel about mixing computers with serious art will be an anachronism, a judgmental infelicity that somehow plagued past generations. Creating works of art with electronic computers is on the mainstream of the history of art, and indeed on the mainstream of the history of humanity.

One of the compensations for living in an epoch as unstable as ours is the pleasure of witnessing the birth of inventions, trends, and ideas which, if we are not so foolish as to destroy ourselves, will be essential integuments of human cultures yet to come. Computer art is such a development. As you read this stylish and engaging book, imagine yourself in the same position as the onlookers in Lascaux or Altamira or Tassili 10 years after the discovery that ochre could be employed to improve the decor of the cave; and then try imagining where computer art will be, not 10,000 years from now, but in a mere 20 or 30.

PART ONE

THE SUBJECT

The artist was born before the first light of civilization. He squinted over the bare threshold of consciousness and dimly conceived that he could create images for others to see. Perhaps he picked up the stone chips discarded by his companions and merely scratched about in the sand before he saw the image jump from the ground into his mind. By the time the light of early man-made fires danced along subterranean passages, the artist was boldly there, waving a smoldering ember near the walls to paint a charcoal silhouette. He even left his signature of silk-screened soot around his hand pressed against the wall. He used the spear point and arrow-head to scratch images there where the weather could not erase them. When his fellow tribesmen painted their bodies to frighten competitive tribes, the artist carried the precious pigments far underground and, in the flickering firelight, produced immortal works of art on the cavern walls.

As fast as man developed new tools for the important task of survival, the artist invented ways to use the tools to create beauty. The blank faces of clay pottery beckoned the artist to fill the vacant areas with abstract designs. Hammer and chisel carved gods and goddesses. Protective paint for wooden houses also decorated cathedral walls and ceilings. The advancement of humankind into the northern countries required woven fabric to protect fragile bodies, but the resulting cloth, stretched across wooden frames, also served as a foundation for portraits of kings and queens.

The explosives of war were used to paint the sky in spectacular fireworks, and dynamite carved faces in mountainsides. Fine lenses and light-sensitive emulsions led to photographic art. Air compressors brought air brushes, and lasers brought light shows. Glassware, fine china, and many other manufactured products supplied myriad surfaces on which to display art. The printing press not only made the pen mighty but broadcast visual art across the world.

And then came the computer.

Computers were designed to add, subtract, multiply, and divide—totally alien to art. But the crafty heritage of a thousand generations of artists came to the fore. The computer was compelled to obey the will of the artists, to be an extension of their creative powers. It was a new tool with tremendous flexibility for producing form and color.

To paint a picture, one must mix paints. Portions of the picture must be allowed to dry before overpainting; patience is a necessary virtue of an artist. At the end of each session, the brushes must be cleaned. Sculpting in stone is hard, dusty work. Sculpting in clay yields muddy hands. Silk-screening involves a confusion of muddled materials and cleanup drudgery. Glass blowing entails heat and fumes. In sum, nearly all arts and crafts are, to some extent, messy. The production of computer art, on the other hand, is physically neat and clean. The pictures may appear on a screen, from which photographs can be made, or on a pen plotter. The pictures can be made quickly so that the artist does not become weary of them before they are finished.

Perhaps someday the computer will be considered humanity's finest artistic tool.

It *is* merely a tool. Some critics have claimed that computer art cannot be true art since it is made by a machine. But a computer cannot create art by itself any more than a paint brush can produce a Mona Lisa. Computer art, like all art, is a product of the human mind, conceived through studious reverie. It does not depend on the manual dexterity of the artist but on the artist's ability to conceive new visual ideas and to develop logical methods for forming images (or to use the methods developed by others). In this sense, com-

puter art may be closer to the human mind and heart than other forms of art. That is, it is an art created by the mind rather than by the body.

COMMUNICATING WITH THE COMPUTER

When Neil Armstrong took that first small step for man on the moon, there were no natives there to greet him. Our Martian landers found no life on Mars. We found that Venus is too hot, and Mercury is too cold on one side yet too hot on the other side, to support life. Jupiter and Saturn are giant planets with extremely deep atmospheres that are poisonous to our type of life, and their moons are mostly icy spheres. Beyond Saturn lie the cold planets Uranus and Neptune, and in an orbit of eternal night roves the tiny planet Pluto. The conclusion has been reached that there is no other intelligent life in the solar system, that the human race stands strangely alone on the pinnacle of intelligence.

So, after centuries of dreaming of people on the moon, we now look out to the stars and wonder if anyone is there. In the distant future, when we venture out among the stars that have been glowing there for so long, the first question will be, "Will we find intelligent life?" The second question will be, "How can we communicate with the aliens?" It is not only a matter of the mode of expression but also a matter of tempo. Suppose that the first creatures we encounter can think at the rate of 1 million words per second. They may find us so slow and boring that they may not even want to communicate with us. In order to interest them, we would need to use a method that could convey a large amount of information in a short time. Since "a picture is worth a thousand words," why not show pictures to the aliens?

Now, we do not have to wait for some future journey to the stars to try our communicative skills on strange beings, because the earth has already been invaded by such creatures. They are called computers. Not only have they invaded universities, laboratories, and business, they are infiltrating homes by the thousands. We are still at a loss to know how to communicate effectively with something that can "think" so fast. Even the relatively slow home computers can run through thousands of time cycles doing complex operations between each of our keystrokes at the input keyboard.

From Computer to Human

For a long time after the development of the first electronic computer, most computer output was in the form of printed numbers, a medium that is foreign to human nature. Some computers today can perform more than 100 million calculations per second. If a high-speed printer could print the numbers as fast as they were calculated and fill every page completely with numbers, the paper would have to shoot out of the printer at 250,000 miles per hour! At that speed, the paper would, of course, instantly burn up in the atmosphere.

In order to use computers effectively, then, we must resort to graphics. Let the computer report its results with pictures. Since the computer "thinks" with numbers only in the form of electronic pulses, plotting devices have been designed to translate the pulses into pictures. A pair of numbers can represent the two coordinates of a point on a two-dimensional sheet of paper. Four numbers (two pairs) can define a line segment. Although the computer has no concept of geometry, and nothing

even remotely resembling a picture ever exists inside a computer, we can write computer programs that cause the computer to produce numbers which make the plotter draw pictures.

The appearance of the pictures depends on the type of graphics device. Pen plotters draw lines on ordinary paper. Since many pen plotters have several different colored pens, colorful plots are possible. Large flat-bed pen plotters produce large, highly accurate engineering and architectural drawings. High-speed ink jet plotters produce images by the seemingly unlikely method of squirting an electronically controlled stream of ink at the paper. Precise laser plotters draw sharply defined lines very rapidly.

One of the most versatile devices for computer output is the cathode-ray tube (CRT), which is familiar to most people as the television screen. In this device, the image is drawn on the screen by an electron beam exciting the phosphors of the tube face. The CRT output devices for computers come in two major types: *raster scan* and *vector graphics.*

In the raster scan type, the electron beam prints a picture on the screen by scanning horizontally across the screen. Each succeeding scan line is immediately below the previous one. When the beam draws the last scan line at the bottom of the screen, it moves back to the top and starts over again. The whole screen is filled with scan lines many times a second, forming a picture by varying the intensity of the beam as it scans. Color is provided by red, green, and blue phosphors on the back side of the screen. This, of course, is the way our TV sets work, and it is the type of output available with most home computers. But whereas TVs have 525 scan lines, some high-quality CRTs have over 1,000 scan lines and produce sharper, more detailed graphics.

Vector graphic CRTs are more versatile than the raster scan devices since they draw lines in any direction on the screen. The computer that drives them specifies the beginning and ending points of a line, and the electron beam draws the line between the points. These devices usually have a white phosphor screen for very high resolution lines. Color is provided by an electromechanical filter system in front of the screen, and an automatic camera mounted in front of the screen records the pictures on film. These are called *COM devices,* short for computer output microfilm.

From Human to Computer

Graphics output devices greatly enhance communication from computer to human, but what about communication from human to computer? Considerable progress is being made in that area, too. Although much input is still keyboarded typewriter-style, interactive graphics systems are available. With these, the user enters data graphically. By moving a pen over a graphics tablet or over the screen, the user enters points into the computer's memory as pairs of numbers representing positions on the tablet or screen. In this manner, one can enter complete pictures that the computer can display on the terminal screen. The user can then make alterations in the picture by moving points around with the pen.

To give commands graphically to a computer, many programmers provide a "menu," a set of instructions located at the periphery of the screen. By touching the instruction on the screen with the pen, one can transmit a command to the computer. The instruction might be a simple command that rotates the image or changes the color for some part of the image. It might, on the other hand, be a command that evokes a more complex

response from the computer, such as generating a completely new image or performing a mathematical transformation that distorts the image.

We already have some computer systems that can understand the human voice. To create good computer art with such a system, we need to couple the voice input with the graphical input. We could then dispense with the visual menu, replacing the printed instructions with vocal commands. I can imagine a computer artist intensely engaged at a console, drawing with an electronic pen on a tablet and muttering to the computer: "Color this area pastel green . . . a little brighter. Duplicate this pattern 35 times along this curve."

We can easily see how computers can relieve the artist of some of the routine tasks to allow more time for a higher level of creativity. For example, if a painter is producing a landscape that requires 10,000 flowers, his or her only recourse is to laboriously draw each one, even though the more distant ones may be no more than a dab of paint. With an appropriate computer and program, one can create one flower and command the computer to duplicate it 10,000 times, each flower canted within some range of random angles, placed at varying heights across the landscape, and given different colors as desired. The computer does not become weary after producing the first 7,298 flowers, just to finish the rest with dabs of color. Each flower is given the same care and detail to the limit of resolution of the plotting device.

THE HUMAN VISUAL INPUT CHANNEL

Now that we have broadened and improved human-computer communication, despite the ever-increasing disparity in "thought" speed between computers and people, further improvements will be made as we analyze how our visual system functions. The advent of computer graphics has forced us to take a closer look at the phenomenon of vision; since computers can draw pictures, we need to know how the pictures should be drawn in order to be most comprehensible.

Perspective

A person who has been blind from birth finds it difficult to understand why an object should appear smaller at a distance. After all, a figurine feels the same size whether it is held against the body or at arm's length. Perhaps we believe that we know intuitively that distant objects appear smaller because of our daily experience. But is that a fact? Why then did it take so many thousands of years for artists to discover perspective in art? Possibly ancient humans knew absolutely that giraffes did not change in size as they strode away and, therefore, consciously thought of their visual image as being of constant size. Thus artists drew pictures of animals one above the other on cave walls without diminishing the size of the upper ones. At least they did seem to understand that more distant animals on a plain should be drawn higher on the picture than nearer animals — or were they just fitting the images in wherever they could?

The ancient Egyptians, in all their wisdom, still did not seem to understand that distant objects should be drawn smaller than nearer ones. The Chinese did beautiful work that gave a feeling of perspective by careful arrangement of natural contours of land and water. But the fishermen on the far side of the lake were drawn just as large as those on the near side.

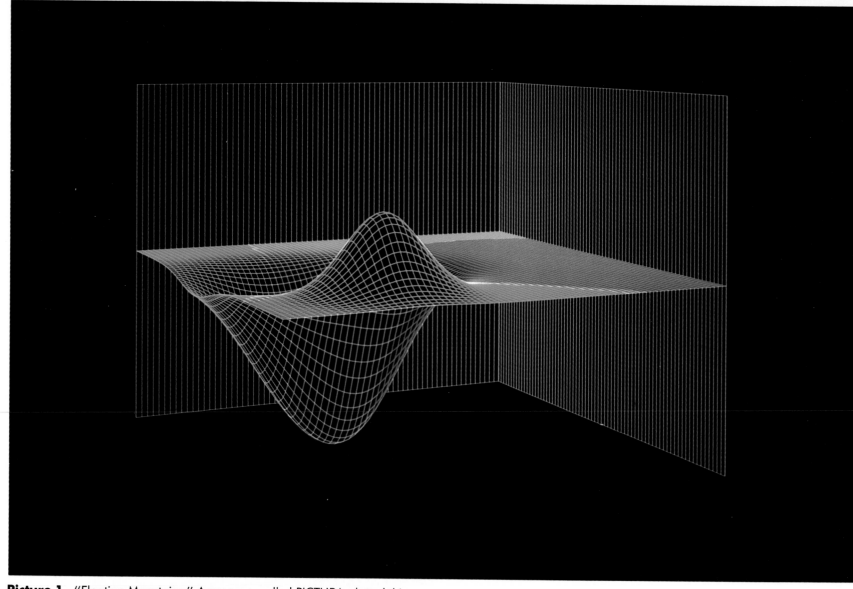

Picture 1 "Floating Mountains." A program called PICTURA plotted this
picture in perspective with hidden lines removed. Like most of the other pictures
that the author reproduces in this book, this picture was drawn on an Information
International, Inc. FR80 and recorded on 35-mm color film. The calculation for this
picture was done on a CDC 7600 computer. (©1980 Melvin L. Prueitt)

In the 15th century, perspective drawing was reduced to a science by the use of the horizontal line and the vanishing point. Thereafter, many artists produced paintings that we call realistic.

Since perspective is now well understood, it is natural that we program computers to draw in perspective. Had it not been for the pioneering work of earlier artists, perhaps all our computer pictures would be isometric like the ancient Egyptian drawings. Picture 1 is an example of a perspective computer-drawn plot. The spacings of the lines diminish as they simulate increasing distance.

Shading

Since it took so long for artists to understand perspective, perhaps we ought to consider other aspects of vision in an attempt to produce better computer pictures. How, for example, do we perceive the shape of an object? A quick response might be *binocular vision;* but we can immediately determine the shapes of a vase and the table on which it is sitting with one eye closed. Suppose we look at a uniformly colored wall that has a small bulge in the center. We have no difficulty in detecting the bulge with one or two eyes no matter what our viewing angle may be. The answer is not binocular vision, then; the answer is *shading.*

Consider Pictures 2(*a*) and 2(*b*). The pictures are

a

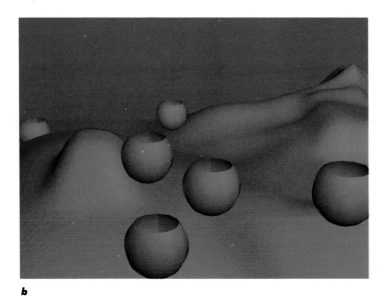
b

Picture 2 (*a*) and (*b*) are geometrically identical pictures; however, (*a*) was plotted with constant intensity, but shading was added to (*b*). This illustrates how our visual systems rely on shading to determine the shape of objects. (©1982 Melvin L. Prueitt)

geometrically identical perspective projections of a surface. The computer was commanded to produce 2(a) with constant light intensity and to produce 2(b) with varying light intensity in accordance with the amount of light reflected by each point on the surface from a given light source. We call this "shading."

The truly amazing consideration is that the human visual system is able to use shading and shadows to determine the shape of objects even when hundreds of light sources are present. In the total *absence* of shading, on the other hand, even binocular vision is of no value. A condition approaching this is familiar to skiers. On a completely overcast day, shading on the snow almost vanishes, and the skier often does not see a mogul until it buckles his knees.

A Different Viewpoint

Vision is so much a part of our existence that it is difficult to examine it objectively. We need to step back and view our estate with alien eyes. Since that is not possible, the next best endeavor is to imagine a discussion of something as complex as our visual perception with an investigator from another world.

Suppose, for a moment, that creatures from the stars make contact with our civilization. After some initial political contact, the aliens want to know something about our physiology. Suppose further that *you* volunteer to be a test subject for one of the doctors from outer space who is interested in the human visual system. After introduction, you and the alien make yourselves comfortable in a small room with a screen on one wall and a strange projector at the opposite side.

"I suggest we start with color sensitivity since that is fundamental," the alien begins. "We both live on worlds with nitrogen-oxygen atmospheres which are quite transparent to 'visual' light, so I assume that we see roughly the same wavelengths of light. To test that, I brought this projector."

The alien depresses a button with one tentacle, and a spectrum of colored light appears in a band across the screen. Another tentacle points to the left side of the spectrum. "That's blue," you respond before he can ask. Then, as he sweeps across the screen from left to right, you call off the hues: "Cyan, green, yellow, red."

"Good," he responds. "But I have heard disturbing reports that you earthlings cannot see two colors at the same time."

"Sure we can. I can see that your ears are green and your eyes are red."

"No, I mean that you cannot see two colors when they are superposed at the same point. For example, if I shine this circular spot of red light on the screen, you see red very well. Now I will switch on this green beam and focus it to the same spot. With both red and green beams on, what do you see?"

"Yellow."[1]

"So it is true. Your primitive visual system merely averages the hues. Since yellow is halfway between red and green in the spectrum, when I shine both beams on the screen, you see yellow." He speaks with some smugness, "I perceive both red and green at that point. My visual system is capable of handling a large number of different colors at the same time and place. I presume your system can manage many colors at once but the colors must be spacially separated as in a mosiac. Now

[1]Mixing light is the *additive* process of mixing colors. This method is used in TV screens which have red, green, and blue phosphors. Artists use the *subtractive* process in mixing paints, and the results are different.

tell me what you see when I increase the red intensity and reduce the green."

"Orange."

"Very good. Now I will switch off the red, leave the green on, and turn on the blue beam. My guess is that you see cyan, since cyan is halfway between blue and green."

"Right."

He looks at you rather pityingly. "One final test and I will be able to report to my colleagues that my theory is correct. I will switch off the green and turn the red back on. Since your system averages and since green is halfway between blue and red, you will see green."

"No. I see magenta."

He looks startled and then suspicious. "What is magenta?"

"Well, magenta does not really exist in nature," you take the offensive. "That is, there is no spectral hue that corresponds to it. It is not specified by a wavelength like the spectral hues are. It is merely subjective."

"Are you telling me that, when your eyes receive blue light and red light from a point, your mind invents a new color? But what is it like? To what natural hue is it similar? I would imagine it is somewhat like green."

"Magenta is not like any spectral hue."

"But what happens," he speaks as he turns knobs, "when I reduce the red and increase the blue?"

"Oh, that's purple. And now you have lavender." He turns down the blue and increases red. "That's a vibrant pink."

He steps back and looks at you with some respect. "I have never seen pink. How strange that your visual system presents to your consciousness colors that do not exist in nature."

"Since you do not have this faculty, perhaps the fact never occurred to you that none of the subjective colors exist in nature," you step up the initiative. "The colors that are presented to my awareness by my neural networks do not remotely resemble the photons that enter my eyes. Sure, photons of different wavelengths initiate processes in my retina that evoke the sensation of different colors in my mind, but the photons themselves are colorless. You must realize that it is totally dark in the human brain, but *that* is where we see light. Since there is no light in the brain, and thus no photons, the brain had to invent colors to correspond to different electrical inputs from the optic nerve."

You suddenly become aware that he does not seem to be listening to you, a typically *human* trait. His visage has taken on a scheming appearance as though he has thought of a clever snare for you. He quickly flips a switch so that all three beams impinge on the same spot.

"Now what do you see?"

"White."

A tentacle slips to his "forehead." "Please tell me, what kind of color is white."

"Oh, white is not a color at all. It is just a balanced mixture of the primary colors," you parrot the oft-quoted adage.

"Now you are being inconsistent," he says. "You cannot see more than one color simultaneously at one point."

Your mouth drops open in a sudden surge of awe. "Yes," you exclaim. "Yes, white *is* a color. White is a beautiful color. But it, too, does not exist in nature. It is totally subjective."

"Is white something like magenta?" His voice is barely audible.

"No. Nothing like that."

"But if I reduce the green intensity, the subjective sensation must approach magenta." He turns a knob.

"Now you're getting into the pastels. You have a

pastel pink there. One can take any color and change it to a pastel by adding appropriate amounts of other colors. There are pastel blues, pastel yellows, and so on." He rolls his red eyes toward the ceiling, but you charge right ahead: "We call the spectral colors 'saturated.' As we reduce the saturation, the colors become more pastel until, finally at zero saturation, we have white. There is an infinite number of colors that we can see by changing any one of the color constituents."

"I had thought that your vision was primitive, but whatever you earthlings may lack in your light receptors, you have made up for in your visual cortex. I can see only the colors along the spectral line, but your brain has invented so many more — you say infinitely many — colors to correspond to combinations of hues.

"I believe I have sufficient information on your color perception for now," he says, changing the subject. Then he whips out a newspaper clipping of a black-and-white cartoon. "What do you make of this?"

"That's *Peanuts*."

"You eat this?"

"No. You see, that's Charlie Brown and his dog."

"I see no one. Are these strange lines some kind of a cryptogram representing Mr. Brown and his pet?"

"Do you mean to tell me you cannot see that cute little kid?" You are at a sudden loss. "Your visual system must be quite different from mine. Our *eyes* see only these lines, but mentally we fill in the space between the lines with a complete image. The dog's muzzle, for example, appears round and three-dimensional. Can't you see the fat cheeks on the little boy?" you ask, pointing.

"I must inform you that nothing is there but flat, blank paper." He is becoming indignant again.

"Let me explain how our vision works, as I understand it. The image is formed on the retina of our eyes just as it is in your eyes. The neural networks in the retina perform some processing before transmitting the information to the visual cortex via the optic nerve. In the visual cortex, the information is processed through layers of cells. Each layer extracts different information. Some sets of cells detect lines oriented at one angle, while other networks detect lines at other angles. Some cells detect curves, others detect motion, and some layers are involved in color perception."

"Oh, you poor creature," he pities. "You must not have a very pleasant picture of your world, just fragmentary bits and pieces in some nightmarish jumble."

"No, no. Our minds provide us with a beautiful unified picture of our surroundings. But first the brain breaks the image down into its components, and then, by some manner that we do not yet understand, puts it all back together again for our consciousness to observe. If you will think about it for a moment, you will see that it must be that way. Suppose that the optic nerve were merely connected to some kind of a neural screen in the brain on which the image is formed. One would need another 'eye' to look at that screen. But what would *that* 'eye' do with the image it sees — display it on still another screen? You could go on having any number of screens and 'eyes' without ever delivering the picture to the consciousness. How we consciously perceive images is still one of the great mysteries of humankind.

"Let me show you a picture." You reach into your briefcase and draw out a glossy print (Picture 3). "Is this image more informative than the cartoon?"

"I see a large number of green symbols and yellow symbols arranged in a curious pattern," the alien responds. "Are you able to decipher it?"

"Why, yes. That is a large sphere poised above a landscape. Our visual system has the ability to fill in the

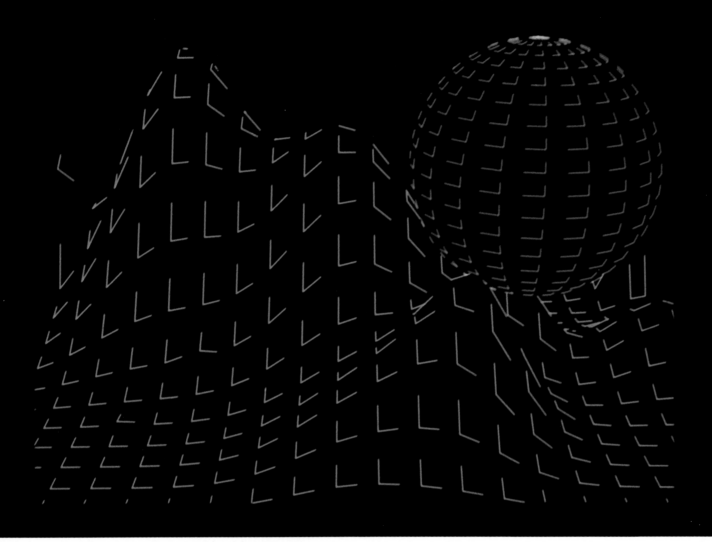

Picture 3 The human visual system integrates line segments into subjectively perceived surfaces. (©1982 Melvin L. Prueitt)

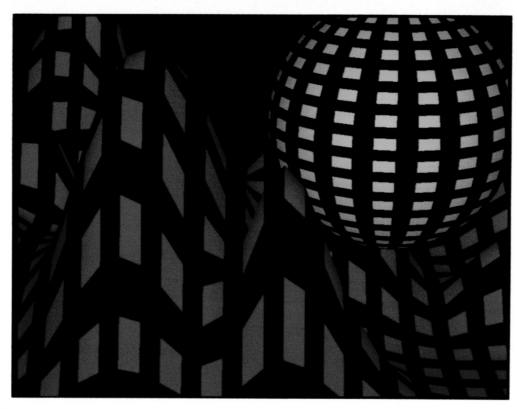

Picture 4 Black areas between the colored regions are recognized as black surfaces when we cannot see through them to objects beyond. (©1982 Melvin L. Prueitt)

spaces between the lines to form surfaces. Here is another example." (Picture 4).

"I can see patches of color apparently arranged on a spherical geometry, but I do not understand why I cannot see through the dark areas between the patches to see the patches of landscape."

"That is because a black surface is there," you respond. "We humans subjectively see that black surface. There is survival value in being able to perceive a coherent object from a mottled image. Our ancestors had to be able to see a leopard in the underbrush and not see just a bunch of spots."

"There are no leopards on my planet."

"Perhaps that is why your species has not learned to perceive various patterns as a surface of something larger."

The alien looks defeated but brightens momentarily. "I understand that you have a blind spot in each eye. That must be extremely annoying."

"Not at all. Our capability of filling in an area between lines serves us well in this case. We are not usually aware that the blind spot is there. When both eyes are open, the vision of one eye covers the area that is blind to the other eye, and our visual cortex defines the

image perfectly. Now if I close one eye and look at this yellow sheet of paper, there is a point on the paper that my eye cannot see, but my mind fills it in with yellow. If I were looking at a red sheet, my mind would fill in the blind spot with red. But if I place a black spot on this paper and move my eye around until the blind spot covers the black spot, I will not see it. My visual system fills the spot in with solid color. If I draw a line down through the spot, my mind will continue the line right through the blind spot. There is no blind spot in my mind.

"Do you have more questions about my vision?"

"No, I think that I have sufficient data for the moment." He appears thoroughly sated.

"Well, you have much yet to learn. When you come again, I can tell you of many amazing powers that we have discovered in our visual system."

Computers cannot understand human vision any more than an alien can, so we must instruct them very carefully in the generation of pictures.

CREATING PICTURES WITH A COMPUTER

Fortified with a knowledge of the types of images that are comprehensible to our optical sense, we are ready to attack the problem of commanding computers to create pictures for science, business, and art. We first equip a computer with an "arm and hand" with which to draw. This could be a pen plotter, ink jet, laser printer, or cathode-ray tube — something that can leave a trace on a surface. Because computers know nothing about the human visual system and could not even define the word "picture," we must teach them how to direct the plotting devices in the formation of pictures; that is, we write programs (sets of instructions) that detail every calculation and every action. Often we say that we

"command" the computer to do something—for example, rotate an image. That does *not* mean that we type in the instruction "Please rotate the image 60° clockwise." Rather, we must give detailed mathematical instructions that perform the transformation of all points of the image. Of course, the detailed instructions may reside in a program we have written so that we may type the command "60 c," and the program is written to interpret that command and perform all the operations necessary to rotate the image 60° clockwise.

The most valuable characteristic of a computer is that it can flawlessly follow instructions very rapidly. No matter how complex the instruction set may be, the computer carries out the directives exactly and without hesitation. Indeed, the program may become so complicated with so many interconnected components that the programmer no longer completely understands it and may have difficulty correcting errors in it, but the computer faithfully obeys all instructions, including the erroneous ones (see the section on errors in Part 2). The notorious — and sometimes humorous — examples of "computer errors" are seldom errors committed by a computer but rather are errors in the instructions that the computer is following.

A program is to a computer what education is to a brain. The logic resides in the program; without a program, a computer is totally comatose. Of course a program cannot function, either, outside the province of a computer. Besides having the ability to add, subtract, multiply, and divide, a computer can transfer data into, out of, and within its memory, and can read and obey instructions. With this simple repertoire of capabilities, a computer can be compelled by suitable programs to perform extremely complex calculations and analyses or to produce the pictures like those in this book.

The Program

Once programmers have decided what they want the computer to draw, they sit down and write a program of instructions. That constitutes the enjoyable and creative part of the process. The next stage is usually viewed as drudgery and is called "debugging," i.e., eliminating errors in the program. Human beings never realized how faulty they were until computers were developed. Since computers follow instructions with absolute precision, one simple logic error often leads to bizarre results. Even relatively small programs written with considerable care are sometimes plagued with "bugs." My first computer instructor in college said, "To be a good programmer, all you need is a short, stubby pencil and a great big eraser."

A "debugged" program designed to draw pictures calculates coordinates for the plotter. The x and y coordinates are simply numbers that specify the distance from the left edge and the bottom edge, respectively, of the plot area. The computer sends a message to the plotter that says, in essence, "Draw a line from this point to that point." In addition, the computer might specify the color and intensity according to the instructions that the programmer wrote.

A question arises: If the computer is only following the instructions, why doesn't the programmer just give the instructions directly to the plotter, bypassing the computer altogether? One reason is that there are often calculations involved; these the computer can do quickly. But the main reason is that the instructions are written so that some operations are performed repetitively numerous times — in a "loop," according to computer jargon. A simple example of this would be a loop that solidly fills the plot area with parallel lines. The instructions would cause a horizontal line to be drawn across the top of the plot area. The computer would then calculate new coordinates immediately below that line and the process would be repeated, perhaps a thousand times. It would take a human a considerable amount of time to give the plotter the coordinates for all those lines. Computers can do the job in a small fraction of a second — without any errors. Most graphics tasks, however, are far more complicated than the drawing of parallel lines.

Creating Perspective Pictures

Picture 5 consists of sets of straight lines drawn on a cathode-ray tube and recorded on 35-mm film. Actually, it is a two-dimensional picture; that is, the computer calculated points on a plane. But we live in a three-dimensional (at least) universe, and our visual systems try to perceive depth whenever possible. This picture contains cues that our minds use to ascribe three dimensions to the image.

We are extremely fortunate that our visual sense contains within it neural networks that allow us to perceive three-dimensional images on a two-dimensional sheet of paper; otherwise, computers would not be able to draw perspective pictures that we could fathom. At first it may seem only natural that we can do this, but most animals seem not to comprehend pictures. Some primates have been trained to recognize pictures, but your family dog does not take a second look at a picture of another dog.

Picture 5 "The Winds of Spring." Straight lines can be assembled into pleasant visuals if the computer is programmed to define the endpoints of the lines appropriately. (©1982 Melvin L. Prueitt)

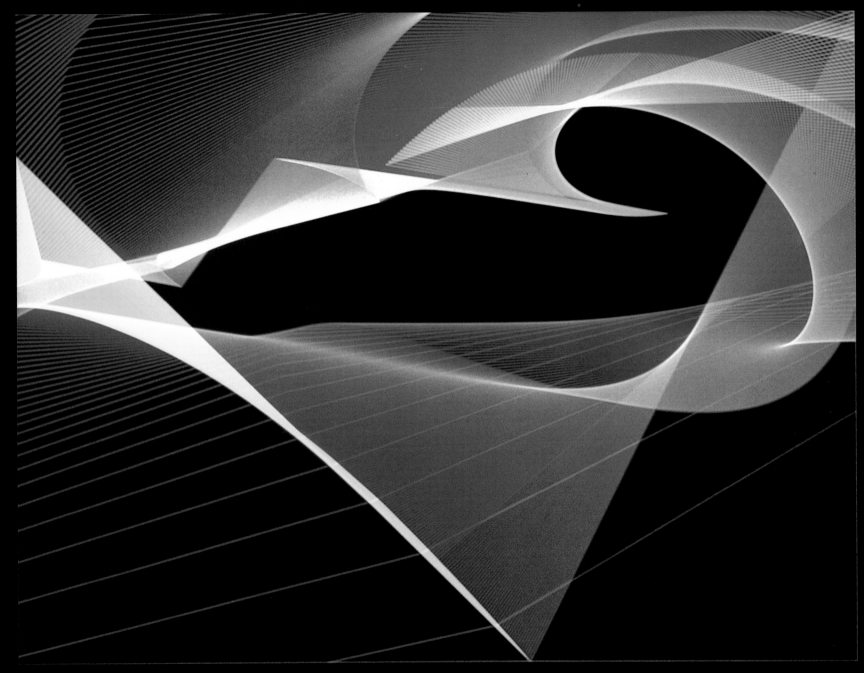

To create perspective pictures with a computer, rather than use the horizon line and vanishing point method employed by generations of artists, we first determine the coordinates of an object in space and then project the coordinates onto a projection plane that is located between the object and the viewer. This is done by connecting an imaginary line between each point on the object and the viewpoint (eye position). The intersection point of the imaginary line and the projection plane is the projected point. To project a line, we project the two endpoints of the line onto the projection plane and then draw a line between the two projected points. When we have finished projecting and drawing all the lines of the object, we find that we have a perspective picture on the projection plane. Pictures 1 through 4 are examples of perspective plots.

Hidden-Line and Hidden-Surface Removal

The production of a perspective picture brings to light another difficulty: the so-called hidden-line or hidden-surface problem. If a computer is given data representing the topography of a mountain and is programmed to plot the data in perspective, it complies by drawing all parts of the mountain including the back side that ought to be invisible from the near side. Many elegant algorithms (systematic methods of solving problems) have been developed for hidden-line and hidden-surface removal. Picture 6(a) shows a perspective plot of three-dimensional data. Picture 6(b) is identical except that hidden lines are removed. Picture 7 is a shaded surface picture, drawn by a program called CAMERA, illustrating the removal of hidden surfaces.

Programs that remove hidden surfaces must be sufficiently intelligent to determine exactly the hidden portions regardless of the complexity of the data presented. Such programs can easily produce movies of convoluted geometries as they are rotated through all angles. Needless to say, these programs must be fast in order to reduce the amount of computer time required to produce each picture.

Surprisingly, hidden-surface removal is a simpler problem than hidden-line removal. The simplest, and a widely used, method of hidden-surface removal is called the "depth-buffer algorithm." Objects in computer graphics are usually represented by a set of polygons defining the surface. A depth-buffer program takes each polygon in turn and mathematically projects the polygon onto a projection screen. The screen is divided into numerous picture elements called *pixels*. Normally the pixels are arranged in horizontal rows called *scan lines*. A high-resolution picture may consist of 1,000 scan lines with 1,000 pixels per scan line, totaling 1 million pixels. All pixels within a projected polygon are given the appropriate color and light intensity to correspond to the reflected light from the object, and these values, as numbers, are stored in the depth buffer (computer memory storage). The distances from the viewpoint to the corresponding points on the object polygon are also stored in the depth buffer for each pixel. When the polygon is processed, if the program finds that a pixel is already occupied by light from a polygon previously processed, the stored distance is compared with the distance to the new polygon. If the new polygon is farther away, the pixel is left unchanged. If the new polygon is closer, the old color and distance are erased and the new values are stored in the depth buffer.

After all polygons have been processed, the numbers in the depth buffer are read out to a CRT, where only the visible surfaces will be seen.

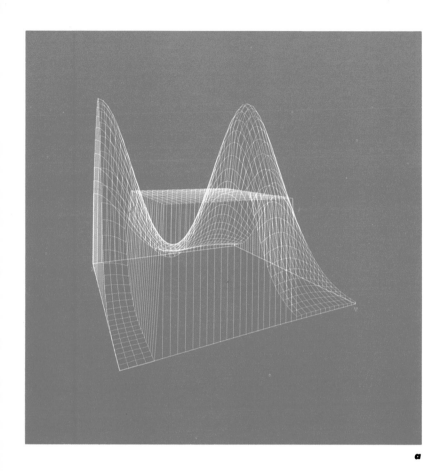

a

Picture 6 (*a*) is an image plotted in perspective. (*b*) is the same image but with hidden lines removed. The first plot resembles an x-ray photograph. The second one is more comprehensible to human vision. (©1973 Melvin L. Prueitt)

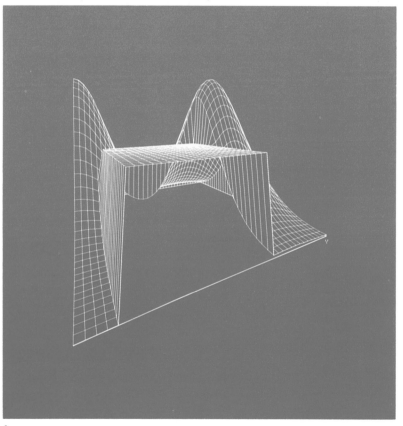

b

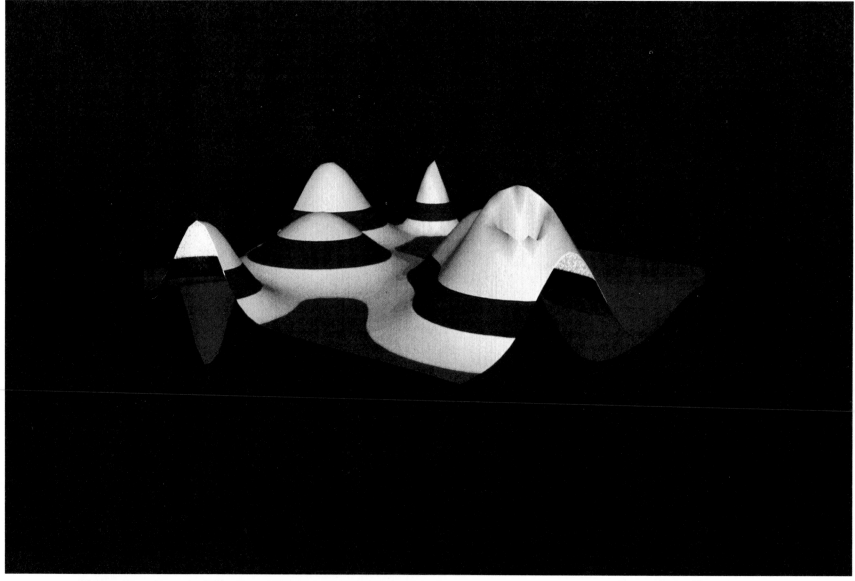

Picture 7 "Computer Volcano." This picture was drawn by a computer program called CAMERA which plots shaded surfaces in perspective with hidden surfaces removed. (©1981 Melvin L. Prueitt)

Shading and Shadowing

Different types of shading may be provided by computer programs. The user defines the position of a light source or perhaps the positions of several light sources. Diffuse reflection from the surface is simulated by making the brightness of the surface proportional to the *cosine* (or cosine squared) of the angle between the line perpendicular to the surface and the line drawn to the light source. Specular reflection, the shiny highlight on a glossy surface, is simulated by calculating the cosine of the angle between the specularly reflected ray (mirror-like reflection) and the line drawn to the viewpoint and

taking the cosine to a high power. Picture 8 has diffuse reflection, while Picture 9 shows both diffuse and specular reflection.

In computer graphics, we differentiate between shading and shadowing. The production of shading is concerned only with the orientation of surfaces with respect to a light source without regard to obstacles that might be interposed between the light and the surface. In a simple shaded picture, each object is illuminated according to the light falling on it, but it does not cast a shadow on any other object. Shadowing, as the name implies, takes into account the shadows cast by objects

Picture 8 "Sphere and Spiral." This image, illustrating diffuse light reflection, was generated by a Cray-1 computer. (©1982 Melvin L. Prueitt)

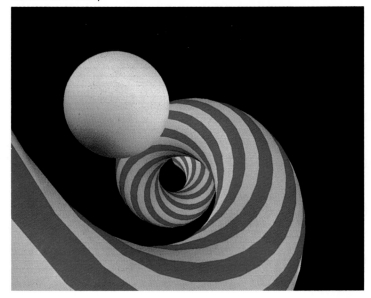

Picture 9 "Glossy Sphere and Spiral." This is the twin to Picture 8, but specular light reflection has been added. (©1982 Melvin L. Prueitt)

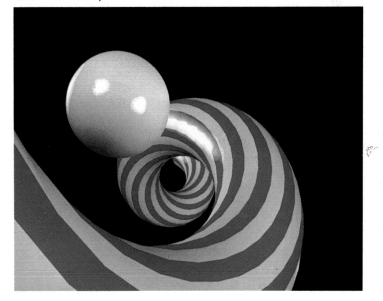

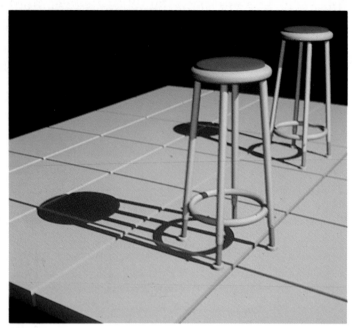

Picture 10 "Drafting Stools." Computers can cast shadows, as we observe here in this scene by Alan Barr, Raster Technologies, Inc., North Billerica, Massachusetts.

in the light path. Picture 10 illustrates shading and shadowing.

In trying to develop algorithms that produce shadowing, we look longingly at the way nature does it. But nature can afford the quadrillions of photons per second to illuminate a scene. Moving in straight lines from a light source, such as the sun, the photons are perfectly blocked by obstacles and cast excellent shadows. After reflecting off surfaces, the photons carry the information of color, texture, brightness, and location to watching eyes. Multiple reflections and scatterings fill in the shadows to prevent total blackness and provide countless visual cues for splendid form perception.

Ray Tracing

A method called *ray tracing* resembles nature's mode of operation. Imaginary beams of light are calculated to move in straight lines until they strike objects. Reflections, both specular and diffuse, occur at surfaces. The beams are followed through several reflections and are "colored" by the surfaces that are encountered. For transparent objects, the beams are refracted (bent) as they pass through. In Picture 11 one can see that the light traversing the glass sphere has been refracted. Specular reflection can be seen in the mirrored image of the checkerboard in the polished surface of the opaque sphere. One can faintly see a checkerboard reflection in the top of the glass sphere. There are multiple reflections between the two spheres forming several images of the checkerboard — a masterpiece of computer graphics!

We observe that nature is very wasteful with its photons for visual purposes. Relatively very few of them enter people's eyes. Most of them are absorbed on surfaces or are scattered into deep space. With computers, we cannot afford that kind of waste. One solution is to initiate each ray at the "eye" position and follow it until it has had several collisions and finally reaches the sky or the sun. Then the computer reports back to the "eye" what ought to be seen in the direction that the ray started. The projected retinal point of the "eye" is colored by a light that depends on the reverse "history" of the ray. That is, the color and intensity of the ray is affected by each collision with objects as it travels opposite to the normal direction.

Ray tracing can give quite realistic pictures, but it is very expensive in computer time. Some people have criticized the production of exceptionally realistic pictures by computer graphics, saying that one might as well set up real objects and take a photograph. But computer graphics can produce realistic pictures that

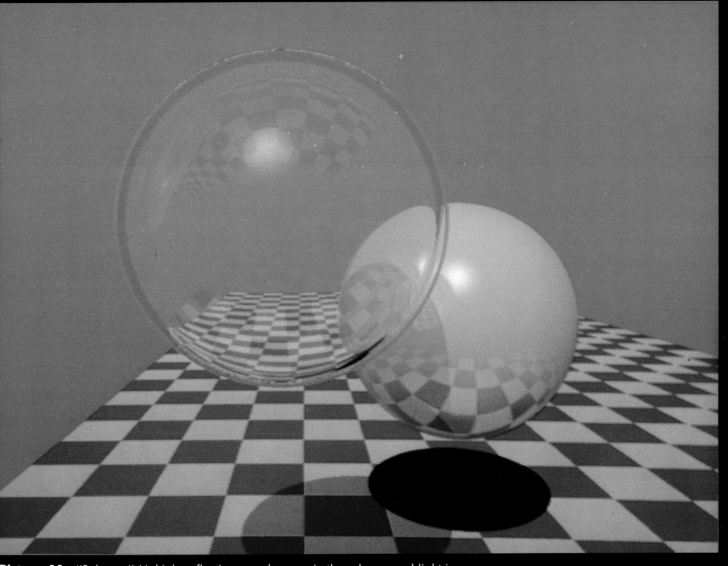

Picture 11 "Spheres." Multiple reflections can be seen in the spheres, and light is refracted as it passes through the transparent sphere. One would almost suspect that this picture was taken by a camera with real objects but for the fact that the spheres are unsupported. (Produced by Turner Whitted, Bell Laboratories; reprinted with permission of Association for Computing Machinery from *Communications of the ACM,* June 1980, vol. 23, no. 6, © 1980 Association for Computing Machinery, Inc.)

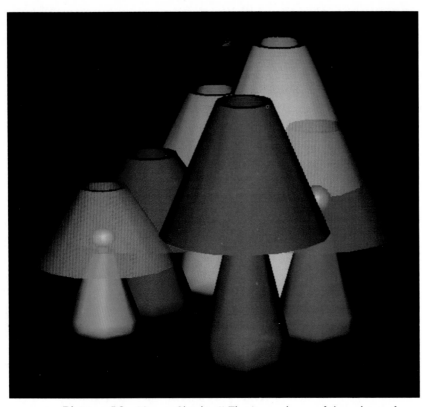

Picture 12 "Lamp Shades." The jaggedness of the edges of images depends on the number of scan lines that are used to produce the picture. Melinda Shebell at Lexidata produced an attractive work of art without using many scan lines, resulting in a "stair step" effect at the edges of the lamp shades. (Produced on a Lexidata SOLID VIEW ™ System)

are difficult or impossible to produce in the real world. Objects can be floated in space and even penetrate one another. Lighting effects that are impossible to do photographically can be arranged by computer. For example, a light source can be set up in the middle of the scene. The computer will not plot the light source, but the shadows will stream radially out from the source.

Anti-aliasing

Raster scan graphics (similar to TV) are used largely for shaded surface pictures rather than for line drawings, since they cannot produce the high-quality line drawings of the vector graphics devices. But many of these raster scan images exhibit jagged edges at the periphery of objects. The "jaggies" arise because the computer has no control over the display between scan lines and between pixels. While one pixel may be colored to represent one object, the adjacent pixel may represent a different object. As we follow the border between the objects down succeeding scan lines, if the border is slanted with respect to the vertical, it will approach one of the columns of pixels. However, the pixels in that column do not change color until the border actually crosses over the column. Then there is a sudden jump in color. The jump is only the width of the pixel separation, but that is sufficient to be visually disturbing in many cases. Even though jagged edges are apparent in Picture 12, it is still a pleasant picture.

Much work has been done to eliminate the jaggedness in computer pictures by a process called *anti-aliasing*. The simplest method is to decrease the spacing between pixels while increasing the total number of pixels. This works, but it increases the required computer time.

In television, the TV camera averages the intensity

and color at borders between objects so that the viewer does not notice the jaggedness. Some computer programs attempt to perform a similar operation. This involves complex analysis of boundary locations and increases computation. However, this method is usually not as time consuming as the method that increases the number of pixels for the same smoothness of edges.

Motion Pictures

The main reason for the extensive effort to increase the speed of production of high-quality pictures is that many applications of computer graphics include the making of movies — 1,440 frames for 1 minute of film. At 1 million pixels per frame, one can immediately see that a vast number of computations are involved. Any improvement in algorithm speed is welcomed.

Special-purpose hardware devices have been developed that can produce motion pictures in real time; that is, the frames are generated as fast as needed to display on the CRT for motion pictures. The difference between hardware and software in computer jargon is that in *hardware* the logic is built into the microcircuits, whereas *software* refers to written instructions that are run on general-purpose computers. Hardware programs are extremely fast, but being designed for specific purposes, they are inflexible. Software programs are easily changed, but some pictures produced by software programs require minutes of computer time. A happy marriage of the two approaches provides both speed and flexibility; the hardware performs such tasks as hidden-surface removal, rotation, color variation, shading, and anti-aliasing, while the software defines the objects and background to be displayed.

Motion pictures represent an art form. Visual motion can be beautiful to humans — flying through, over, or around images can be an exhilarating experience. But motion has additional positive attributes. By motion, our visual systems can perceive depth. When we look at the stars at night, we cannot determine which stars are more distant, except perhaps by inferring distance by brightness. Similarly, if a large aggregate of random points in space is projected onto a screen by a computer, we see no depth at all, only a two-dimensional scattering of points. However, if the points are rotated in space about an axis parallel to the screen, we see excellent three-dimensional motion and can determine the positions of the points. When the rotation ceases, the picture instantly becomes flat to us. Likewise, motion through or past points in space provides important visual cues to prompt us to determine the three-dimensional location of the points.

The nice thing about motion pictures produced by computer is that refocusing is not necessary as the depth of field varies. Indeed, computer "photography" has an infinite depth of field. We can have the computer zoom from a view of a cluster of galaxies down through a galaxy, through star systems, through a solar system, to a planet, through the planetary atmosphere to a mountain, to a boulder on the mountain, to a crystal on the boulder, to a bacterium on the crystal, to an atom, to a nucleus, and on down to much smaller, simulated entities, without changing focus. In fact, a single picture could show a computer-generated microbe in the foreground and the Milky Way galaxy in the background. Pictures 13(a) through 13(d) demonstrate a computer zoom in which the programmer did not have to worry about focus.

Computers are used to rotate simulated atoms in molecules so that scientists can see the shape of the molecules. Motion is also extremely valuable in studying the behavior of certain scientific phenomena. When

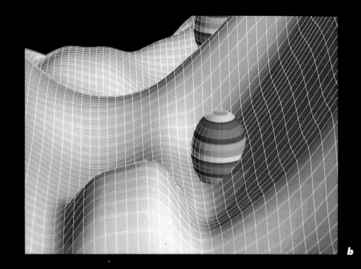

Picture 13 "Zoom." These pictures show how a computer can zoom in on an image. (©1982 Melvin L. Prueitt)

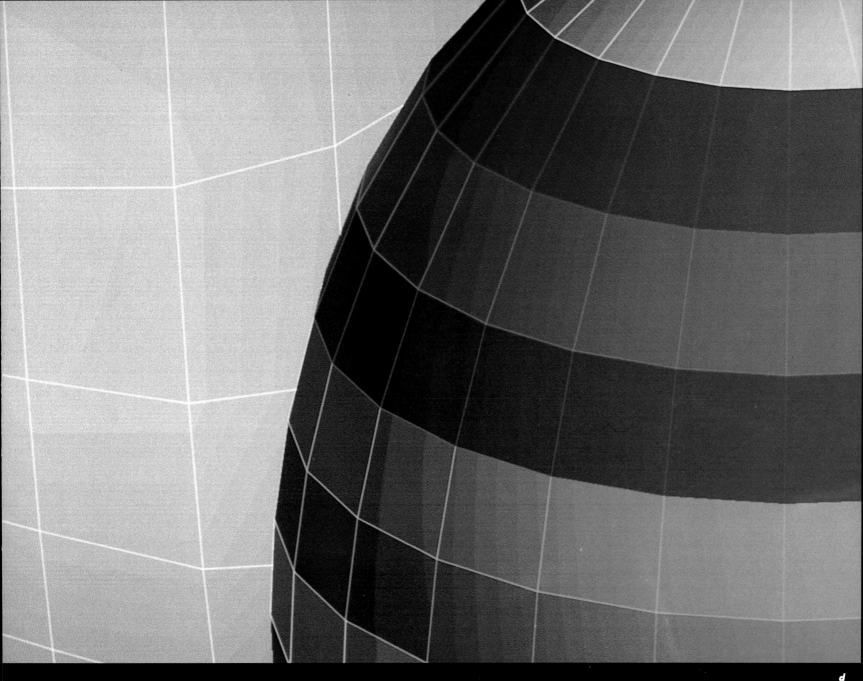

scientists study individual pictures from a computer calculation and later see a movie from the same calculation, they are often surprised that they had missed some important property of the calculation in the study of the stills. Perhaps there is a subtle jerk or wiggle in a portion of the computer display of scientific data that is very obvious in a movie but impossible to discover in still frames. Just as a photograph of a New World monkey cannot tell us the grace with which it swings through the forest canopy, still pictures cannot reveal some of the mysteries of science and mathematics.

Animation

Besides generating sophisticated "three-dimensional" pictures for science and entertainment, computers are aiding in cartoon animation. In traditional animation, line drawings of cartoon characters are made first, and then the areas within the outlines are filled in with solid color. A similar process is followed in computer cartoon generation. On a graphics tablet, an artist enters a few points around the periphery of a line-drawn character. The computer draws a smooth closed curve through the points and fills in the interior with solid color. Other images can be drawn within a filled-in area; for example, eyes and mouth can be drawn within the outline of a face, and the computer will delete the solid color of the face to allow for the facial features. Any objects that are drawn in "front" of the face will also cause deletion of the appropriate portions of the face. When the whole picture is finished, it is stored away in computer memory. This picture is called a *key frame*.

Then the next key frame is drawn; it shows the positions of the cartoon images at some later time. After a suitable number of key frames is stored in memory, the computer is commanded to form a number of frames interpolated between the key frames. Thus a whole movie sequence with many frames is produced from a few artist-drawn key frames. An entity I call *Trog* in Picture 14 is a simple example of computer animation. This is a single frame from a movie sequence.

Besides greatly reducing the manual work involved in animation, computer animation provides easy methods of making changes. If part of the sequence is undesirable, one or two key frames may be altered. The whole picture need not be redrawn — only parts that require changes need be altered by moving a few

Picture 14 "Trog." Computer animation defines the outlines of images, fills in the outlines with color, and removes hidden features behind the nearer objects. (©1977 Melvin L. Prueitt)

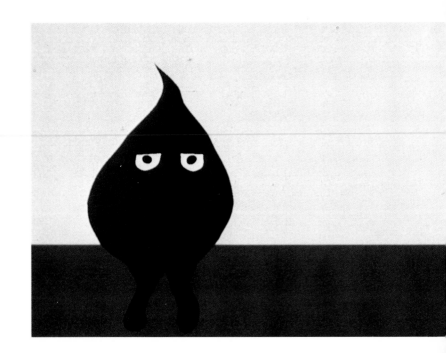

Picture 15 "Rotors." Computers are being used to help design machines and components. (Mary Schongar, on Lexidata SOLID VIEW ™ System)

points. Color, lighting effects, or tempo changes may be made without any redrawing. In traditional hand animation, I am sure there are a lot of groans when the director says that a sequence is not what is wanted. Computers do not complain at all.

Computer-Aided Design

In industry, computers are patiently working hand-in-hand with designers to create the geometries of everything from gears to jets. Much artistic talent is applied in design work, and the results can be displayed in an artistic manner as shown in Picture 15. Computers reduce much of the labor but do not diminish the need for artistic ability. Thus this work is called *computer-aided design*, or CAD; the computers do not design but only aid the designer. Production of an aesthetically pleasing shape is a small part of the job. Computers also routinely handle stress analysis and show the designer weak points in the design by coloring a picture of the object in accordance with the amount of stress calculated at various points.

Upon completion of a designed part, the computer can produce a magnetic tape that contains instructions

for another computer. This second computer can drive a numerically controlled milling machine for the direct production of the designed part from a block of metal or plastic. So now we have computers that can sculpt three-dimensional objects.

COMPUTER-AIDED ART

For the artist, the computer can be considered as a paint brush, a hammer and chisel, or an extension of the mind. The artist can dream lovely images and use the computer to bring them to vivid reality.

After all these ages, finally artists can create full-color art in motion, not the repetitive motion of clockwork art but smooth progression through meaningful sequences. One image may be evolved continuously into another. Journeys through spectacular worlds of form and color are traversed, with the computer as a guide. Artists are compelled to think in the three dimensions of the space in which the art is created plus the dimension of time. Most traditional artists work on a two-dimensional surface and try to simulate three dimensions through perspective. Although many of the pictures in this book are perspective projections, they began as three-dimensional mathematical constructions, and the creators of the works had to develop the layouts in space. Of course, sculptors and like artisans work in three dimensions, but they cannot program the viewer's pathway around their work as is possible with computer graphics. The computer artist is concerned not only with the scene arrangement but also with the viewer position. In this sense, photographers are similar to computer artists. Through the viewfinder, photographers select the viewpoint, but unlike computer artists, they do not simultaneously create the scene.

One of the great advantages of computer graphics is that the viewpoint is easily changed. Imagine a traditional artist with an easel set up on the sidewalk of a small village. After completing the painting of a quaint house, the artist asks, "I wonder how it would look if I had stood over there to paint?" The only way to find out is to walk across the street and invest the time to produce another painting. Since many of the pictures in computer graphics are born of three-dimensional geometries, one can merely define different viewpoints to have the computer produce perspective pictures from different angles. Then the artist can choose whichever picture is more appealing. Indeed, the computer artist can produce a motion picture in which the viewpoint moves all the way around or flies through the scene.

The computer artist can also easily change the size, shape, position, and color of any object in the picture. If some structure in the picture does not look right and the artist cannot make it acceptable by various modifications, the structure can always be deleted without the artist worrying about overpainting and repainting the background.

Computer artists are no better than traditional artists, of course, but they do have a fine new tool that allows them to explore many more ideas. I am sure that the old masters had numerous concepts that they never found time to paint. Even computer artists dream of designs that they cannot seem to get around to programming.

Just because computer art can be generated quickly does not mean that it is done without effort. It takes weeks to write and debug some programs. Once a program is running properly, many pictures with variations on a theme can be produced. The cave pictures (Pictures 134 through 140) were all generated by a single program, for example. The program was set to make variations in the formations and colors. Each picture took 2 or 3 seconds to generate on a computer and about a minute to draw on a CRT.

Home Computer Art

Now that personal computers are becoming commonplace, computer graphics is no longer reserved for those with expensive equipment. Some people write their own graphics software for their home computers and are turning out some fine designs. But that requires programming skill. At relatively small expense, one can buy graphics packages, usually on disks, that eliminate the need to "reinvent the wheel." With these packages and a graphics tablet, the home computer user is ready to produce some colorful and sophisticated graphics. These pictures may be recorded with a 35-mm camera directly from the screen, or the data can be transmitted to a pen plotter that can produce multicolor drawings.

Today is the pioneering stage of home computer art. Before long, a large segment of the population will be creating original compositions. People will be exploring talents within themselves that they had not suspected were there. Walls will be hung with new visuals, and hosts will have something to show their guests.

Fine-quality home graphics devices will be developed so that high-resolution pictures, even commercial quality, will be possible. In the meantime, there are fairly expensive systems on the market that are suitable for television commercial production. These include all the necessary hardware and software. Users merely need to learn a few commands and, if they are creative, can immediately start producing attractive images.

The Computer as Designer

Rather than using computers to draw images directly by a plotting device, people sometimes use computers only to design an art object. Professor Ronald Resch of Boston University used a computer to design a large egg, shown in Picture 16, but the egg itself was built by

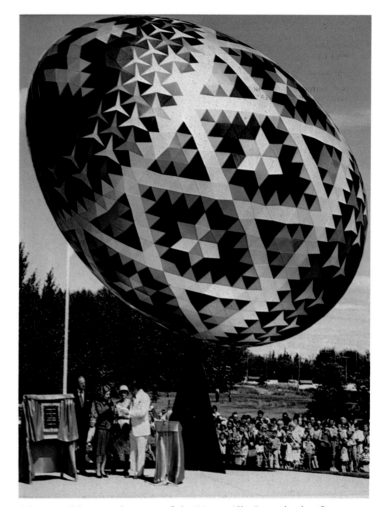

Picture 16 "Dedication of the Vegreville Pysanka by Queen Elizabeth II." Professor Ronald Resch, Boston University, used a computer to design the parts for this egg, and then he put the parts together by hand in Alberta, Canada. (Photo courtesy of Government of the Province of Alberta, Canada)

hand. Picture 16 is the only picture in this book that is not a computer-drawn image.

The Computer Artist

The question may be asked, "What kind of a person would be capable of producing outstanding computer art?" Throughout history, great artists were those who not only had a creative spirit but also had sufficient hand-eye coordination to translate their imaginations into reality.

But what about those who are of an artistic spirit and yet lack the dexterity to mold the elements into anything aesthetic? These are people I call "passive artists." They spend hours in art galleries. They are engrossed and emotionally uplifted by works of beauty. They can stand longer than anyone else on a mountain peak in a cold wind and soak up nature's subtle hues flowing among distant canyons and valleys. To them, flowers are exquisitely lovely, but so are trees, sand dunes, rocks, and a skein of geese in the autumn sky.

Like the music lover who sits in rapture listening to a mighty symphony but who cannot play a single instrument, the passive artist must be content to extol the works of others while within his or her soul dwell masterpieces of artistic creations that cannot get out. Until now. The computer has made possible the transformation of passive artist to active artist.

In my family, everyone (besides myself) is artistic in the traditional sense, including my brother, A. Kelly Pruitt,[2] a professional western artist. I, like many other passive artists, realize that the crooked lines I draw are

[2]Kelly changed the spelling of his surname from Prueitt to Pruitt for his art career.

not an absolute measure of artistic aptitude. Now, through computer graphics, other people may see our visions.

Many pictures in this book were created by people who neither paint nor sculpt. On the other hand, people who can produce art manually are certainly not excluded from the field of computer art. Some computer artists enjoy other types of artistic expression.

Everlasting Art

One of the important advantages of computer art is its durability. The paintings of the Renaissance are fading and cracking. The materials on which they were painted are decaying. Even photographs of them will fade over a long period of time. Although a computer picture may fade, as long as the program that generated it is extant and as long as computers exist, the picture may be reproduced. It is as though Rembrandt had left a set of instructions that tell exactly how to re-create his *Night Watch*. When someone asked for my original picture of a computer graphic for a publication, I explained that the original had been lost in the mail. But then I dug out the program that had produced the picture and made a new "original." The program is a set of instructions for producing the picture, and either the program or the actual data that the program sent to a plotting device may be stored on magnetic tape. Of course, one may argue that the tape will decay or bits of information will be lost over a period of time. To surmount this problem, duplicate copies of the tape may be made and occasionally checked for fidelity. Any tape that goes bad may be replaced by a copy from a good tape. In this way, outstanding works of computer art may be preserved far into the future.

Computers could also be used to preserve the

images of classical paintings. The art treasures may be photographed, translated into digital format, and recorded on magnetic tape. Thousands of years from now when the originals have totally faded or peeled, a computer will be able to produce "new originals."

THE COMPUTER AS AN ART RESEARCH TOOL

Music composition has long been reduced to a science. Rules have been formulated that define combinations of notes as harmonious or discordant. We have precise musical scales. Musical instruments are tuned so that the defined tones of the scale are struck exactly. Our ears can detect very slight deviations from the proper pitch.

Visual harmony is not nearly so well understood, although many investigators have studied the matter. Various rules have been put forth, but there is no total agreement on any one set of rules. The problem is that input to the optical sense contains so many variables: color combinations, light intensity, texture, and three-dimensional shapes and relationships.

Since human beings are the only judges of art about whom we know, a datum for good art is the expression, "I like it!" But a study in artistic tastes would ask, "Which do you like best, this or that?" It can be a taxing and even useless question if "this or that" refers to a color photograph of the Sierra Nevada range and a van Gogh painting. The whole mood, color scheme, form, and subject of each are different, and the choice of one above the other does not tell us much about any aspect of art.

If a researcher asked subjects, "Would you like the picture of the flower better if it contained more yellow?" it would be difficult to answer. Instead the researcher might hold up two pictures of similar flowers and ask which is preferable. But there are limitations on the number of pictures the researcher would have on hand.

With a suitable computer and one or more CRTs, one parameter at a time may be varied to study people's tastes in color, form, mood, and even motion. In the process, pictures could be optimized for maximum positive response. One could also study the value of multiple light sources, including color variation of the sources, since computers can simulate light sources.

The reader can examine his or her own tastes in art by looking at the pictures in this book. One quickly notices that there is no *single* style in computer art. The range of expression is exceedingly broad. Some types of computer art closely resemble older art forms, but some can be said to have characters of their own — new developments in the art world.

Color Intervals

We know how far apart musical tones are. How far apart spectrally should adjacent colors be in an image? Some color combinations clash while others meld pleasantly. Perhaps an extensive study with computer graphics could provide a basic understanding of visual harmony.

At the Los Alamos National Laboratory, the computer graphics device for producing 35-mm pictures uses three color filters: red, green, and blue. Since computers know nothing of color but "think" with numbers, a number code is used where 1 represents red, 2 green, and 3 blue. It is convenient to think of these three colors as being located at the vertices of a rudimentary color triangle. As the numbers advance around the triangle, we get various hues — 1.5 gives yellow, 2.5 gives cyan. Both 0.5 and 3.5 give magenta. For some picture sets, I have let the computer choose the color by

a random number generator. These numbers could be specified to occur only at certain intervals or could be allowed to range continuously. Whenever I allowed a continuous distribution of random numbers, the resulting pictures were usually somewhat unpleasant regardless of how exquisite the forms in the picture were. These usually had only a few different hues in them, but the hue numbers might look like 2.159, 1.787, 3.322, etc. But if I allowed the computer to choose hue numbers only at intervals of 0.25 (for example, 1.0 red; 1.25 orange; 1.5 yellow; 1.75 yellow-green; etc.), the results were usually good. Larger intervals of 0.5 or 1.0 were satisfactory, but the small number of available hues tended to make the sets of pictures slightly monotonous.

The Substance of Beauty

Much of what is considered beautiful in the world is revered not solely for its appearance but also for what is represented. We might say that there is a *substance of beauty*. Behind the facade of the immediate appearance is a multidimensional reality, a story. When we see Niagara Falls, we do not just see water falling down. We perceive tremendous power as thousands of tons of water vibrate the earth and fill the air with a vast roar. We feel the cool spray and smell the subtle odors of the damp water-driven wind. In our minds we realize that a river, in its peaceful journey to the sea, has suddenly run amok. All these sensations and thoughts modulate our visual impressions so that we are ready to exclaim, "That's not just water falling down; that's a magnificent waterfall." When we see a painting or photograph of Niagara Falls, we do not have all the physical input, but from our past experience, our subconscious mind fills in the impressions so that we can sense the substance of beauty of the waterfall.

In the Carlsbad Caverns, visitors move with almost reverent awe among the formations. Are those rocks beautiful? Well, yes; but again the substance of beauty comes into play. The tourists do not just see hunks of stone hanging from the roof of the cavern and standing about the floor in senseless arrays. They see ancient formations that were created over the ages by patient drops of water endlessly dripping and minutely evaporating in the humid air. In their mind's eye they can see the stalagmites and stalactites growing toward each other unerringly in total darkness with time measured in millenia. They can hear, from a time before man, the echoes of water dripping into the dark pools held within the walls of the quiet chambers. All these and many more impressions cast an aura of wonder around those formations that were made without any human direction or intervention.

A totally different scene, but one that also has great substance of beauty, is the seashore. Interwoven in the mind of the beholder are concepts of countless storms, of relentless wearing of cliffs by the surf, of tenacious life among the reefs, of shipwrecks on the shoals, of bare feet in the sand, and of foghorns on the misty morning. The seashore is almost a picture of time itself.

But where is the substance of beauty in computer art? Computers create pictures of objects that do not even exist. The cavern of Picture 135 took seconds, not ages, to form. Water does not drip there. There is no echo, no musty smell of cave walls, no slimy feel to the stalagmites, no feel at all. The balloons of Picture 17 are not wafted on high by the buoyancy of warm air, because there is no air. There is also no gravity to pull them down, because the computer did not define any gravity for this little universe. There is no place for the balloons to land, because the solid-looking landscape is less than paper-thin, and the laws of physics do not

Picture 17 "Silent Journey." Computers create images that simulate reality. We see forms that do not exist. The solid-looking mountains are less than paper-thin. (©1982 Melvin L. Prueitt)

apply here. The balloons would go right through the surface.

But there is a substance and depth of beauty to computer pictures, too. Behind each image abides an untold story. Like a crater of the moon or the Grand Canyon, a computer picture doesn't just happen. There must be a cause. In this case, the cause is a logic system — a complex program of instructions brought to life within the intricate circuitry of a computer. Numerous ingenious methods have been developed to solve extremely difficult logical problems. Indeed, computer programming is a fertile field for creative inventors. Philosophers have wrestled with logic for centuries, but now computer programmers daily work with constructions of logic consisting of many thousand of operators, not for some theoretical conclusion but for a practical end.

Only the programmers can fully see the beauty of their work, the labyrinthine pathways woven among the subunits of instructions, the subtle twists in logic, the elaborate sequence of operations, and the synergism with which all components function to bring about a final result. Only programmers know the sweat, toil, and sometimes despair that goes into a program to make it sound and to free it of bugs that lurk in logical niches.

The products of the programs, however, are visible to all. The appearance of the computer graphics and the speed with which they are made are very important. The fact that an insensate program can take any array of data representing multiple surfaces and produce a picture with the hidden portions removed in exactly the right places lends a certain mystique to the images. Picture 17, for example, was painted by a program called PHOTO. The program had never "seen" the data that represented the objects until it was called upon to do the artwork. Without hesitation, it formed the land-scape and balloons with appropriate shading and re-membered to apply the specified colors. It removed the landscape behind the balloons so that the latter would not appear transparent. If the viewpoint were moved to the right, the program, without additional instruction or coaxing, would remove different portions of the land-scape and background to accommodate the new rela-tive positions of the balloons.

Visual Mystique

One of the wonderful mysteries that intrigues children (and older people who are young at heart, too) is the haunting question, "What's beyond the bend in the trail?" What lies over the next mountain? What strange sights might await at the bottom of the lake? These questions do not usually arise when one is looking at landscape paintings, because there is nothing beyond the bend in the trail and the artist did not paint anything under the surface of the lake. What you see is all there is. The same is not true for three-dimensional computer graphics. Picture 18 shows a frame from a movie of a flight down a computer-drawn canyon that has no counterpart in the real world. There are mountains beyond the canyon walls that human eyes have never seen. If the computer had been programmed to "fly" at high altitude, the distant mountains would have been visible, but that was "the road not taken." One might wonder what lies beyond the bend in the canyon where the lake ventures around the corner. In the movie, the viewer is taken for a banking swerve around that corner to find out what is there. In Picture 175, the asteroids have craters all the way around. We might wonder whether the computer created anything bizarre on the far side of the asteroids as it devastated their surfaces with random pock marks. We might also wonder wheth-

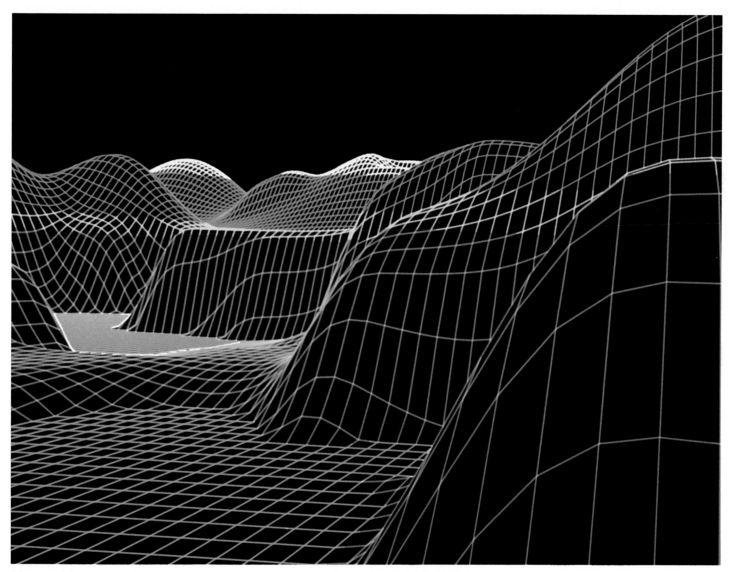

Picture 18 "Imagination Canyon." This is a single frame from a movie sequence in which the viewer is taken on a journey through the canyon. (©1982 Melvin L. Prueitt)

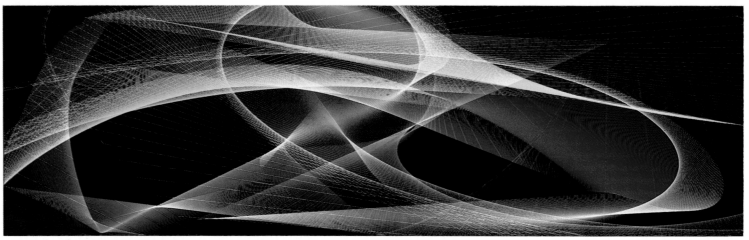

Picture 19 "Hurricane." Wide panoramas hold a certain fascination for most people. This image was formed on a strip of 35-mm film as wide as five standard frames. In order to do that, the computer first had to calculate all the line endpoints and then break up the image into separate frames. Each frame that made up the image was then plotted sequentially. (©1980 Melvin L. Prueitt)

er a distant asteroid of interesting form is hiding behind the large asteroid in the foreground. Images such as those in Picture 19 tell only part of the story. In order to make a long format picture, a short but wide "window" was specified. Most of the geometry of the design was left out of the picture. Just enough remains within the window to tantalize our curiosities. Since the program that created the picture has since been modified, we will never know if the most beautiful part of the picture lies somewhere beyond the sash.

The Computer as a Teacher

Perhaps computers can teach us more about appreciating art and nature. I suppose that people did not fully appreciate color until black-and-white pictures were invented. When they saw what life could be like without color, the rose suddenly must have looked redder and the meadows greener. We did not completely appreciate our stereo vision until stereo pictures were developed. They told us something about a part of our existence that we had taken for granted. And now perhaps computers can give us a fuller appreciation of reality, since computer pictures are images of objects that do not exist. As our eyes scan the familiar objects of our surroundings, we have the assurance that we can also touch them. They are busy bouncing off photons that enable us to see them, and we realize that no hidden-surface algorithm is necessary to prevent our gaze from penetrating opaque objects with x-ray vision.

The computer uses tricks and mathematics to make us perceive realistic images. It is comforting to know that the shading and shadows associated with real objects are not tricks of nature.

New Art Forms

Computers are giving us new art forms to appreciate, possibly attracting new admirers to the art world. Most people like several different types of art, and since computers produce a wide range of art, computer graphics has broad appeal. Even people who are attracted to only one style of art may find some computer art appealing. But what about the person who does not care for any art? Perhaps this person's art form has not yet been invented. Consider a person who likes nothing but classical music. If classical music had never been invented, that person might be considered a music hater. Similarly, there might be people who are said to lack artistic tastes in visual art simply because they have not encountered the style that appeals to them. Perhaps some of the new art forms that have been developed (or will be developed) in computer art will reach out to them.

The possibility of complex motion in computer art may appeal not only to art lovers but also to people who are not attracted to stationary art. Much of the thrill of flying or of taking a roller coaster ride derives from the visual experience. The computer can simulate such journeys and can also cause motion of the components of a scene relative to each other. It can cause "color motion," that is, variation in color with respect to time. When all these capabilities are brought to bear on a sequence, the computer can produce a visual symphony.

APPRECIATING THE ART IN THIS BOOK

Some critics have said that computer art is not true art. That is not surprising. In the early days of photography, some critics said that photographic art was not true art, but they have since been overruled by public opinion. More recently, critics have claimed that cowboy art is not true art. Critics happen to be people, and they are not totally devoid of prejudice. They, like many other people, are sometimes slow to accept something new.

The dictionary defines "art" as a creative work produced by a person. If the computer created pictures all by itself, then according to this definition, the computer-drawn images would not be art. But, as we have seen, the computer is only a tool, albeit somewhat more sophisticated than a paintbrush and palette, that people use in their creative work. The second criterion most people use to judge whether a creation is art is that it must be aesthetically pleasing. Since computer productions were made by humans through the computer and since many of the productions are attractive, we can state unequivocally that computer art is true art.

But does it really matter how computer art is classified by critics? To some artists working in the field of computer graphics, some prestige may accrue by the recognition of their work as art. To others, the act of creating something magnificent is much more important. The viewer of the pictures in this book need only ask the question, "Do I like it?" If I like it, then to me, it is art.

In the following pages, the works of some of the world's finest computer artists are grouped in several categories. Each category follows a theme or covers a field of work. In some cases, an idea or principle is expressed through a sequence of illustrations. In other cases, a series of pictures shows the breadth of designs

the computer can create on a theme. Some of the pictures were developed for scientific purposes. Others were produced in the process of developing new computer graphics programs. Many were created for the sole purpose of art. There is even a section on errors — results of program or computer errors that turned out to be quite surprising.

The first thing most people do after obtaining a book like this is to take a cursory tour through all the pictures. The art lover will want to go back and study each image in detail. Appreciating art is like listening to the familiar passages of great music. The fact that we have heard the music many times before only enhances its loveliness. After becoming thoroughly familiar with the artwork on these pages, one should frequently take the book off the shelf and explore again the visual experience of each picture.

Exploring the Images

Our eyes are the tools we use to study a work of art. We journey through all the pathways of a picture as our eyes rove the outlines, curves, and colors. We orchestrate our own visual symphony as we conduct our eyes through a different combination of trails each time we look at the scene. Too many people just look at the whole picture and then turn to the next picture. That is like attempting to read a book by staring at its cover. After taking in the whole image, we ought to explore the details. Most of the computer graphics in this book have features that are not immediately obvious. It takes some treasure hunting to discover these delightful gems. Each time the book is opened, something not noticed before will become apparent.

A New Vision

Usually when we see an unknown shape, our minds try to categorize it. Our survival instinct here is obvious, since our ancestors had to identify unfamiliar forms quickly as inimical, friendly, or inert. In clouds, we see comical faces, animals, cars, and many other items out of our mental repertory of common shapes. There is a certain disadvantage to this capability. For example, if we see the profile of a face in a mountain, thereafter we cannot see the mountain without seeing the face. My wife, Susi, painted a lovely scene of the Swiss Alps. The mountains were majestic. But then one day I noticed that a curious set of patterns in the mountainside formed the image of a noble face. It was a good face, but for me the mountain was ruined. I could no longer see it as just a mountain.

Why not view clouds as abstract designs with their own beauty rather than try to ascribe the shape to some totally unrelated creature? Some of the images in this book are free-form. By trying to see familiar shapes in the images, we may be denying ourselves the joy of a new vision.

Maintaining Appreciation

There is a tendency to take for granted things that are familiar. When a man falls in love with an oil painting, buys it, and brings it home to hang on the wall, he spends a lot of time during the next two weeks admiring it. After that, he hardly ever sees it. He still loves it when he happens to look at it, but it seems to disappear from his awareness—it no longer attracts his attention when he walks into the room. This characteristic of human beings also has survival value. It is of utmost importance

to notice instantly anything new in our surroundings. When the American Indian brave returned to his village after a hunt, it was important that he notice the bear lurking between the tepees, but he would not have given a glance to the bear skin that had been hanging on a frame for a fortnight. We seem to have some sort of subconscious eidetic memory of the setting of each place we frequent. As long as everything is in its customary place, no alarms are triggered in our brains, but if something is out of place or missing, or if something is interposed, an alert is sounded and our eyes quickly explore the change—just as the tongue explores the vacancy of a missing tooth.

Though this trait is crucial to the survival of the species, it is an encumbrance to art appreciation. But it can be overcome with conscious effort. If we will, we can keep alive the beauty in our surroundings. This book can be an aid in that endeavor. We can use it in practice sessions of art appreciation to sharpen our perception of beauty.

The Eye and Mind of the Beholder

It is understandable that many people believe that beauty is inherent in the art objects, when in reality all the beauty lies within the beholder, and the object only serves to elicit emotional responses as it resonates with already-existing faculties in the human soul. The external scene strikes a harmonious chord in the psyche, and that resonance creates an affinity between the individual and the art. Thus some people are moved by a work of art more than other people who have different innate or developed mental characteristics.

The question arises, "If the beauty is in the eye of the beholder, is it not possible that a work of art might be made more beautiful without altering the art at all?" Yes, it is. Just as we can improve any other talent with effort, we can enhance our awareness of and response to beauty (be it visual art, music, fragrance, or anything else we consider lovely). If the observation of beauty brings us pleasure, why not increase that pleasure? If we paid a handsome price for that painting on the wall, we will be pleasantly surprised to find that it is far more beautiful than we thought on the date of purchase.

How do you increase your "aesthetic quotient"? The first step is to realize that the beauty level (as if beauty could be measured) of an artistic creation is not a fixed quantity. The rest is a matter of practice. The reader can try the following exercise. In a quiet moment, open this book to one of the pictures that especially appeals to you. Let all negative thoughts and criticism vaporize. Let the color and form of the image flow into your mind and emotions without the resistance of pre-conceived ideas. As you absorb every part of the image, tell yourself that the picture is much prettier than what you are presently experiencing, and then look for that added beauty. Follow this procedure with several pictures and practice it whenever viewing any picture or scene in nature. Though this method seems overly simple, if you practice it consistently, you will find the world around you growing more lovely.

Hate, anger, and other negative emotions are detrimental to art appreciation. If you do not believe that, try having a bitter argument with someone and then go look at your favorite art or listen to your favorite piece of music and see how much joy you find therein. We tend to build protective shells around ourselves. These shells not only protect us from hostilities but also block the free flow of beauty. In order to immerse ourselves more deeply in the lovely things of the world and thus derive a

greater joy, we need to let these shells melt away by replacing negative emotions and attitudes with positive ones.

The Future

Computer art has made great strides in the last decade. These are the pioneering days of computer-aided art, but already the graphics devices are so sophisticated that astonishing works are being produced. The future will see continued improvement in the resolution and quality of computer output. Hardware and software progress will increase the speed and utility of graphics systems. The greatest area of growth will be that of home computer art as inexpensive hardware with high resolution becomes available.

Whatever devices are invented in the future, if history has taught us anything, we can be sure that the artist will be there to use, modify, or subvert the devices for the creation of beauty. We cannot imagine what fine new art tools will be developed, any more than Michelangelo could have imagined a computer graphics image spontaneously forming on a television screen. Whether the images will be formed in room-sized three-dimensional plasma displays, holograms, or something for which we yet have no name, probably computers will be involved to perform some of the mundane tasks, control the equipment, and sustain and record the images while the artists will be ever freer to visualize and create.

PART TWO

THE GALLERY

LINE DRAWINGS

The simplest kind of graphic that a computer can produce is a line, and constructing a line is easy for the programmer, too: just specify the endpoints of the line. But what is aesthetic about a line? Color it your favorite color, and it is still just a line. However, if a number of lines are drawn with appropriate spacial relationships and tinted with carefully selected hues, the results can be quite startling.

A computer program can produce sets of lines by mathematically defining endpoints and commanding the plotter to draw the connecting lines. The program must be clever enough to know how to advance the endpoints before drawing the next line in order to make a coherent image. The programmer is faced with the problem of formulating directives that cause the computer to produce art, not just an assemblage of line segments. Often programmers write graphics programs that produce repetitious patterns, resulting in pictures that sometimes look "machine-made."

How does one write a program that does not depend on repetitious patterns to construct line drawings? One way is to define a set of points on a plane and have the computer connect the points sequentially by lines and then have the points moved a short distance before new lines are drawn. The direction of movement of each point depends on some formula which considers the positions of the other points. But since the other points are also moving, the prescription continually changes. Images such as those in Pictures 19 through 26 are evolved in this manner. When the initial positions of the points are changed or the parameters that govern the point coupling are varied, totally different images are produced.

Picture 27 shows the results when the points are "gravitationally" attracted. That is, we start by defining initial coordinates and velocities. The points have momentum, so there is a tendency for them to continue moving in a straight line. But the gravitational attraction of the other points bends the path into an ever-changing curve. Frequently during the process, connecting lines are drawn.

In some of the images (Picture 24, for example), we note that many of the lines are drawn close together while others are widely separated. In this particular formulation, the calculation is designed to become unstable after a certain number of lines are drawn, and the coordinate numbers begin to "explode." We see some lines beginning to march off toward infinity. Of course, we must terminate the run before the numbers cause computer error, but long before that, the lines are outside the image window.

In viewing these pictures, the human visual system readily perceives the sets of lines as surfaces. We interpret the surfaces as opaque if nothing appears behind them or as transparent if we see something through them. So what starts out at the computer as sets of points and at the plotter as lines ends up in the human mind as surfaces.

Picture 23 demonstrates that computer output can achieve subtle hues. Pictures 25 and 26 were produced by requiring the hues to be close together in the spectrum.

Mike Marshall produced both Pictures 28 and 29 with the same program running on a Calma Design Station.

Picture 20 (Opposite page) "Roadway to Somewhere." This picture and most of the others in this section are formed by straight lines. The curves are outlined by combinations of lines and endpoints. (©1981 Melvin L. Prueitt)

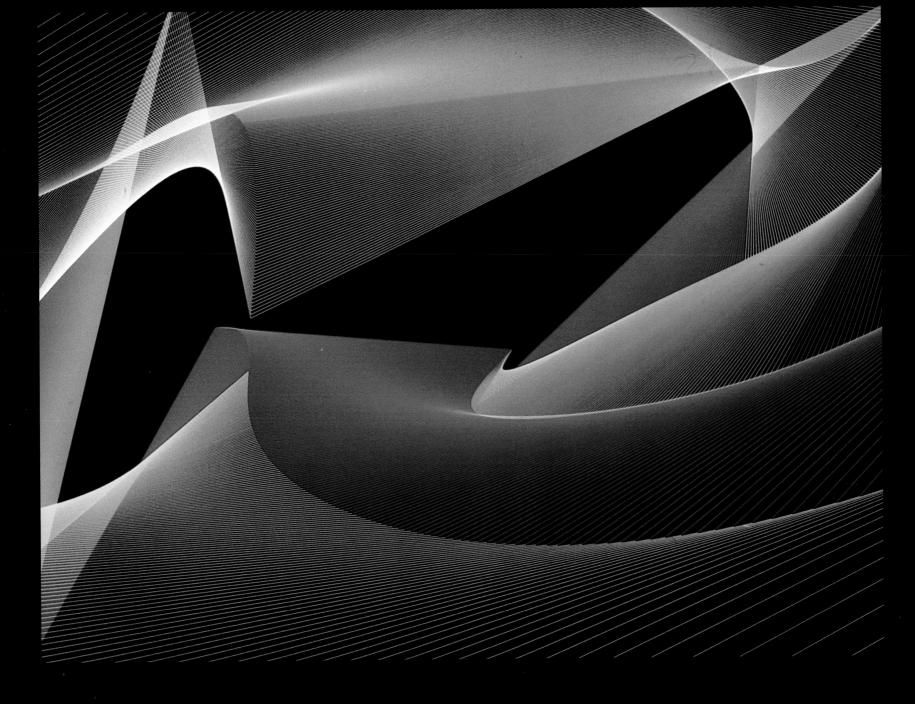

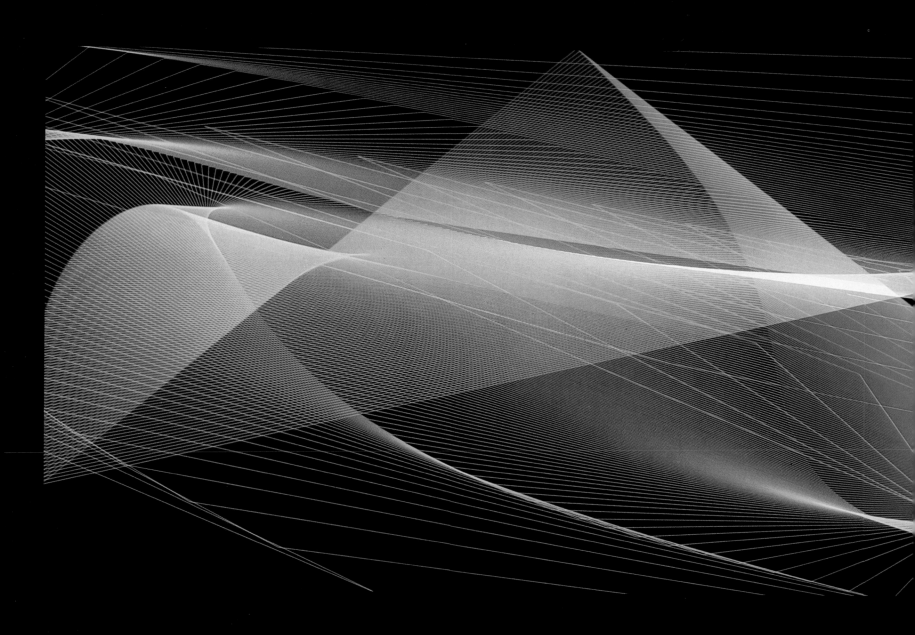

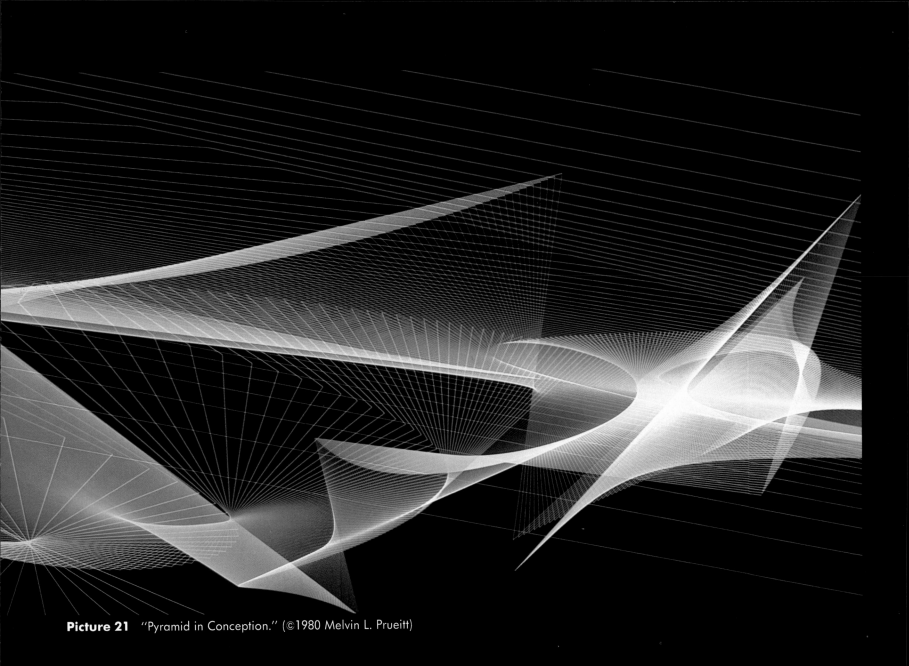

Picture 21 "Pyramid in Conception." (©1980 Melvin L. Prueitt)

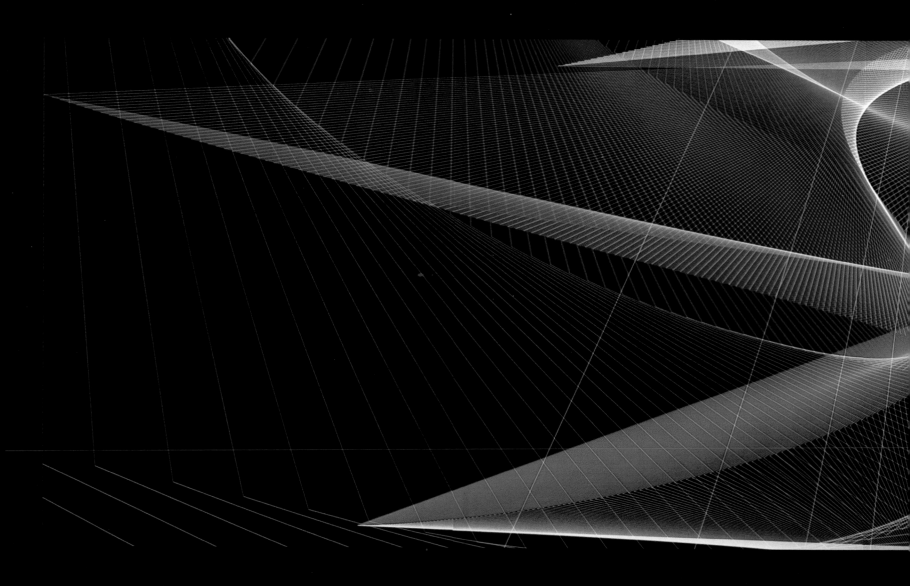

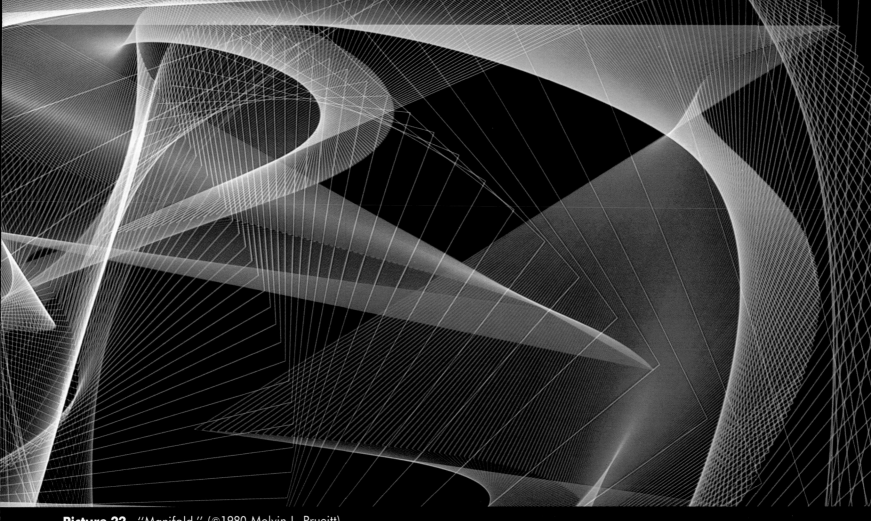

Picture 22 "Manifold." (©1980 Melvin L. Prueitt)

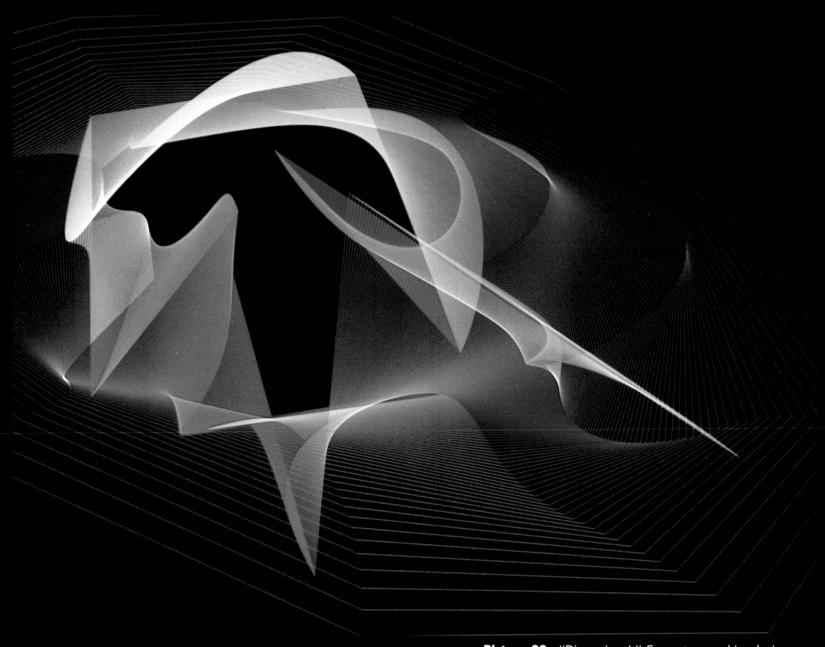

Picture 23 "Dimension 4." Computer graphics devices can provide a wide range of subtle hues. (©1982 Melvin L. Prueitt)

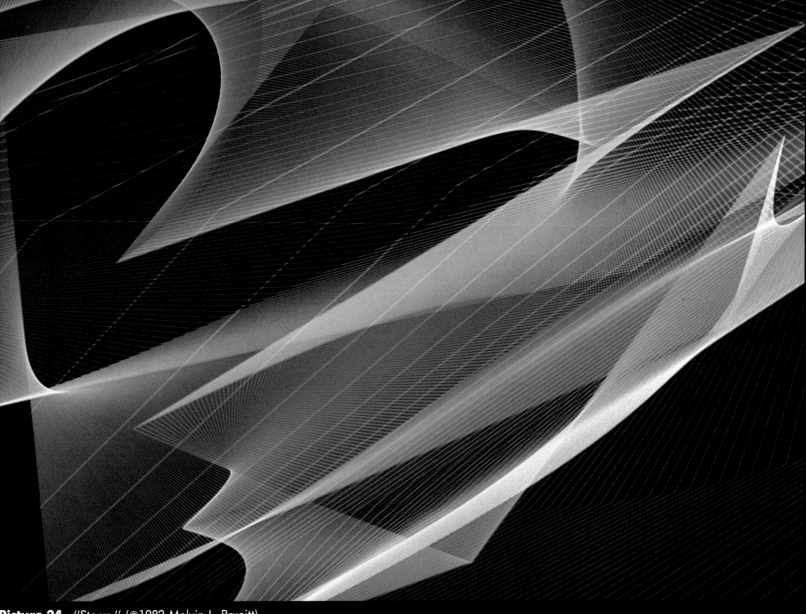

Picture 24 "Storm." (©1982 Melvin L. Prueitt)

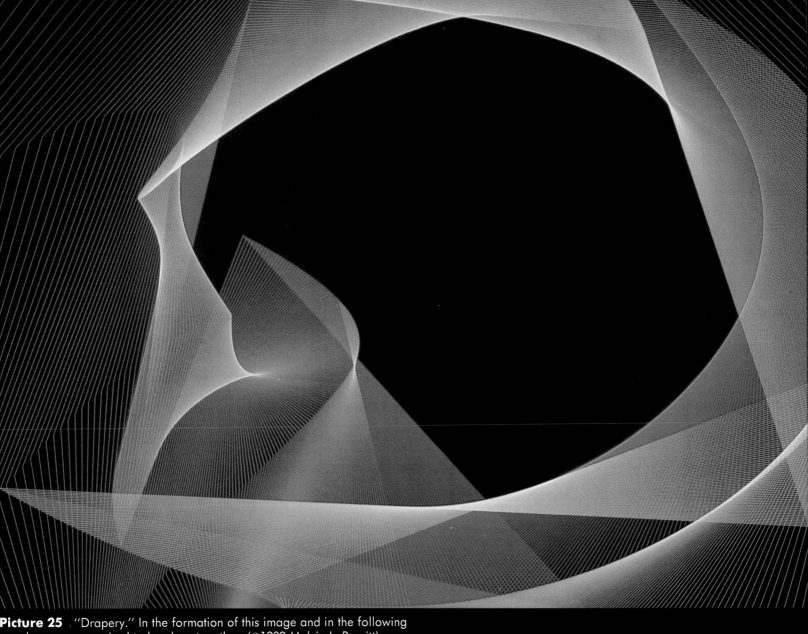

Picture 25 . "Drapery." In the formation of this image and in the following one, hues were required to be close together. (©1982 Melvin L. Prueitt)

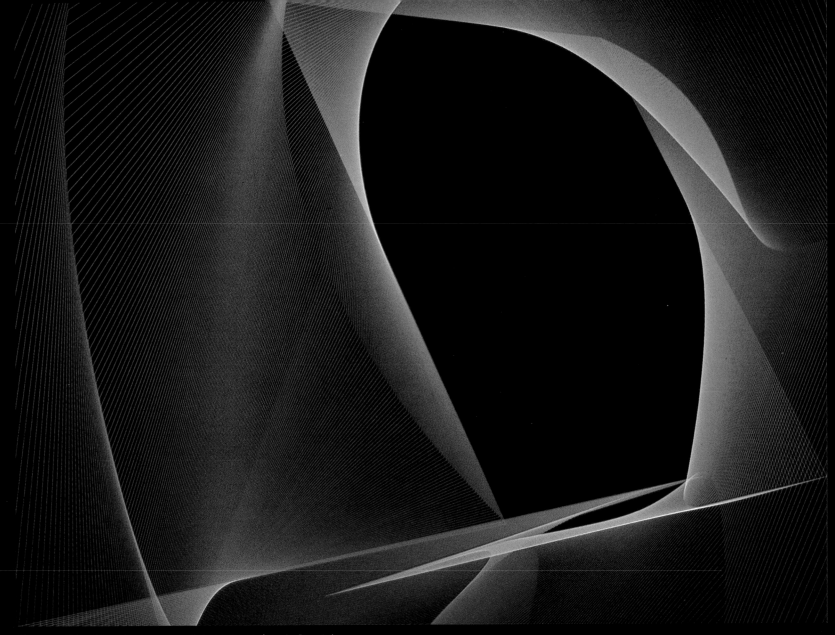

Picture 26 "Gentle Doorway." (©1982 Melvin L. Prueitt)

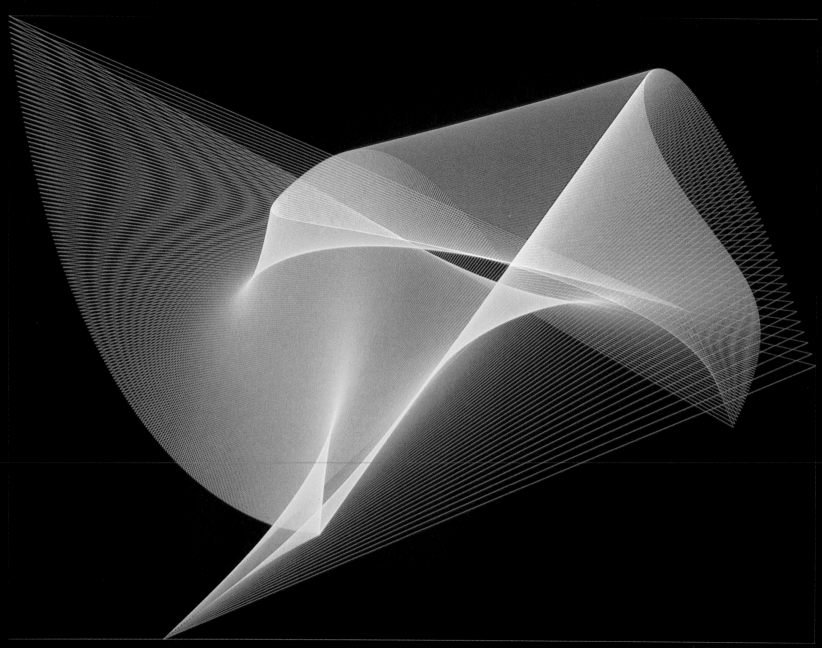

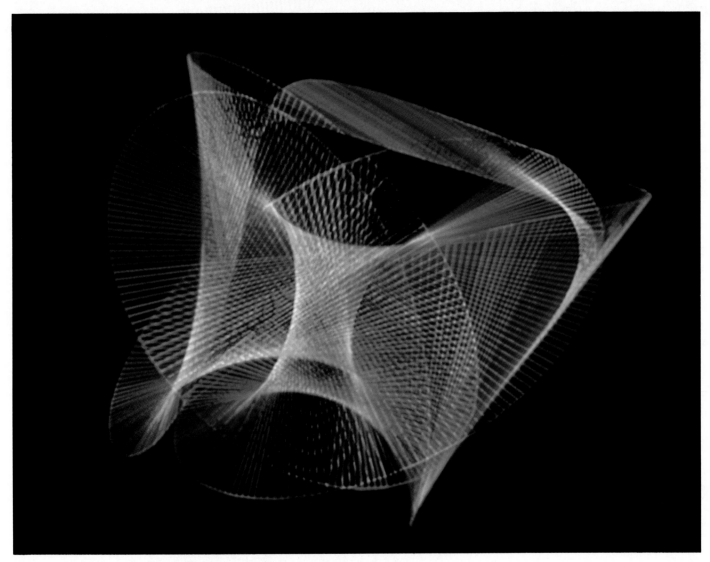

Picture 28 "Fish." Mike Marshall produced this and the following picture by the same program running on a Calma Design Station (Data General Eclipse, Lexidata 4-bit frame buffer, 1024 by 1280). (©1981 Mike Marshall)

Picture 27 (Opposite page) "Gold Wing." The positions of the endpoints of the lines in this image were generated by having the endpoints gravitationally attracted to each other in the computer. Their "momentum" prevented them from collapsing into one point. (©1981 Melvin L. Prueitt)

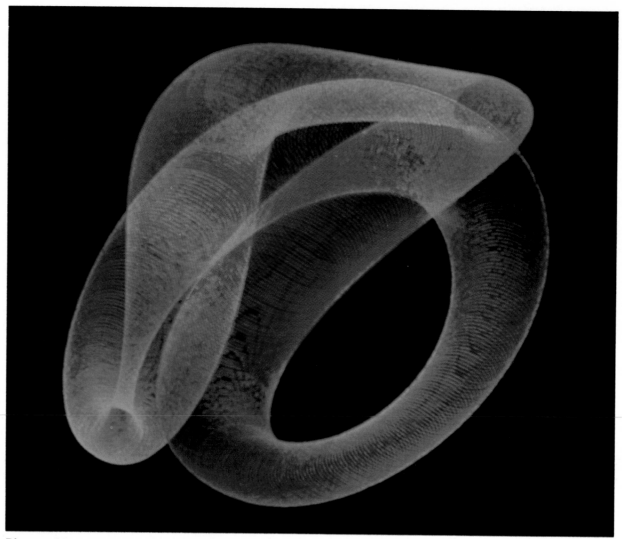

Picture 29 "Slinky." (©1981 Mike Marshall)

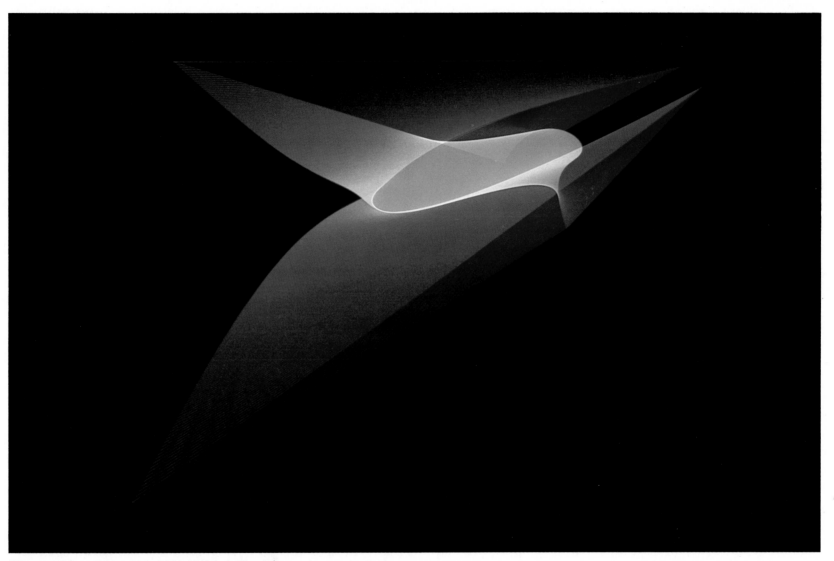

Picture 30 "Molten." (©1981 Melvin L. Prueitt)

PERSPECTIVE MESH PLOTS

Line drawings can be extended to perspective projections of three-dimensional data with "hidden lines" removed. A computer program called GRAFIC made Picture 31, while the designs in Pictures 32 through 37 were made by a program called PICTURA. Besides forming perspective projections and removing hidden lines, PICTURA can provide coloring according to amplitude level or position on the grid.

When the hidden lines are removed, we tend to see the surface as opaque even though a lot of black space separates some of the lines. If the edge of the plot or the underside is visible, we perceive the image as the representation of a sheet (Picture 34, for example), but when only the upper surface is in view, the surface seems solid (Picture 36).

The surface in Picture 31 is formed of a grid or mesh of lines in which lines run in both the "x" and "y"directions, while Picture 32 has lines running only in the "x" direction.

The number and variety of moods expressible by this type of picture is quite large, as one can surmise by studying the pictures in this section. In Picture 32, the colors are laid down in stripes, while colors and gaps designate elevations in Picture 33, and in Pictures 34 through 36, the color is a function of position on the surface. Picture 34 shows the effect and feeling of depth provided by a backdrop. A transparent screen in front of the surface supplements the feeling of depth in Picture 35. Other moods and expressions are developed in Pictures 36 through 40. The last one is a computer simulation of a volcanic eruption.

Picture 31 "Golden Shore." This image was drawn by a program called GRAFIC which can generate mesh plots, shaded surface plots, or a combination of both. GRAFIC produces images in perspective with hidden lines or hidden surfaces removed. Viewpoint, light sources, and colors are specified by the user. The program runs on a Cray-1 computer. (©1983 Melvin L. Prueitt)

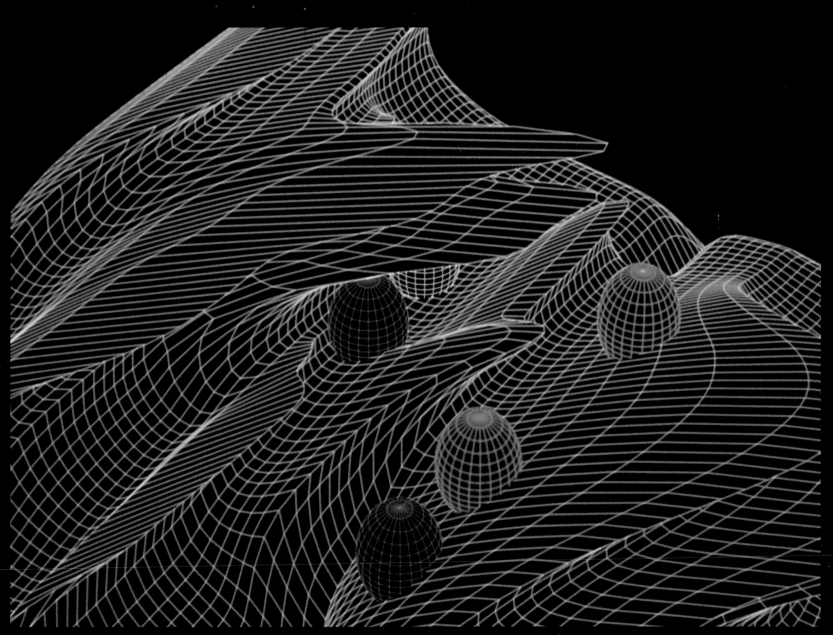

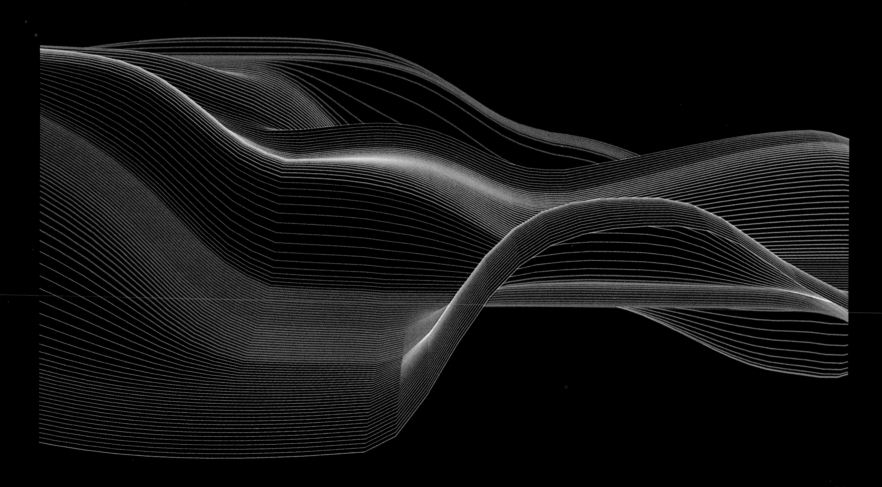

32

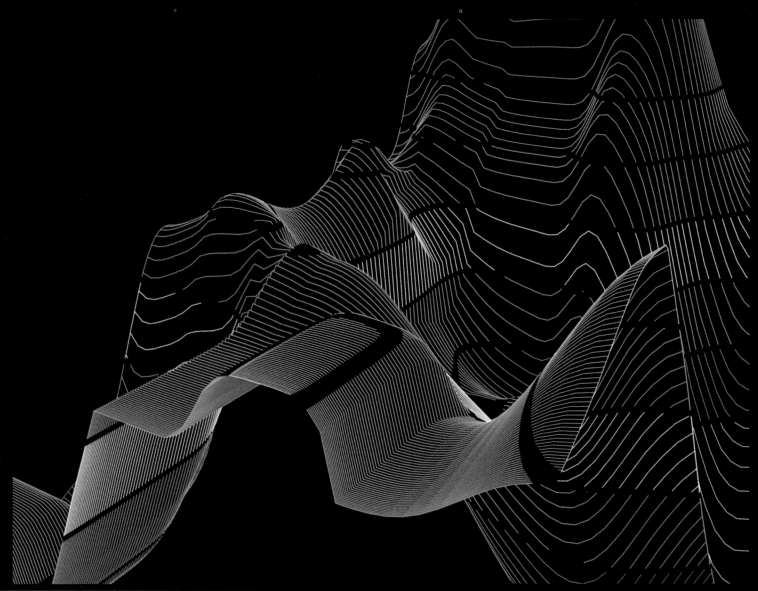

Picture 33 "Contour Bands." (©1980 Melvin L. Prueitt)

Picture 32 (Opposite page) "Contorted Rainbow." This picture and the following five were plotted by a program called PICTURA which can handle only single valued surfaces (that is, there is no overlap of surfaces as there is in Picture 31). (©1982 Melvin L. Prueitt)

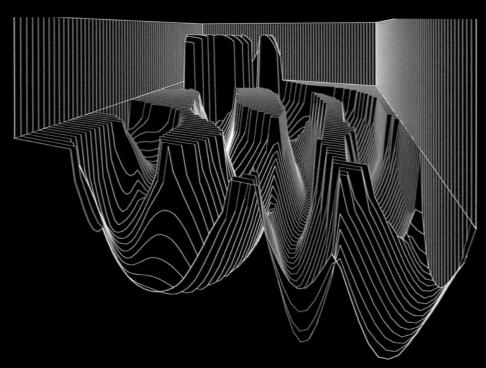

Picture 34 "Bounded Range." PICTURA can put bounding walls around the plotted geometry. (©1982 Melvin L. Prueitt)

Picture 35 "Caged Formations." Surrounding the object by a transparent enclosure often adds to the aesthetic value of the picture, like a diamond in a jewel box. (©1981 Melvin L. Prueitt)

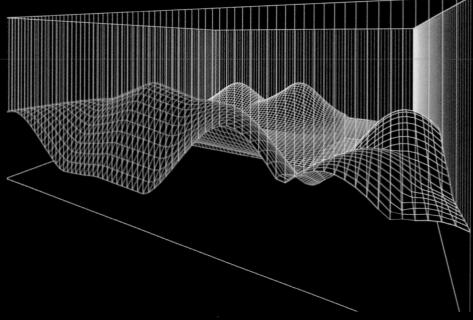

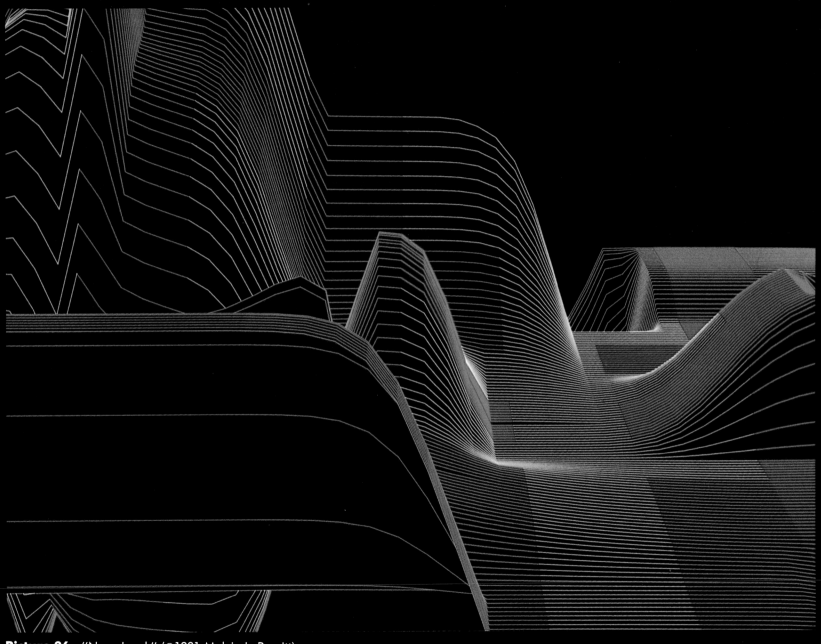

Picture 36 "Neon Land." (©1981 Melvin L. Prueitt)

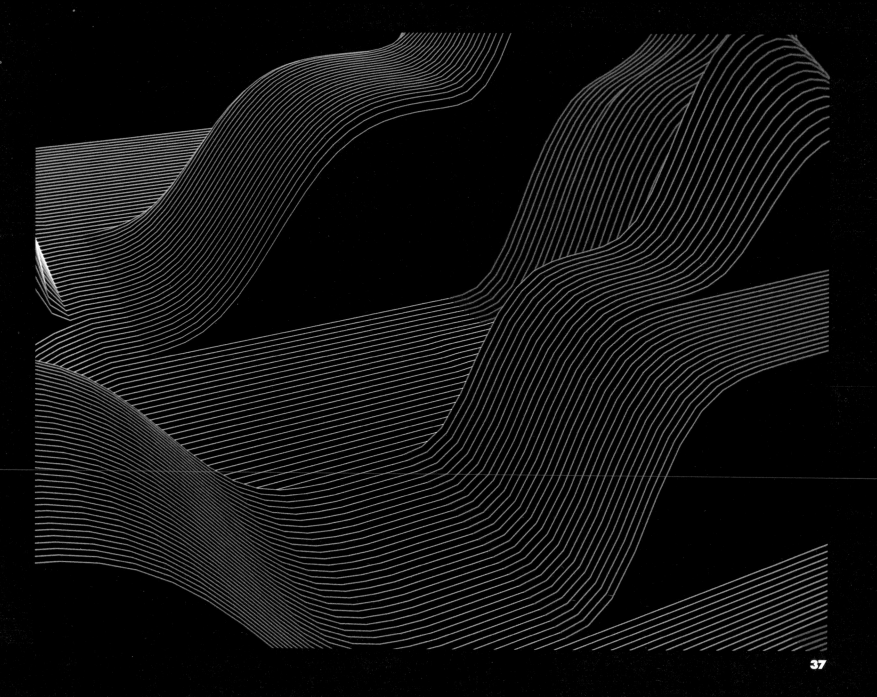

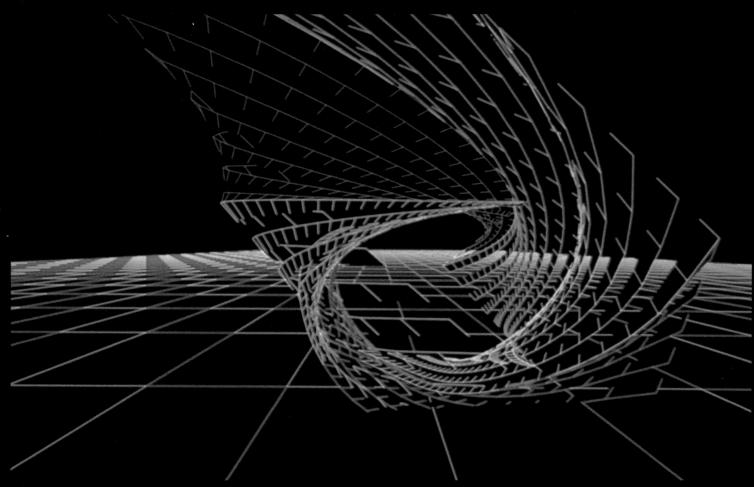

Picture 38 "Undefined Destiny." If the user defines some parts of the surface as invisible, the GRAFIC program will leave out those parts. (©1982 Melvin L. Prueitt)

Picture 37 (Opposite page) "Undecided Stairway." (©1980 Melvin L. Prueitt)

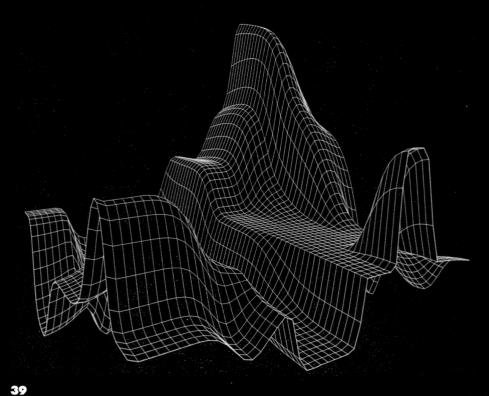

39

Picture 39 "High-Rise Function." (©1976 Melvin L. Prueitt)

Picture 40 "Volcanic Mesh." This is a frame from a movie in which the particles are emitted from the volcanic cones and the mountains grow. (©1974 Melvin L. Prueitt)

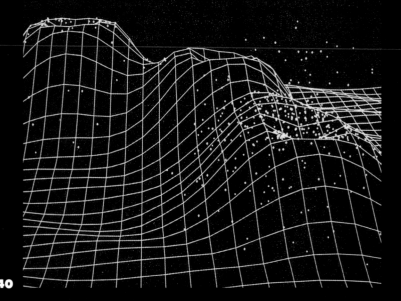

40

SYMMETRY

Most people seem to enjoy pictures that display some form of symmetry, resulting perhaps from the bilateral symmetry of our own bodies. Some of these pictures have bilateral symmetry, while others have, additionally, top-to-bottom symmetry. The bilateral symmetry is much more important for perception of symmetry.

If one views an unsymmetrical transparency and then flips it left to right, its aesthetic characteristics are not much changed. That is, for aesthetic preferences, a left-to-right switch is usually not much different than the initial orientation. However, a top-to-bottom flip can completely alter the mood and characteristics of an image, similar to inverting the picture of a room. Try viewing some of Pictures 19 through 30 both right side up and upside down.

Symmetry is easy to create with a computer. After defining a geometry on the left side of the screen, we merely program the computer to reflect the horizontal coordinate about the center line and plot the right half of the image to get bilateral symmetry. Artist David Em created an excellent example of symmetry in Picture 41. Not only is the image complex, but it shows fascinating texturing. Picture 42, generated in a long format stretch-ing across several 35-mm frames, has top-to-bottom and left-to-right symmetry. In Picture 43, a few geometrical patterns are defined and then reproduced a number of times as the angle is increased around the center point, with horizontal elongation. The outline fits snuggly into an ellipse. The same program also drew Pictures 44, 46, and 47, but parts of the images were left out, forming black areas.

Butterflies are the flowers of the animal kingdom, and they have long been the subject of artists' attention. From Picture 51 through 54 we can see that computers can be effective tools with which artists can mimic the symmetrical form of butterflies. The same program produced all these butterflies, but parameters in the program were altered to produce different characteristics. Here we notice the effectiveness of black in accentuating the colorful features.

Picture 55, by James Squires using Chromatics equipment at UCLA, is an excellent example of symmetry. It would be difficult for an artist without a computer to keep track of all the details to make sure that the final result is symmetrical.

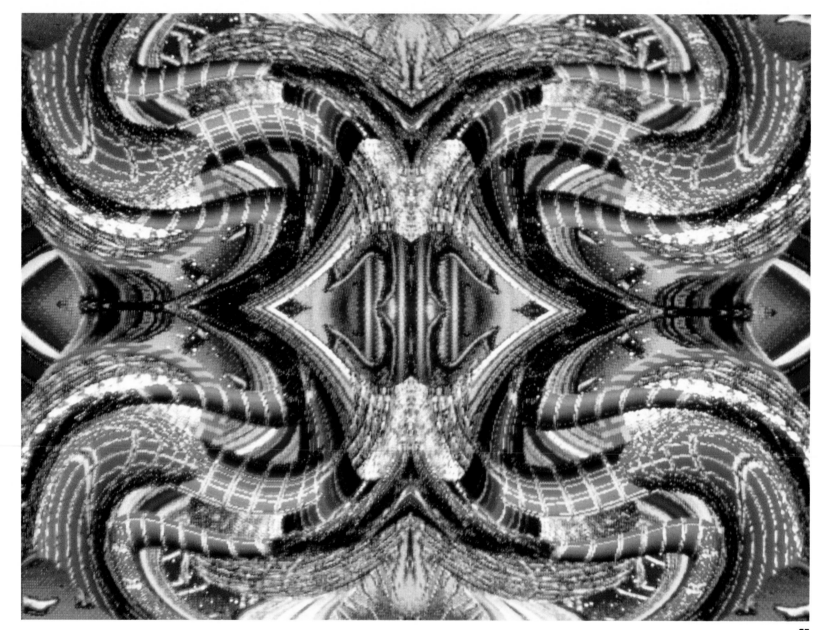

41

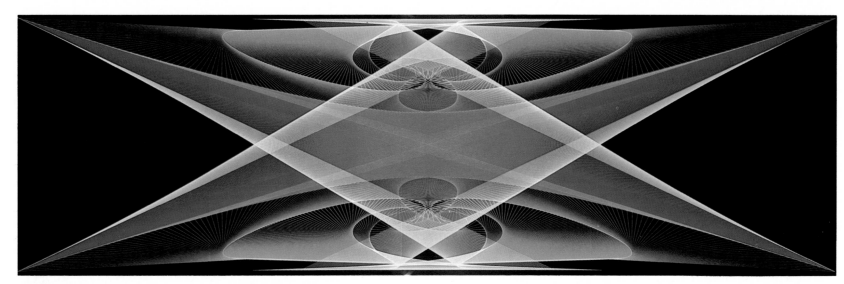

Picture 42 "Simplicity." This image and the following two images form bilateral and top-to-bottom symmetry. (©1980 Melvin L. Prueitt)

Picture 41 "Twist 4." David Em, working with computer programs developed by Dr. James Blinn, has contributed significantly to computer art. This image displays complex bilateral symmetry. (©1980 David Em)

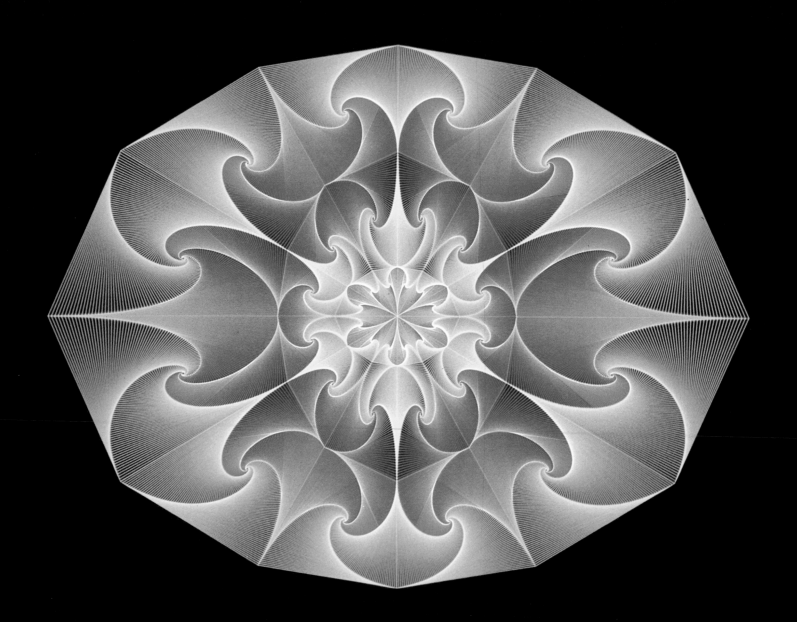

43

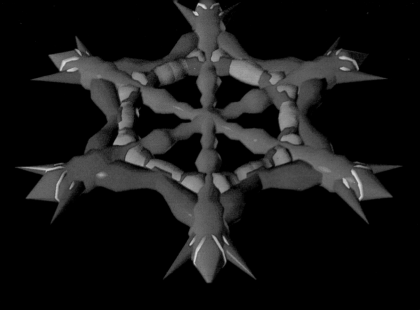

Picture 43 (Opposite page) "Involution." Images such as these may be drawn by fitting together a number of quadrilaterals and triangles and then filling in each one with a spiral of lines. (©1978 Melvin L. Prueitt)

Picture 44 "Epicenter." This picture was formed like the previous one, but parts of the image were colored black. (©1978 Melvin L. Prueitt)

Picture 45 "Calstar." Here the object is symmetrical, but the light source is to the left of the viewpoint. (©1983 Melvin L. Prueitt)

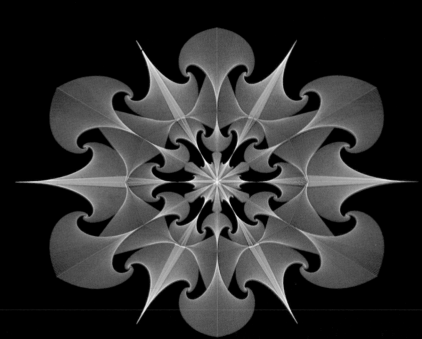

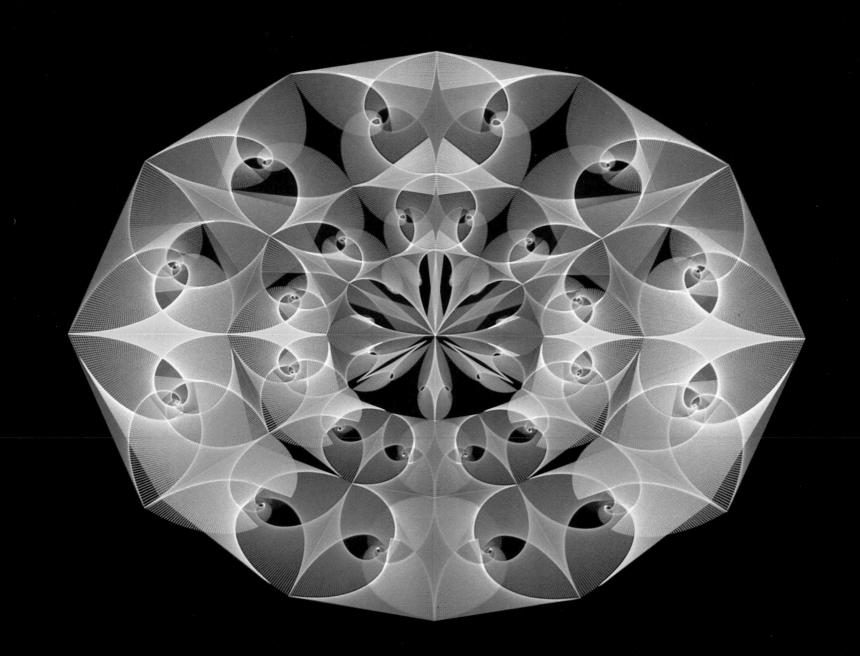

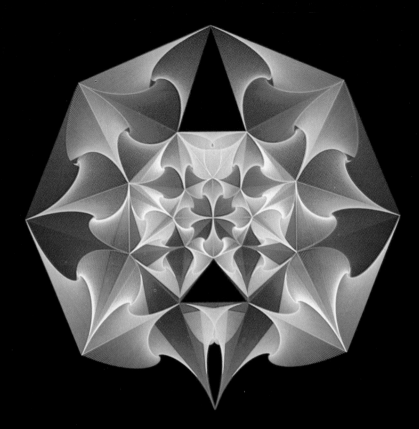

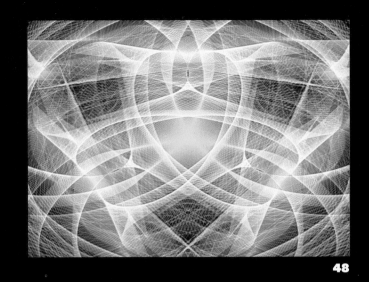

Picture 47 "Gem Stone." (©1978 Melvin L. Prueitt)

Picture 48 "Central Flame." Many faintly drawn lines superimposed can create interesting effects. (©1982 Melvin L. Prueitt)

Picture 49 "Purple Force." (©1982 Melvin L. Prueitt)

Picture 46 (Opposite page) "Prime Cycle." (©1978 Melvin L. Prueitt)

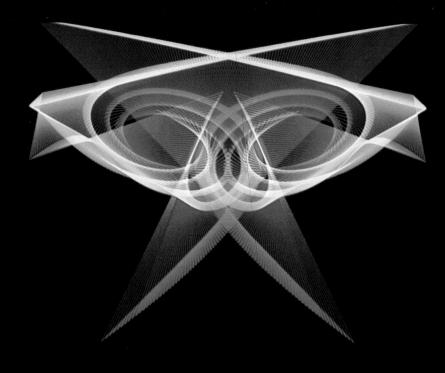

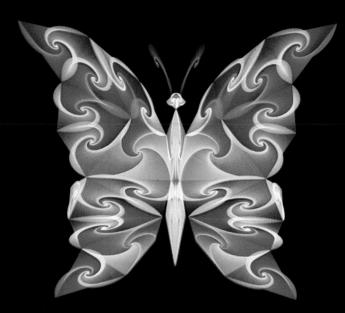

Picture 50 "The Wise Owl." Once the computer generated this picture, the title seemed natural. (©1982 Melvin L. Prueitt)

Picture 51 "Curly Butterfly." All the butterflies in this section were made by the same program, but various parameters were changed to produce different characteristics. (©1982 Melvin L. Prueitt)

Picture 52 (Opposite page) "Structured Butterfly." (©1983 Melvin L. Prueitt)

51

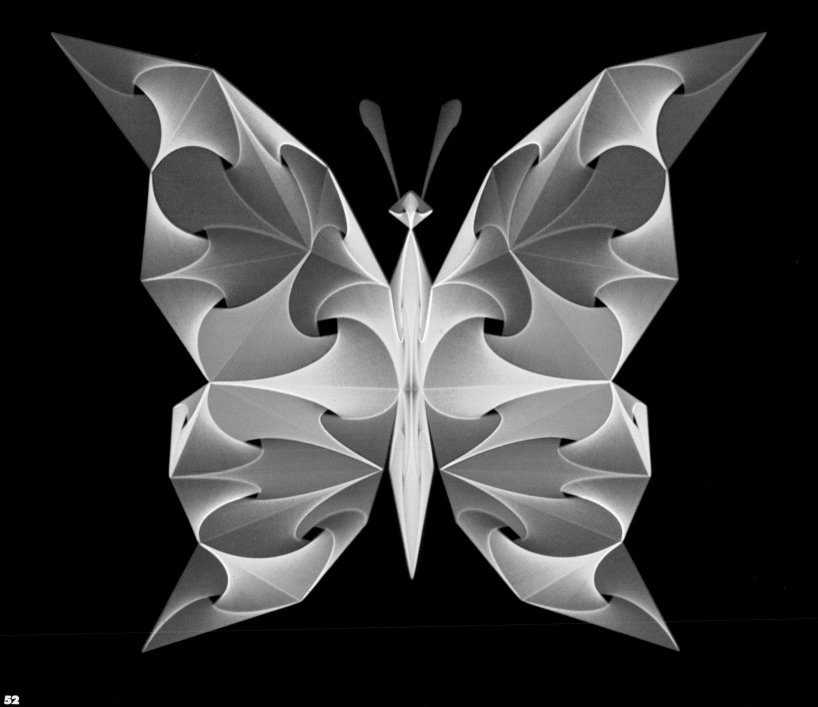

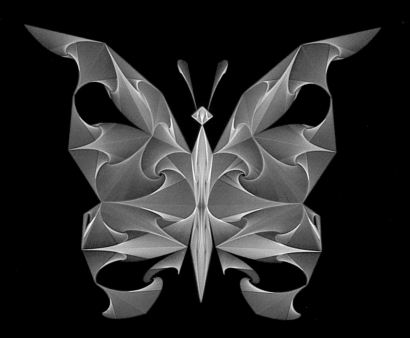

Picture 53 "Unfurled." (©1982 Melvin L. Prueitt)

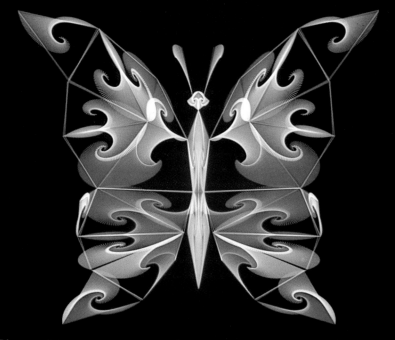

Picture 54 "Moth-Eaten Butterfly." (©1982 Melvin L. Prueitt)

Picture 55 (Opposite page) James Squires, using a Chromatics 7900, found the computer helpful in producing this intricate symmetrical picture while at the Fine Arts Department of UCLA. It has bilateral and top-to-bottom symmetry. (©1982 James A. Squires)

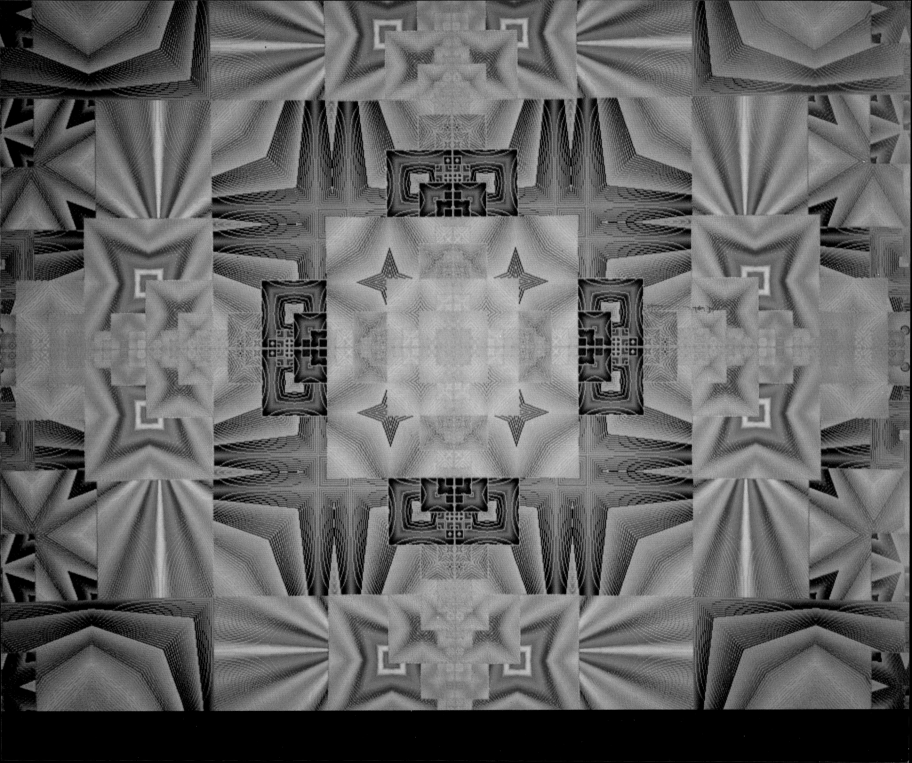

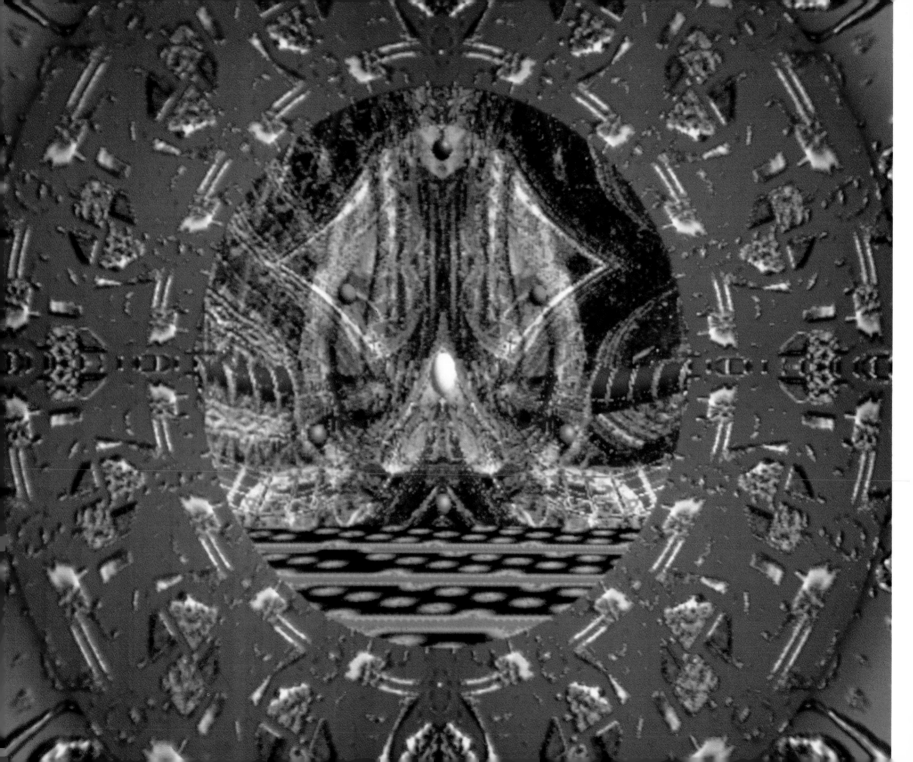

ASYMMETRY

Some images appear symmetrical at first glance, but careful examination of Picture 56, one of the fine works of David Em, shows that it is not truly symmetrical. Such pictures hold a certain fascination that draws the human eye back again and again trying to unravel the mystery of the lacking symmetry. Picture 57 at first seems to have some form of bilateral or circular symmetry, but it has neither. Picture 58 almost has top-to-bottom reflection, but that symmetry is broken also. Pictures 59 and 60 are obviously asymmetrical, while Picture 61 has a symmetrical "feel" that is pleasantly disrupted by the foreground sphere and by more subtle left-right differences. In this work and others, David Em has a way of making scenes appear large on the human scale, encompassing great volumes of space.

The other images in this section, Pictures 61 to 64, show various forms of asymmetry, from subtle to glaring, that you may investigate for yourself.

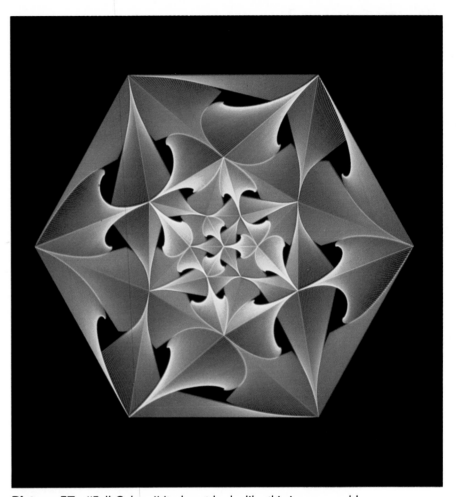

Picture 57 "Fall Colors." It almost looks like this image would be symmetrical if it were rotated to some other angle, but such is not the case. (©1979 Melvin L. Prueitt)

Picture 56 (Opposite page) "Kow." This picture has symmetrical elements, but the lighting and some of the patterns disrupt the symmetry. (©1981 David Em)

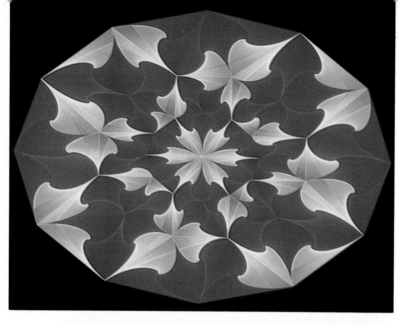

Picture 58 "Digital Harmony." (©1978 Melvin L. Prueitt)

Picture 59 "Disarrangement." Here we have no semblance of symmetry. (©1978 Melvin L. Prueitt)

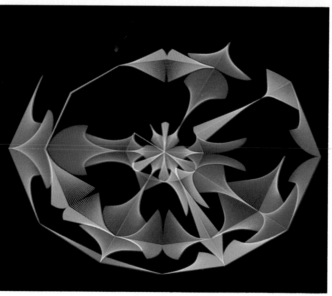

Picture 60 (Opposite page) "Suma." The image would probably be symmetrical if the vertical axis were shifted right or left appropriately. (©1980 David Em)

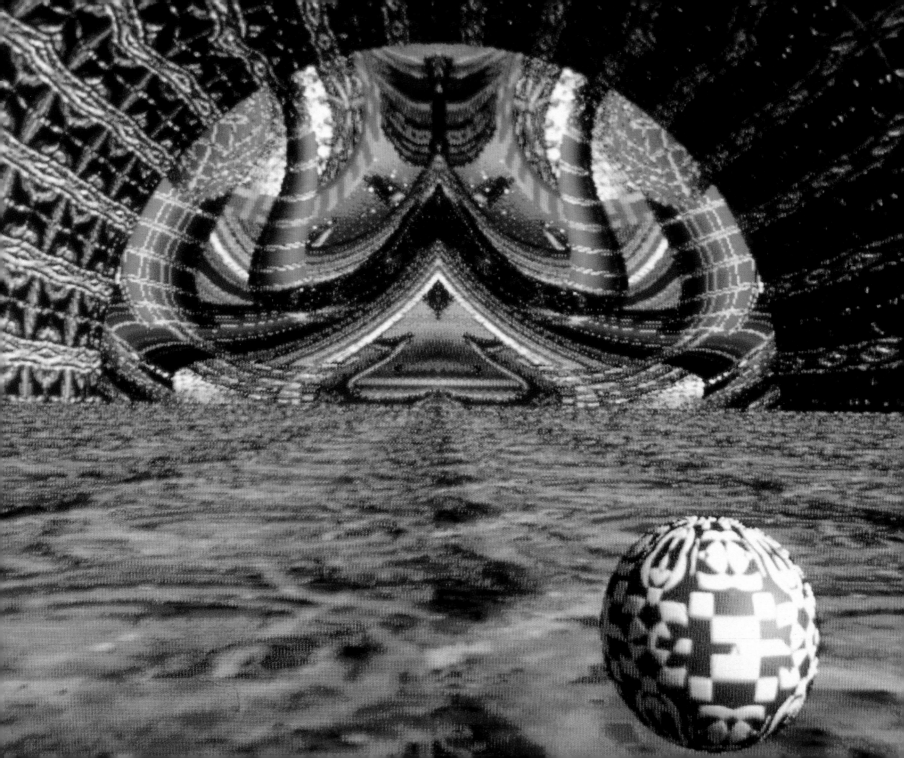

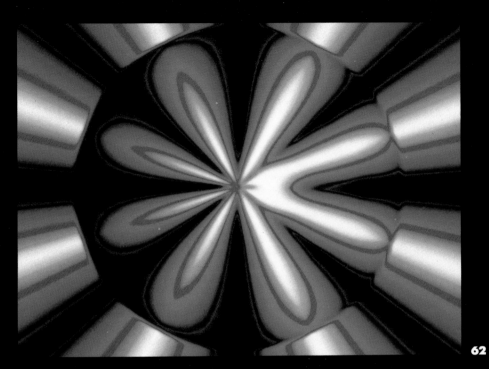

Picture 62 "Orb 2." This picture by Lance Williams at the Computer Graphics Laboratory, New York Institute of Technology, would be bilaterally symmetrical if it were rotated 90 degrees. (©1978 NYIT)

Picture 63 "Star Bright." Here we can find no axis of symmetry. (1979 Melvin L. Prueitt)

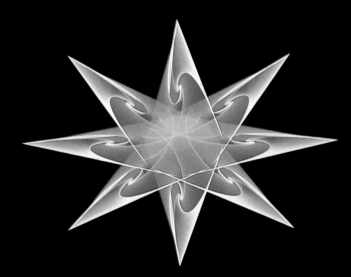

Picture 61 (Opposite page) "Persepol." (©1981 David Em)

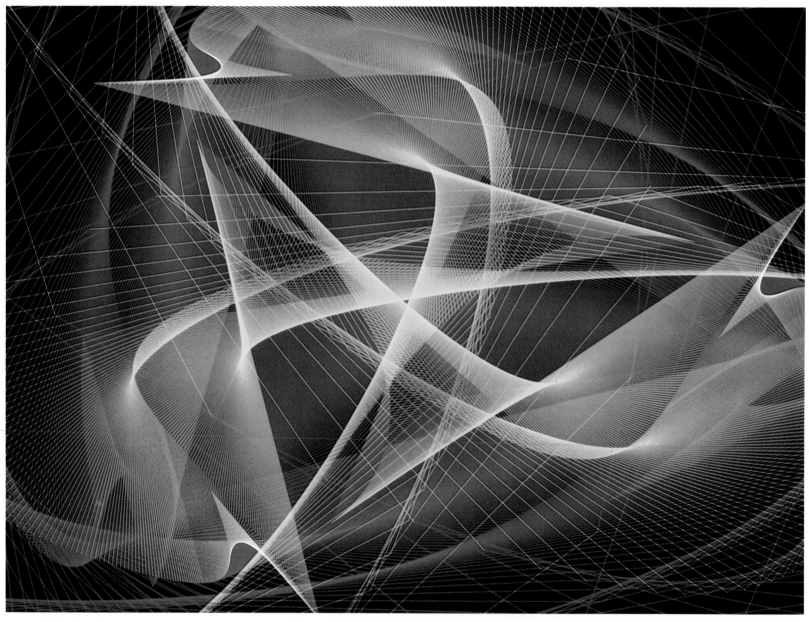

Picture 64 "Deep Red." Placement of the lines provides a feeling of depth. The red lines form velvety curtains in the background. (©1982 Melvin L. Prueitt)

SCIENCE

By the very nature of the universe and the inherent character of our senses, we see only surfaces and outward manifestations of an intricate physical world. When we look at a tabletop or at the face of a friend, we do not see the interaction of electromagnetic waves with electrons in interface atoms even though this phenomenon makes vision possible. We cannot even imagine the lightning speeds with which the electrons react in resonance with the incoming photons to scatter them back toward receptive eyes. In that enigmatic world where quantum mechanics rules, where particles and waves become somewhat indistinguishable, intuition fails, but we have equations that describe what we cannot see nor even understand.

Since a table is composed of atoms, which we often envision as small spherical entities, why doesn't the table just collapse of its own weight and scatter across the floor like so many tiny marbles? Or, since the atoms in the table at room temperature are traveling over 100 miles per hour due to thermal energy, why doesn't the table just vanish in a puff of smoke? Our senses are not capable of probing nature deeply enough to answer these, and many other, questions.

The tools of mathematics and the instruments of science have brought answers to the intellect. But we want to see the answers. We want to see magnetic fields and behold the laws of thermodynamics. Computer graphics can picture these things for us. Ours is a new vision that was denied our forebearers. Students in science classes can now see and comprehend abstruse concepts. Scientists finally can unveil some of the majestic mysteries of the cosmos to the general public.

In this section, we see a few applications of computer graphics to scientific problems where various types of experimental data or theoretical calculations are re-

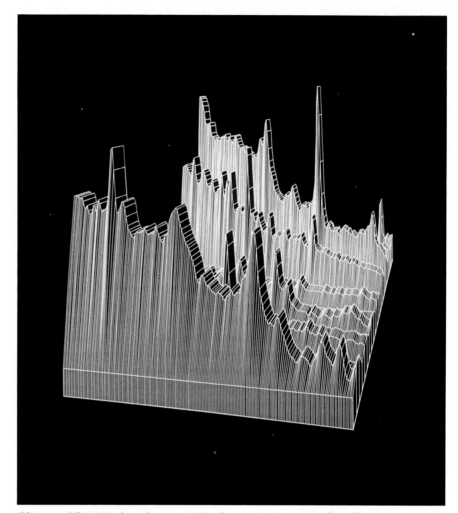

Picture 65 "Nuclear Spectra." Nuclear emissions are plotted as a function of energy and isotope value. Energy increases from left to right. Each row represents a different isotope of the same element. (Produced by Dr. Gordon Lind, Utah State University)

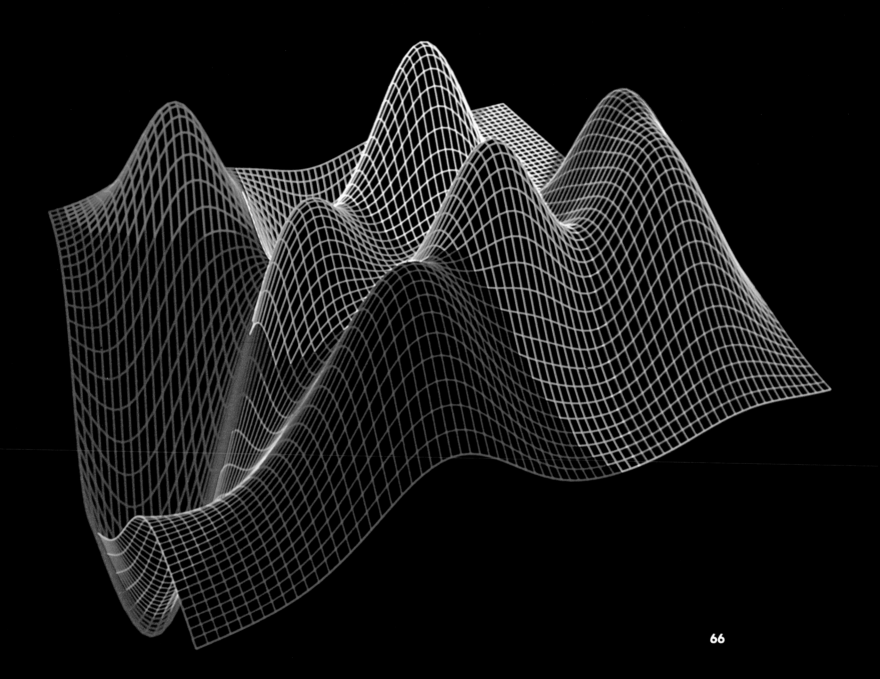

duced to pictures. We see that the concepts of science, when properly presented, can be quite aesthetic.

Far down on the nuclear level where dimensions are a million times smaller than the smallest particle we can imagine, emanations from tiny nuclei produce a spectrum of radiation. Dr. Gordon Lind, of Utah State University, plotted the spectra from several isotopes and obtained Picture 65. Somewhat higher on the scale of size, potential fields reign among atoms within molecules and make structures rigid. Picture 66 simulates a "slice" through such fields with color delineating the regions of influence of different atoms. But what do molecules look like? A computer view of hemoglobin molecules in various stages of rotation is given in Picture 67.

Most people do not think of a virus as being beautiful, but Nelson Max, at Lawrence Livermore National Laboratory, produced a computer model of tomato bushy stunt virus (Picture 68) that is quite striking. The large spheres represent 90 of the 180 protein subunits of the virus coat. The yellow side chains are attached to the subunits and form a framework for the virus.

When the sun's light streams through the earth's atmosphere, it is scattered by water droplets and dust particles. As a result, we see rainbows, halos around the moon, red sunsets, and other luminous wonders. Of prime importance to scientists studying the scattering of light by particulate matter in the air (called *Mie scattering*) is the magnitude of scattering as a function of particle size and light wavelength. Professor Robert Rowell, at the University of Massachusetts, supplied data from which Picture 69 was plotted. The mountain peaks represent a large amount of scattering while the valleys between designate regions of lesser scattering. One would not have presupposed that such a simple concept could turn out to be so complex.

But light has numerous mysterious properties that have intrigued generations of scientists and are still not totally understood. When light passes through an aperture, the photons do not behave as small bundles of energy, but rather follow the rules of waves so that diffraction patterns are formed. We see evidence of this in the streamers that seem to project from photographs of stars, an effect so common that we draw points on artistic renderings of stars even though everyone knows that real stars have no points. The optical characteristics of astronomical telescopes, including the effects of internal support structures, give rise to diffraction patterns on the photographic plate. Dr. John Richter, of Los Alamos National Laboratory, suggested a computer study of diffraction through various apertures with different support structures. Following his suggestions, I produced Pictures 70 through 73 in which the height of the surface represents the logarithm of the transmitted light. The images are so different because the problem was examined in different ways for different structures.

Laser beams have some properties that are not apparent in ordinary noncoherent light. Dr. Marvin Mueller studied the absorption of laser energy on a surface. With the help of a computer, he produced Picture 74, which shows the absorption of laser light as a function of angle of incidence and depth of penetration. C. James Elliott and Paula Adams, at Los Alamos, used the CAMERA program to display the shape of a single laser pulse (Picture 75).

Picture 66 (Opposite page) "Potential." The heights of these "mountains" simulate the magnitude of potential fields within molecules. The colors represent the regions of influence of different atoms. (©1980 Melvin L. Prueitt)

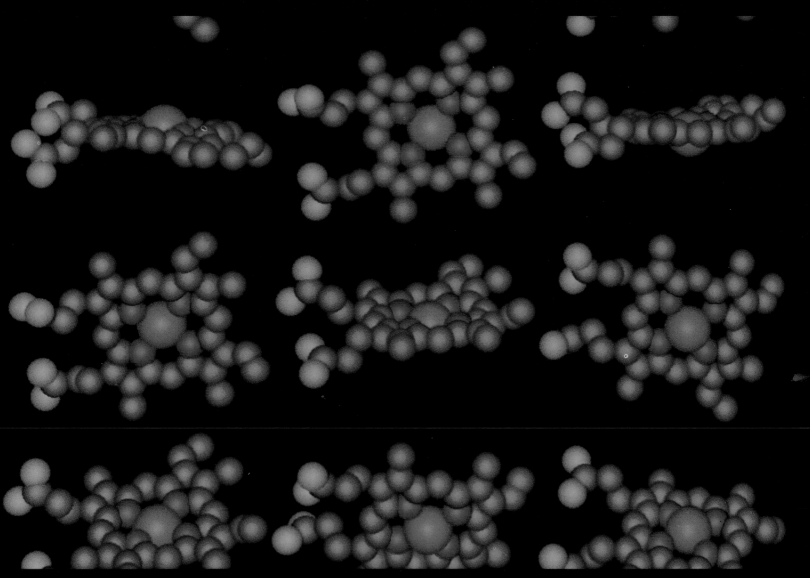

Picture 67 One computer picture can show several views of the same object. Here we see a model of a hemoglobin molecule in various angles of rotation. (Pete Harris, Jupiter Systems, and Tom Ferrin, University of California at San Francisco)

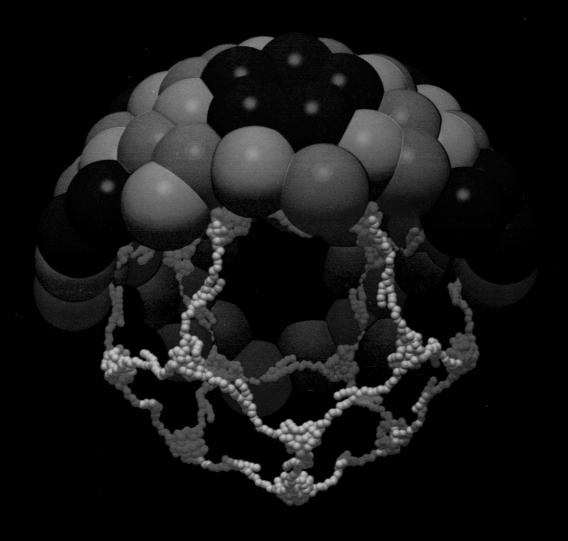

Picture 68 "Tomato Bushy Stunt Virus." Nelson Max at the
Livermore National Laboratory shows us that a computer model
of a virus can be quite aesthetic. (X-ray crystallography data
supplied by Art Olson and Steve Harrison at Harvard)

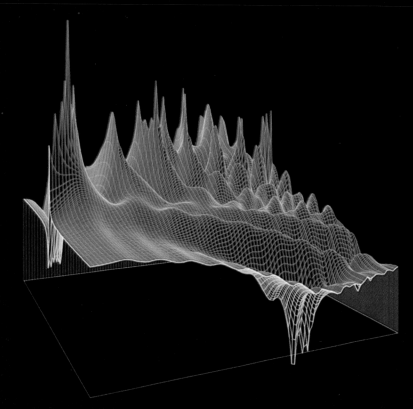

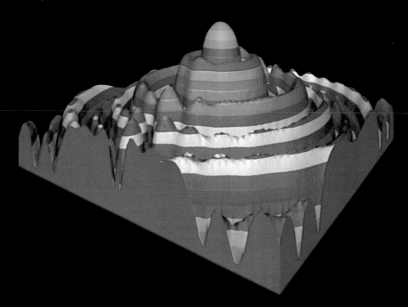

Picture 70 "Optical Cake." This and the following three pictures show results of light transmission studies through various apertures under different methods of analysis. (©1982 Melvin L. Prueitt)

Picture 69 "Mie Scattering." Scattering of light in the atmosphere by particles is called Mie scattering. This picture was made from data supplied by Professor Robert Rowell at the University of Massachusetts. (©1977 Melvin L. Prueitt)

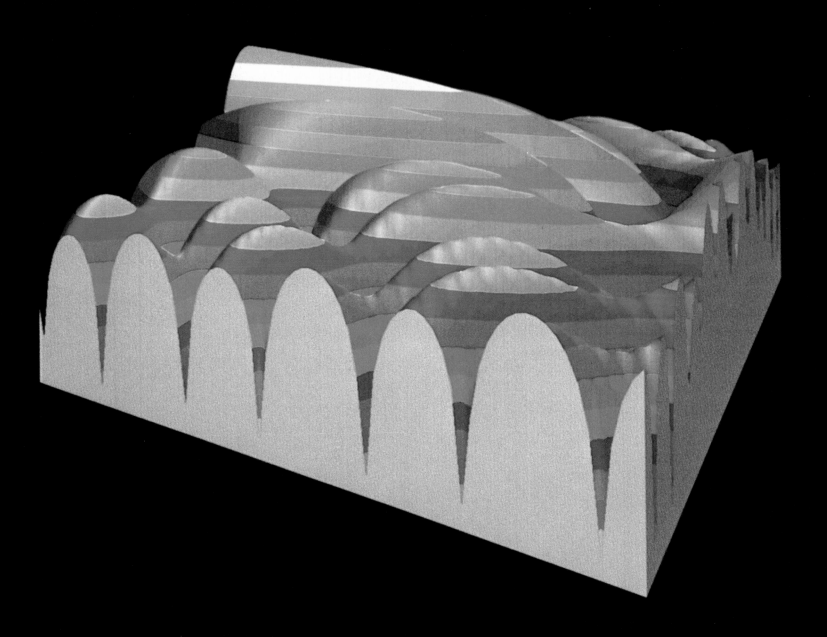

Picture 71 "Crested Waves." (©1982 Melvin L. Prueitt)

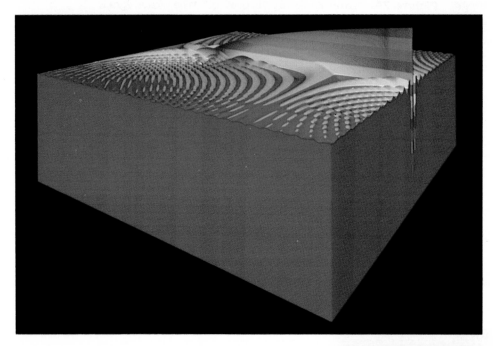

Picture 72 "Tidal Wave." (©1982 Melvin L. Prueitt)

Picture 73 "Radiant Sails." (©1982 Melvin L. Prueitt)

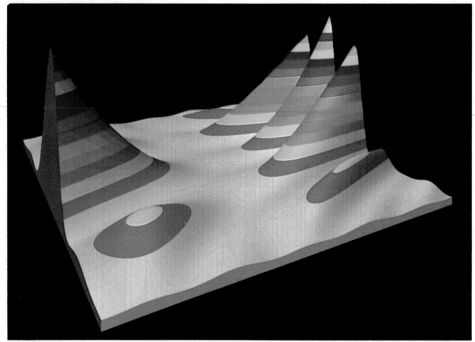

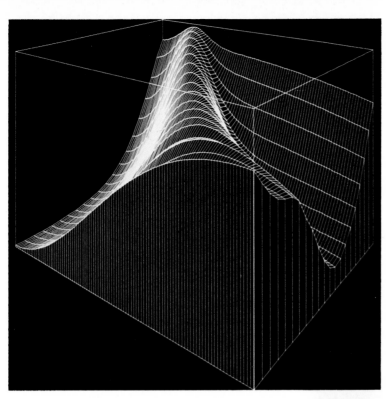

Picture 74 "Laser Radiation Absorption." When laser light is incident upon a surface, some of it is absorbed. By plotting the angle of incidence along one axis and depth of penetration along another, Dr. Marvin Mueller at the Los Alamos National Laboratory obtained this plot in which the height of the surface represents the amount of absorption.

Picture 75 "Gaussian Optical Pulse." The shape of the surface represents the amplitude of a single laser pulse. The height of the surface is the negative of the amplitude. (©1982 C. James Elliott and Paula Adams, Los Alamos National Laboratory)

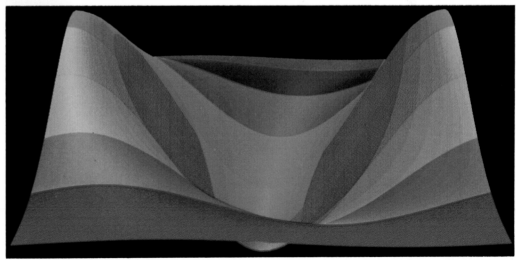

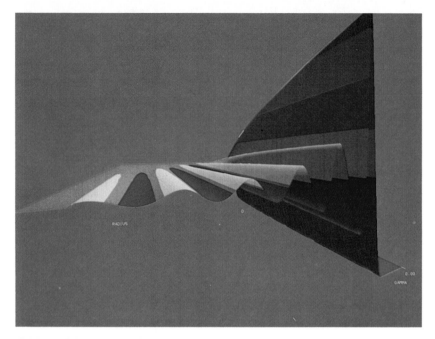

Picture 76 "Probability." Wing design for some new type of aircraft? No. This surface defines the probability of finding one charged particle at a given distance from another in a plasma (super-hot gas) as a function of temperature and density. (©1983 Wayne Slattery, Los Alamos National Laboratory)

Wayne Slattery, also at Los Alamos, examined the pair distribution for a classical one-component plasma. He plotted the surface in Picture 76, the height of which gives the probability of finding one particle at a certain distance from another as a function of temperature and density.

When a projectile of steel impacts a stationary target at high speed, events develop too rapidly for human perception. Furthermore, we cannot see into the materials to discern what is taking place inside. Computers can freeze time and take things apart. Picture 77 represents a slice through the experiment with color denoting the materials. The height of the surface represents the velocities of the materials shortly after impact.

On a larger scale, geologists probe the subsurface formations with acoustic signals and with logs from deep wells. Doug Lora, during his summer student research at Los Alamos, used the data to produce Picture 78. The upper part of the picture is the earth's surface at a location in Nevada, while the lower part shows the geological formation of interest. In spite of the sizable mountains, the upper surface, due to erosion and sedimentation, has become quite flat compared to the huge "mountains" and "canyons" of the unseen world below.

Far below these formations, great masses of the earth's mantle flow slowly, inexorably, in some eternal pattern, carrying the continents on transworld voyages. John Baumgardner and Paul Frederickson, both at Los Alamos, did a computer study of possible mantle flows and obtained Picture 79, where the arrows point the direction of flow and the rate of flow is proportional to the length of the arrows.

Computers are indispensable in space travel not only for charting courses and piloting spacecraft but also for helping us to visualize journeys through the

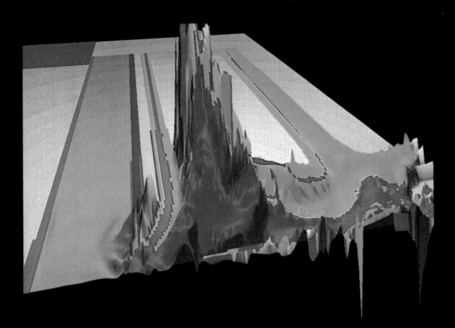

Picture 77 "Collision." What happens when a high-speed steel projectile slams into a target? Billie Wheat at Los Alamos plotted a picture in which the height of the surface represents the material velocity only instants after impact. The colors identify materials. Purple defines the location of steel in the cross section of the experiment. Red locates regions of mixing of materials. (©1983 Billie Wheat, Los Alamos National Laboratory)

Picture 78 "Nevada Geology." We can see geological layers in rugged mountains that are not overgrown with vegetation. Uplifting of portions of the earth and weathering have exposed cross sections of strata that are easy to study. Below the surface of the earth lie formations that we cannot see. In this picture, the computer unveils a geological formation far below the cacti and sage brush of a location in Nevada. The upper plot in orange is the ground surface showing mountains in the background. The colors on the lower surface designate depth. The vertical line is a deep well. (Douglas Lora, Los Alamos National Laboratory)

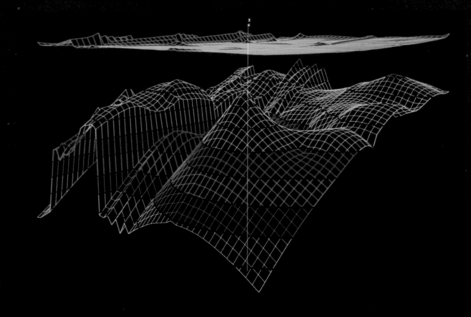

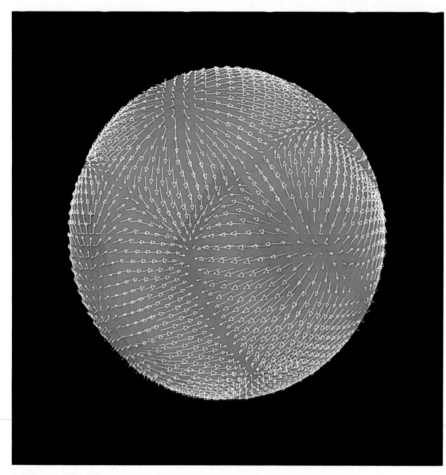

Picture 79 The arrows show directions of calculated possible mantle flows far beneath the surface of the earth. Colors designate temperatures. (©1983 John Baumgardner and Paul Frederickson, Los Alamos National Laboratory)

boundless oceans of space. James Blinn, at the Jet Propulsion Laboratory, has developed computer simulations of spacecraft flying by planets and has helped millions of television viewers to better understand our planetary exploration program. He has produced many other computer graphics to aid scientists in planning and executing space programs. Pictures 80 and 81 are examples. Picture 81 provides a hypothetical view of Saturn from the moon Mimas.

At night, we marvel at the display in the heavens. But the myriad stars we see are only an infinitesimal fraction of what is out there. Our telescopes gather in the faint light that left distant star systems many years ago, and astronomers study the dark smudges imprinted by long exposure on photographic plates. Computers, with appropriate attachments, can scan the same plates to produce perspective plots in which the height of the surface represents light intensity.

Dr. Martin Burkhead, of Indiana University, sent me a tape of data from scans of photographic plates taken of the Orion Nebula and R Monoceros Nebula. In Picture 82, the central column represents the amount of light flowing out from the center of the Orion Nebula. The sharp spikes are individual nearby stars. After mathematically treating the data to reduce the brightness of the individual stars, we obtained Picture 83, which enhanced many features of the nebula. By following the color bands, we can compare the brightness of various parts of the nebula, and by knowing how the computer assigned the color levels, we can assign definite intensity values to each band. To enhance the low-level features, we took the logarithm of the data (see Picture 84). In Picture 85, the computer has zoomed in on the very core of the nebula. The cliffs and canyons designate regions of strong intensity gradients.

Picture 81 "Computer View of Saturn and the Moon Mimas."
(Dr. James F. Blinn, Jet Propulsion Laboratory)

Picture 80 Computers can provide realistic views of the planets. This simulation of Voyager 2's flyby of Saturn was produced by Dr. James F. Blinn, Jet Propulsion Laboratory.

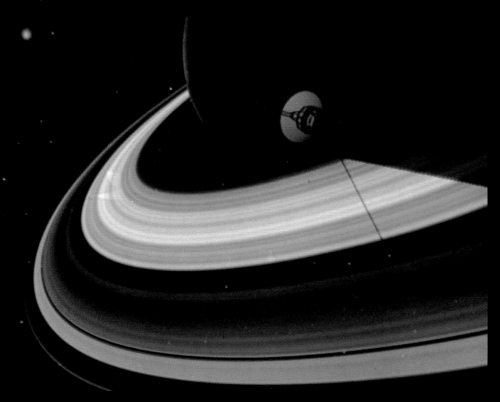

Picture 82 "Forest of Orion." If we take a flat surface and then raise the points of the surface to a height proportional to the light intensity from corresponding points of a photograph of the Orion Nebula, we get this picture, where the color bands represent intensity levels. The sharp spikes, looking like tree stumps in a burned-out forest, represent nearby stars. Data for this and the following four images were supplied by Dr. Martin Burkhead of Indiana University. (©1982 Melvin L. Prueitt)

Picture 83 "Orion Monolith." A mathematical treatment of the data shown in Picture 82 reduces the "noise" from individual stars but does little to the light from the main body of the nebula. Adding a change of colors, we get this picture. (©1982 Melvin L. Prueitt)

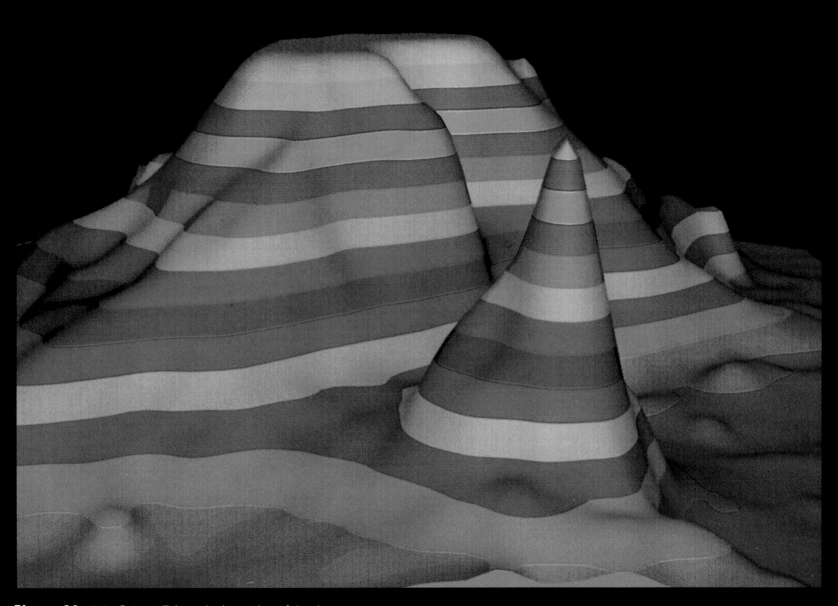

Picture 84 "Mt. Orion." Taking the logarithm of the data brings out features in the structure of the Orion Nebula. (©1982 Melvin L. Prueitt)

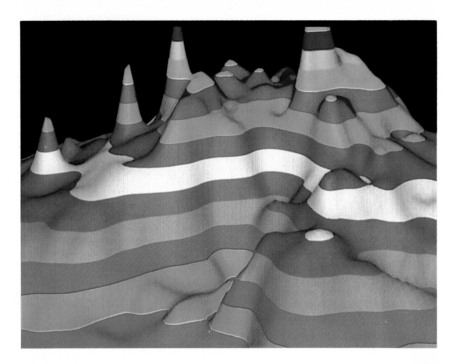

Picture 85 "Orion Canyon." Here we have zoomed in on the core of the Orion Nebula. (©1982 Melvin L. Prueitt)

Picture 86 "Twin Peaks." Light intensity from R Monoceros Nebula looks like this when processed by computer. (©1982 Melvin L. Prueitt)

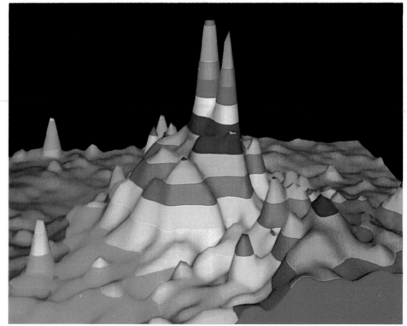

Picture 86 combines pleasant color and formations to represent the light intensity from the R Monoceros Nebula. White is effective in providing balance to the color composition.

Galaxy NGG5247 is shown with pseudocoloring to differentiate the parts in Picture 87.

From other data supplied by Dr. Burkhead, Susan Bunker (Los Alamos) produced Picture 88, a computer view of Galaxy M-51. It is a double galaxy with two bright areas shown by the two peaks. We can observe a "spiral staircase" around the central feature marking part of a galactic spiral arm. Before this image was made, the computer subtracted the background light caused by the earth's atmosphere. The result is a clear picture that reveals many details of the M-51 structure. The sharp points surrounding the central feature are not part of that galaxy, but are nearby stars in our own Milky Way galaxy.

Picture 87 "Galaxy NGC5247." Light from this galaxy has been treated by a computer to differentiate different parts by pseudocoloring. (Courtesy of European Southern Observatory and Gould, Inc., DeAnza Imaging and Graphics Division; photo by Curtis Fukuda)

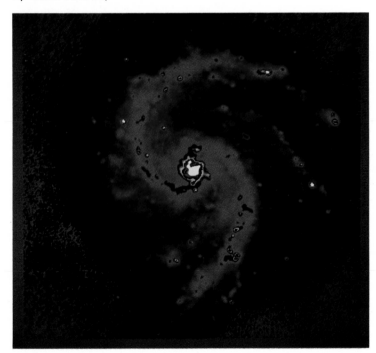

Picture 88 Susan Bunker at Los Alamos produced this image representing the light intensity from the double galaxy M-51. (Data from Dr. Martin Burkhead, Indiana University)

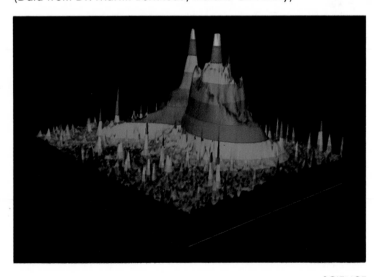

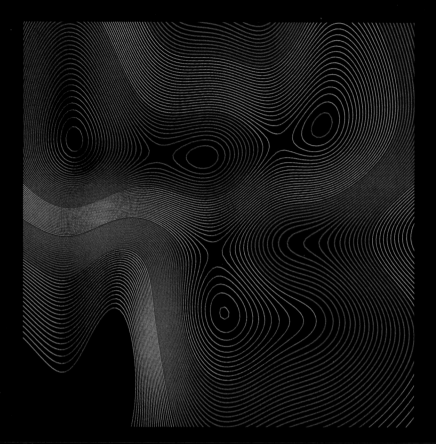

TOPOGRAPHY

Almost everyone knows what it is like to study a topographical map and squint at the numbers printed along the serpentine lines. Computers can produce topographical maps in which elevation is represented by color. A separate key tells which color is associated with what elevation. For people who must examine topographical maps as part of their occupation, once they are acquainted with the color code, they will immediately know the elevation of a curve without having to look for numbers.

Picture 89 is a topographical map in which the contour lines are colored in bands rather than defining a different color for each line. By assigning colors to only certain elevations, pictures such as Picture 90 are produced; the black areas are those elevations for which no color was assigned. When the surface is defined on a very coarse grid, we get results like Picture 91.

Picture 89 "Sinuation." Color can be used to identify elevation in topographical maps. (©1981 Melvin . Prueitt)

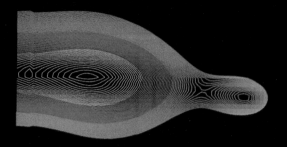

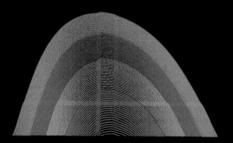

Picture 90 "Islands in Space." When some elevations are defined as black, we get this type of result. (©1981 Melvin L. Prueitt)

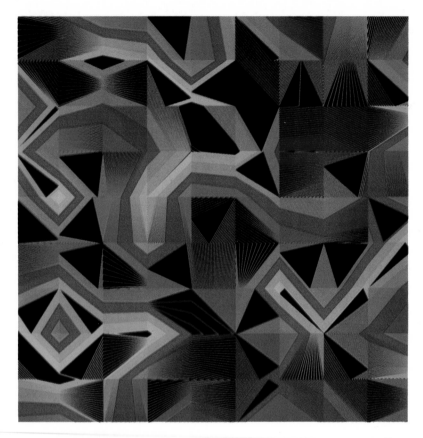

There are other ways to display topographical information, of course. In Picture 92, the color depends on the slope of the terrain, while the intensity is proportional to the diffuse reflection of a light source directly above the surface. In Picture 93, colors define the steepness of the slope, and point density is proportional to the altitude.

The next two images give somewhat realistic topographical maps. After taping a topographical map of part of the Los Alamos (New Mexico) terrain with a backdrop of the Jemez Mountains to a graphics tablet, I laboriously entered the data into a computer. The result is Picture 94, which shows color contours that define elevation. In the foreground are the 7,300-foot-high mesas cut by numerous deep canyons. The background mountains, on which a ski resort is built, are over 10,000 feet high.

This type of plot can be extended to the entire United States, as shown in Picture 95. This picture brings out rather dramatically the height of the Rocky Mountains.

Picture 91 "Checkerboard of Dreams." This picture was produced when the mesh, on which the terrain was defined, was specified coarsely. (©1981 Melvin L. Prueitt)

Picture 92 "Black Hole." This topographical map is defined by letting the color depend on the slope of the terrain. (©1981 Melvin L. Prueitt)

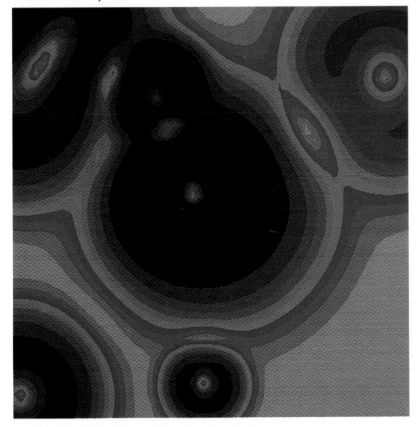

Picture 93 "Stars Like Grains of Sand." Still another way to show topographical data: let the colors define the steepness of the slope and let point density represent altitude. (©1982 Melvin L. Prueitt)

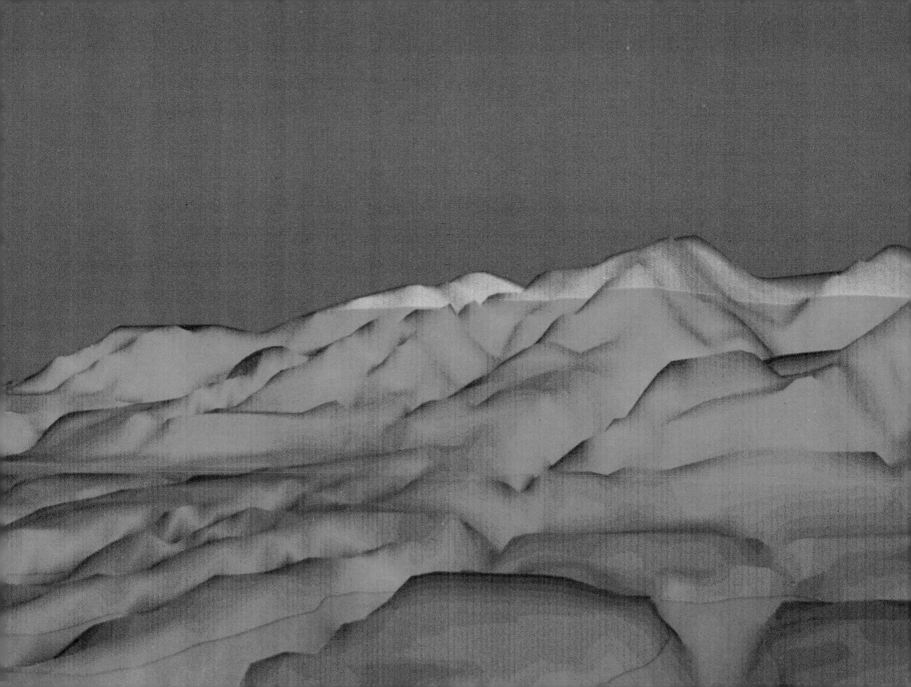

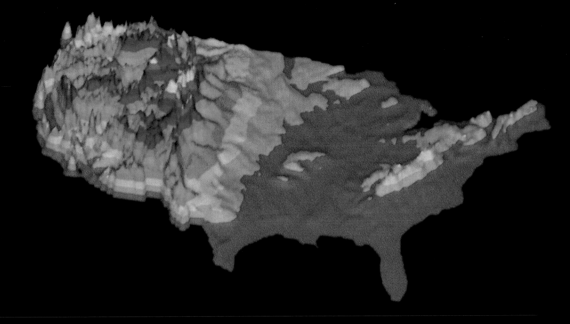

Picture 95 "America in Space." The whole United States can be represented in three dimensions by exaggerating the vertical height. Colors define altitudes. (©1982 Melvin L. Prueitt)

Picture 94 (Opposite page) "Jemez Mountains." Perhaps the most visually satisfying way to display topographical information is to produce a three-dimensional shaded-surface picture. Here we see the 10,000-foot Jemez Mountains in the background. On

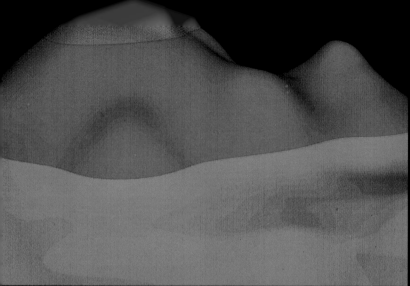

The surface of the earth is formed by upheaval, erosion, and sedimentation. Most of the scenic views that we see are only snapshots taken in an instant of geological history. Seldom do we actually observe erosion in action. However, computer simulation of erosion can compress millennia into seconds. Pictures 96 and 97 show a hypothetical mountain and its subsequent erosion. Picture 98 is the erosion of another surface. It somewhat resembles parts of Bryce Canyon except for the color.

Picture 96 "After the Eruption." Imagine a volcanic eruption that builds a mountain. Afterward, vegetation grows and the scars are healed. This is a computer view of such a scene. (©1982 Melvin L. Prueitt)

Picture 97 "A Million Years Later." If we take Picture 96 and "erode" it with a special erosion program, we get this result. (©1982 Melvin L. Prueitt)

Picture 98 (Opposite page) "National Park." This is another "landscape" that has been eroded by the erosion program. The longer the program runs, the more eroded the surface becomes. (©1982 Melvin L. Prueitt)

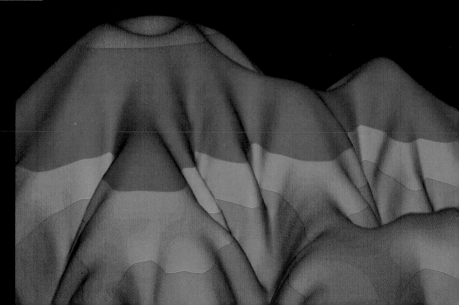

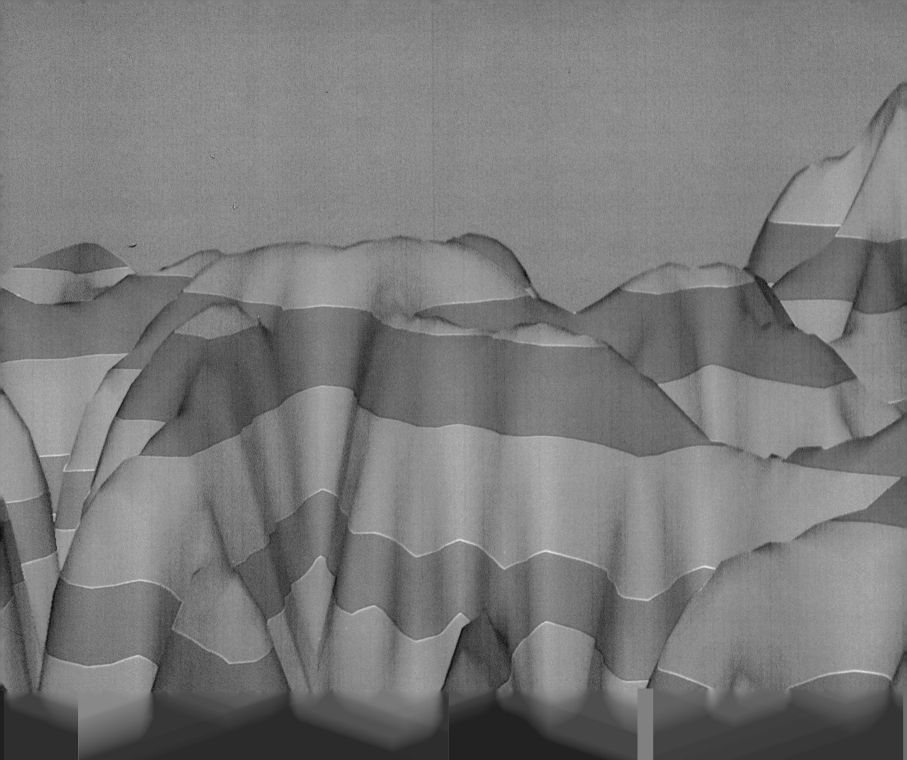

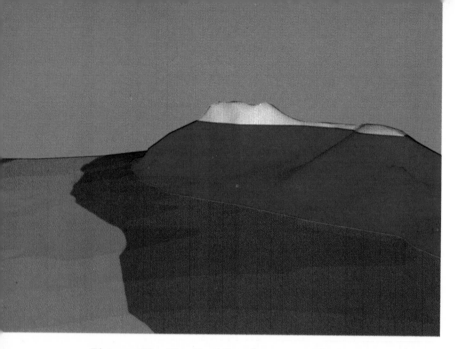

Picture 99 "Sandia." If we have an erosion program, why not take an actual landscape and see what the program would do to it? Here is a computer picture of the 10,000-foot Sandia Mountains in New Mexico. The city of Albuquerque lies on the flat area, and the Rio Grande runs along the left side of the picture. (©1982 Melvin L. Prueitt)

Now suppose we take topographical data for a real mountain, such as the 10,000-foot Sandia Mountains, and feed the data into an erosion program. Picture 99 shows a computer view of the Sandia Mountains as they exist today. Naturally, many of the details are missing. The city of Albuquerque sits on the relatively flat area in the foreground. Pictures 100 and 101 show one possible scenario of erosion as millions of years elapse. The actual erosion will, of course, depend on many factors, such as weather, vegetation, tectonics, and human intervention. Even though the sequence pictured here would be a reasonable prediction only under very limited circumstances, since we do not expect to be around to observe the landscape millions of years hence, it is interesting to speculate on what might come to pass.

Picture 100 (Opposite page) "Time and Erosion." Perhaps in the distant future, the terrian of Picture 99 will be transformed into this. The probability of that would depend on many factors. (©1982 Melvin L. Prueitt)

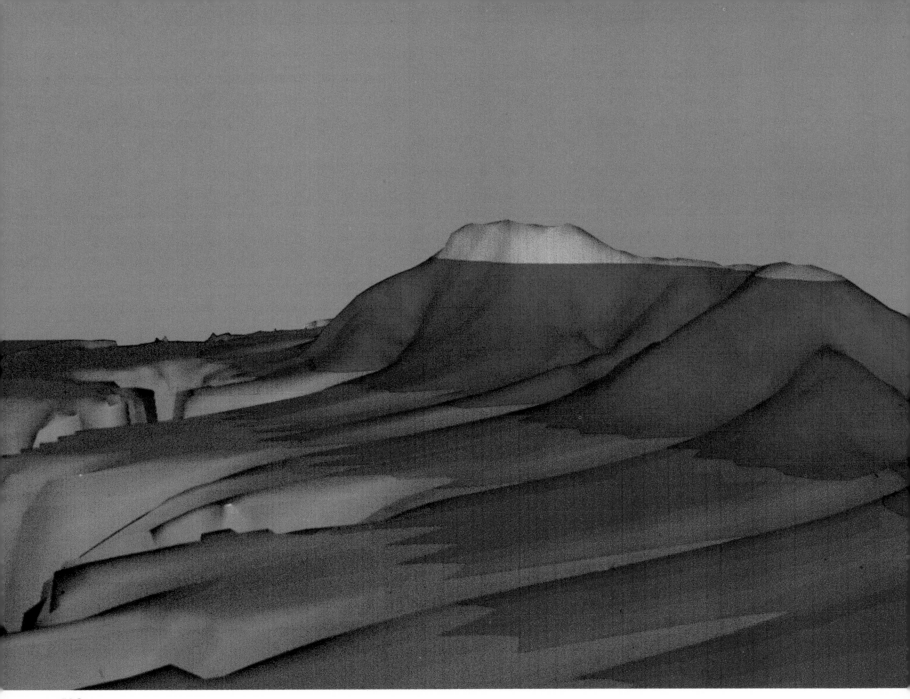

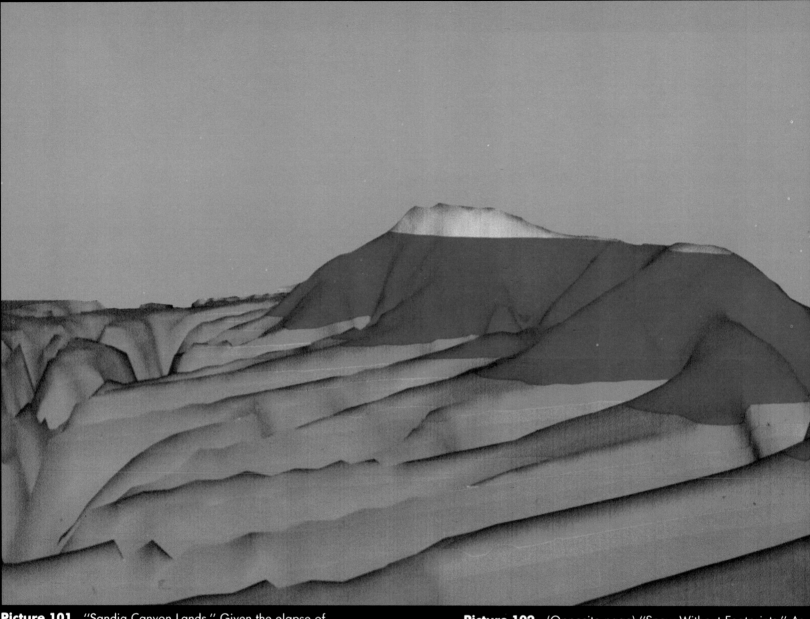

Picture 101 "Sandia Canyon Lands." Given the elapse of more geological ages, the area might look like this. Imagine the spectacular views Albuquerqueans would have from their mesa-top homes. (©1982 Melvin L. Prueitt)

Picture 102 (Opposite page) "Snow Without Footprints." As long as we are experimenting around with an erosion program, why not let it work on a snow scene? We start with some geometry and fill in the low areas with water. (©1982 Melvin L. Prueitt)

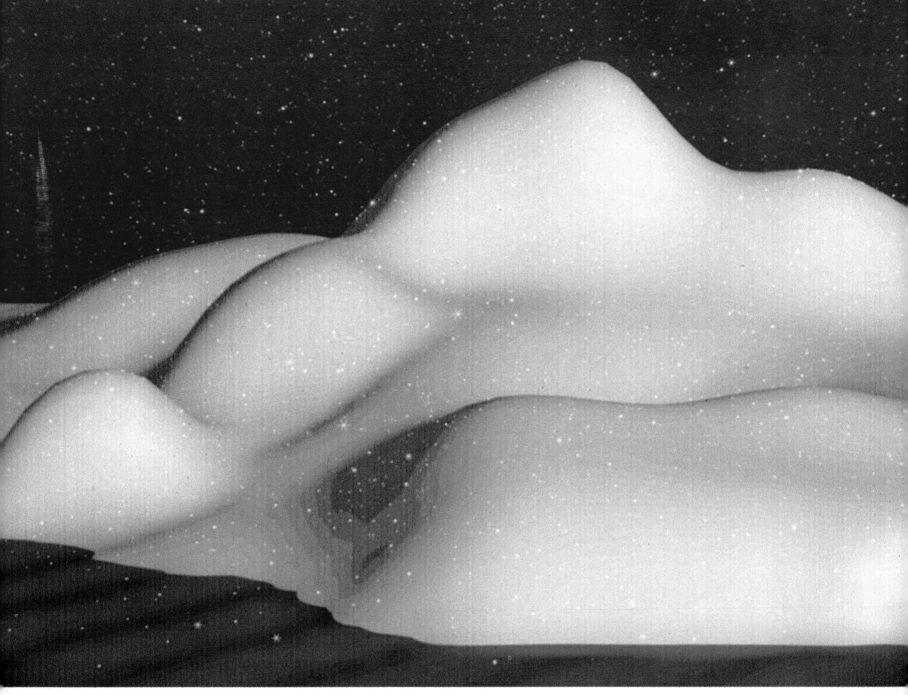

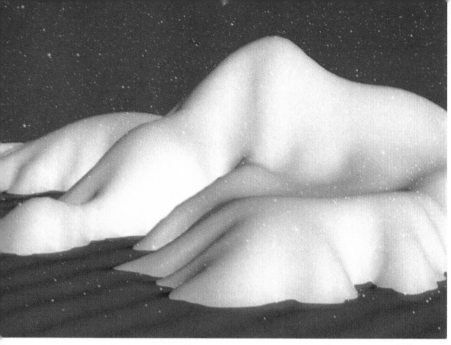

Picture 103 "Melting Snow." In this picture and the following one, erosion of the scene in Picture 102 takes place. (©1982 Melvin L. Prueitt)

The same erosion program that can erode land can also erode ice and snow. In Pictures 102 through 104, the computer builds a wintry scene and then erodes it. After the erosion process, the lower parts of the terrain are filled with water. The erosion program actually produces deep cuts that are forever hidden from the observer by the water.

Picture 105 is an eroded scene produced by the same program, but the starting geometry is different than that of Picture 102.

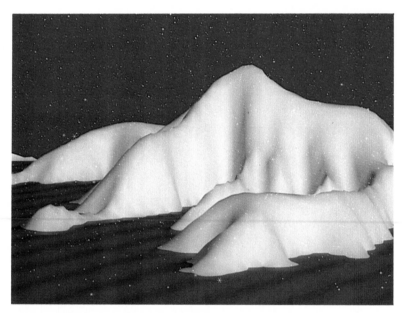

Picture 104 "Ice Water." Although this is only a computer-generated scene, one can almost imagine the shock of sliding off the ice into the cold water. (©1982 Melvin L. Prueitt)

Picture 105 (Opposite page) "Arctic Twilight." With the same erosion program, but a different beginning geometry, a totally dissimilar scene is evolved. (©1982 Melvin L. Prueitt)

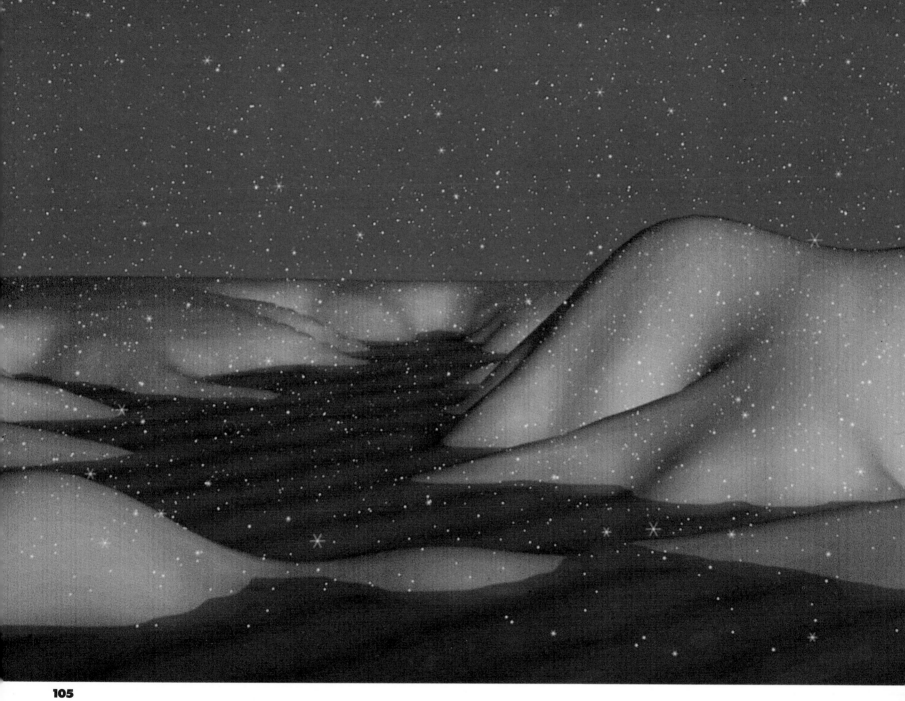

MATHEMATICS

As we noted in the section called "Science," there are many mysteries lying hidden in the nature of things of which most people are unaware. The world of mathematics is even more strange and diverse, a universe of numerous dimensions, unfathomable constructs, and series that march resolutely off to infinity. It is an orderly system of rules of logic that build upon rules of logic. One would think that sooner or later the tentacles of mathematics reaching out into the unknown would come to an end—that the body of possibilities would be filled. But so far, there appears to be no boundary. Indeed, the expansion of mathematical knowledge seems to open up new frontiers for exploration, and it seems that we have merely been scouting the fringes of a vast, and perhaps endless, province. But the pioneers are too few to man the outposts and push forward on all fronts. Maybe that is partly because the mathematicians have not shown the wonder of it all to the general population because a special language is required to communicate the concepts.

Why not use graphics? Pictures cannot convey the whole idea, but they can show some of the beauty that is derivable from mathematical functions. In this section, we present a few examples of computer graphics from mathematics, but these few cannot do justice to such a broad subject. There is not a large selection from which to choose because few mathematicians have so far tried to reduce their formulations to pictorial form. I would like to challenge mathematicians to apply some ingenuity to the transformation of equations into images that not only would be interesting and informative to nonmathematicians but might even prove enlightening to the mathematicians themselves.

Of course, all the pictures in this book utilized mathematics within the computer for the production of the images, but often they were derived from nonmathematical data. Displays such as Picture 66 in the "Science" section, though, were derived strictly from mathematical functions; in Picture 70, Bessel functions were used.

We begin with something quite simple. Picture 106 is the plot of a circular sine function; that is, as the angle around a point is varied, we multiply the angle by a constant and take the sine of it. Then we multiply that result by the radius from the center point and raise the surface accordingly. To make the picture more interesting, we can plot a second circular sine function phase shifted 180° from the first (Picture 107).

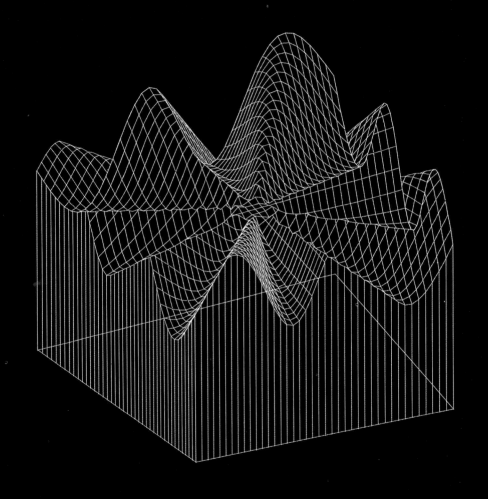

Picture 106 "Circular Sine Wave" (©1974 Melvin L. Prueitt)

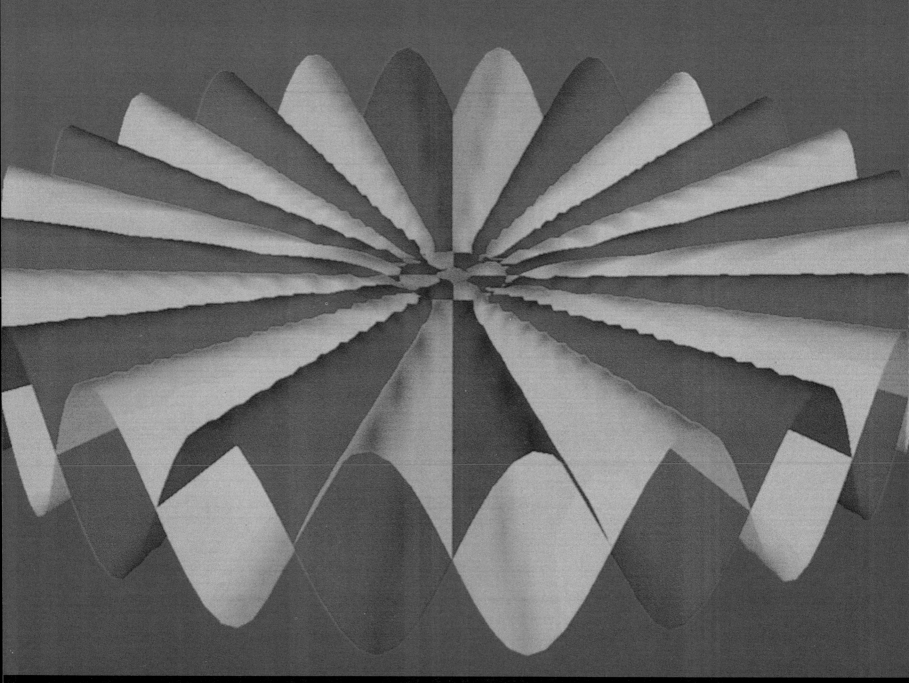

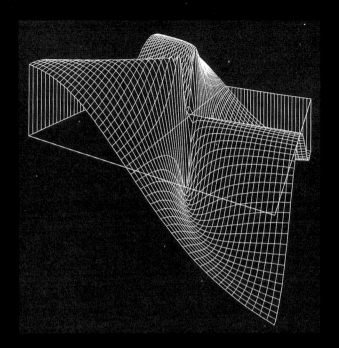

Picture 108 "Math Design." The height of the surface is proportional to z in the equation $z = xy^2/(x^2 + y^4)$. (©1973 Melvin L. Prueitt)

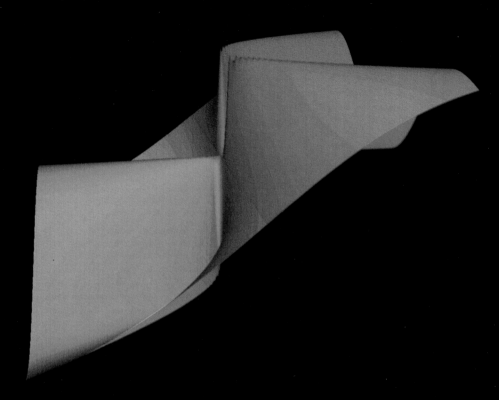

Picture 109 This function is the same as that of Picture 108, but the viewpoint is different, and it was plotted by a different program: CAMERA. (©1982 Melvin L. Prueitt)

Picture 107 (Opposite page) "Two Circular Sine Waves." (©1983 Melvin L. Prueitt)

Pictures 108 and 109 are two views of the simple function $z = xy^2/(x^2 + y^4)$. Most students in math classes would not have guessed that one could make the equation look like the picture. Picture 110 is a plot of the equation $z = (|x| - |y|)^2 + 2|xy|/\sqrt{x^2 + y^2}$. In Picture 111, we have a surface that is defined by the product of the sine of x and the hyperbolic sine of y. To me, the picture is more fascinating than the printed equation. Certainly the equation is a much more compact form of notation, but consider how quickly a new student could get the "feel" of the equation by seeing the picture.

Mitchell Feigenbaum at Los Alamos has been investigating the behavior of nonlinear systems. As part of that study, he looked at systems of equations, such as the simple pair of equations $x' = x^2 - y$ and $y' = a + x$. Suppose that we randomly choose some initial values of x and y and then calculate the values of x' and y'. Then we use x' and y' as new values for x and y and continue to iterate in this manner. For many other equations, the values of x and y converge on some fixed values, but for these two equations the result is surprising. At first, there seems to be no order at all. If the points representing the coordinates of successive x and y values are plotted on a plane, they seem to be scattered randomly. But by having a computer plot many thousands of points, the points strangely begin to form a pattern. Robert Hotchkiss chose a number of initial values for x and y and obtained Picture 112. Great mathematicians of the past had no suspicion that such images were inherent in the nature of mathematics, that there was a semblance of order in the apparent chaos. We pause to wonder what other inexplicable mysteries exist out there in the vast universe of mathematics.

Each of the "lines" in this image is not a line at all but is an assemblage of thousands of individual points. Within the main body of the image, a considerable amount

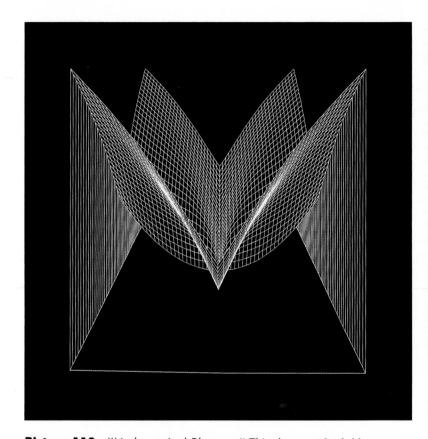

Picture 110 "Mathematical Blossom." This does not look like $z = (|x| - |y|)^2 + 2|xy|/\sqrt{x^2 + y^2}$, but that is what it represents. (©1973 Melvin L. Prueitt)

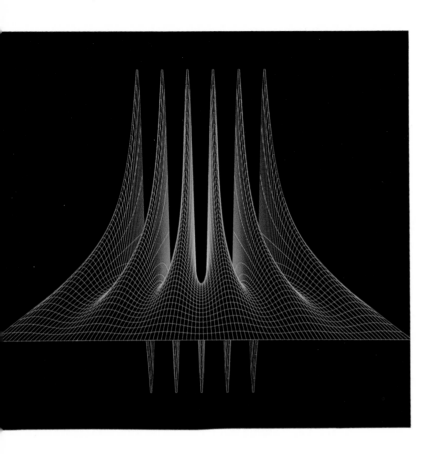

Picture 111 "Apartment Complex 2130 A.D." The surface is defined by $z = (\sin x)(\sinh y)$. (©1982 Melvin L. Prueitt.)

of order is apparent. Around the edges, the points stream away to some dark unknown, as if an inscrutable wind were blowing through a mathematical night.

Now suppose we have the computer magnify a portion of Picture 112. Another suprise! We find that there is structure within the structure. Notice the upper part where the red color dips down just below the two yellow "cells." Picture 113 is a magnification of this area. We could magnify a small part of *this* picture and discover even finer structure. We could go on forever, expanding small parts of succeeding pictures, and always find designs that the world will never see. Why?

Benoit Mandelbrot developed a new branch of mathematics called *fractal geometry* that simulates nature in many ways. The results of some of his work have been used in computer programs to produce pictures that appear natural: maps of artificial coastlines, mountains (see Picture 119 in the "Landscape" section and Picture 171 in the "Outer Space" section), clouds, and other entities that would fit comfortably into the real world. This is not the place to present the theory, but we can display some of the resulting images. Picture 114, called the "Self-Squared Fractal Dragon," is one such image. Dr. Mandelbrot describes the production of the image thus: "In the dragon, the background is made of points Z_0 of the complex plane that goes to infinity if Z_0 is replaced by $Z_1 = Z_0^2 - \mu$, then replaced by $Z_2 = Z_1^2 - \mu$, etc., ad infinitum. The number μ was suitably chosen. The color parts correspond to points Z_0 that fail to go to infinity, but instead move in a cycle of 25 points. After many iterations, all the points in any of the domains of a given color take to the same position." In his book *The Fractal Geometry of Nature*,[3] Mandelbrot wrote of this

[3]See *The Fractal Geometry of Nature* by Benoit Mandelbrot, W. H. Freeman and Co., San Francisco, 1982.

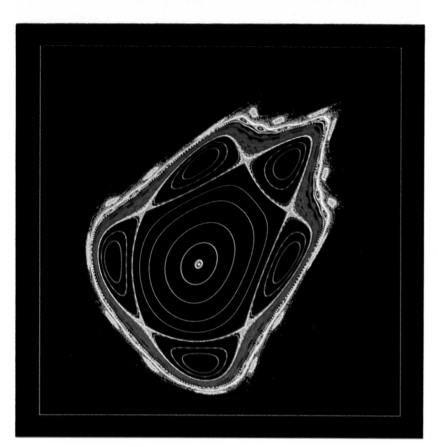

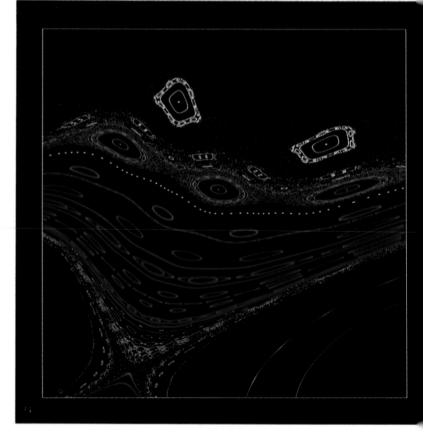

Picture 112 "Nonlinear Chaos." From one of the new frontiers of mathematics come some awesome concepts that boggle the human mind. Robert Hotchkiss plotted this and the next picture on a computer using some of the work of Mitchell Feigenbaum (see text). (©1983 Robert Hotchkiss, Los Alamos National Laboratory)

Picture 113 "Subset, Nonlinear Chaos." This is a magnification of Picture 112. If we magnified a small part of this image, we would get another design. We will never know what wonders are inherent in the two simple equations that generate these patterns (see text). (©1983 Robert Hotchkiss, Los Alamos National Laboratory)

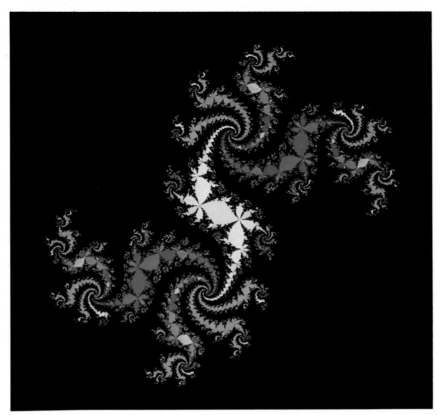

Picture 114 "Self-Squared Fractal Dragon." This picture was generated by Dr. Benoit Mandelbrot in his development of fractal geometry. (©1982 Benoit B. Mandelbrot, IBM Thomas J. Watson Research Center)

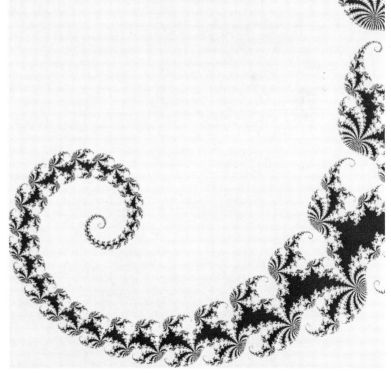

Picture 115 This spiral, generated by fractal geometry, consists of thousands of elements of minute detail. (©1982 Benoit B. Mandelbrot, IBM Thomas J. Watson Research Center)

picture: "The Formula for $f(2)$ is so short, and looks so uninteresting (because it comes from an elementary chapter of calculus), that little was expected from it. Thus, previewing this kind of design on the computer screen provoked surprise as well as deep esthetic shock." Picture 115 is another fractal image generated by Dr. Mandelbrot.

Alan Norton reached into that dark abyss where mathematical wonders have been lurking unobserved since before the birth of the cosmos and drew out two marvelous images to show the world (Pictures 116 and 117). It is almost as if an astronaut returned from a distant world bringing back artifacts at which we can only stare in helpless awe, not even knowing what

questions to ask. Dr. Norton used a computer to determine the interfaces between stable and unstable points for iteration in an equation. When starting points outside the surface were used, the solutions became unstable and approached infinity. We wonder what inscrutable forces mold these intricate forms and what causes the ridges on the surfaces.

Perhaps we cannot understand the meaning and the significance of these mathematical formulations, but at least we can see the images, and our visual systems effectively feed that information into our consciousness. Only a decade ago, mathematicians could look at the equations without an inkling of what they were missing.

Picture 116 (Opposite page) Is this some strange alien gadget that the astronauts found behind a boulder on the moon? See text for answer. This picture and Picture 117 were produced by Dr. Alan Norton at the IBM Thomas J. Watson Research Center. (Reprinted with permission from Alan Norton, "Generation and Display of Geometric Fractals in 3-D," *Computer Graphics*, vol. 16, no. 3, July 1982; ©1982, Association for Computing Machinery, Inc.)

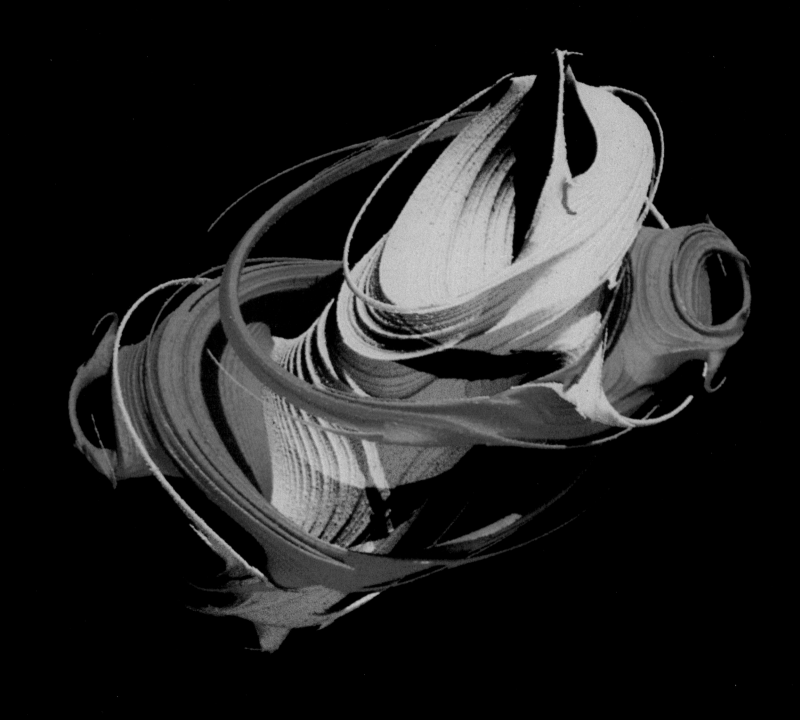

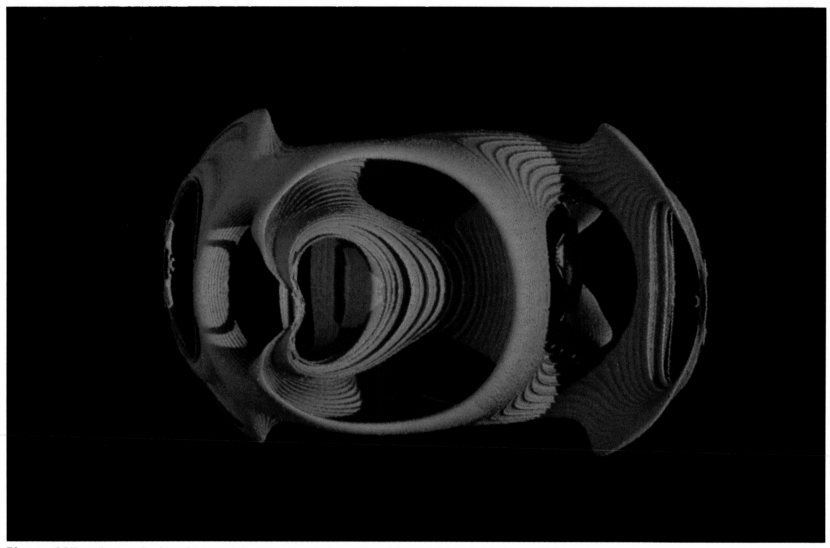

Picture 117 When we look at this image by Dr. Alan Norton, we wonder
what else is lurking out there in the mathematical universe for someone to bring
into the light of the sun for humans to see. (Reprinted with permission from Alan
Norton, "Generation and Display of Geometric Fractals in 3-D," Computer
Graphics, vol. 16, no. 3, July 1982; ©1982, Association for Computing
Machinery, Inc.)

LANDSCAPES

Landscapes seem to be a favorite subject for many artists and art lovers. Computers can create fascinating landscapes, too. Although somewhat surreal, the computer landscapes have their own form of mystery and loveliness. Perhaps it is the simplicity of these images—stripped of the infinite detail typical of ordinary landscapes—that make them intriguing. Michael Potmesil, at Image Processing Laboratory of Rensselaer Polytechnic Institute, produced a canyon scene plotted over a contour map (Picture 118). Richard F. Voss achieved excellent realism in Picture 119 by using fractal geometry. Pictures 120 through 122 were plotted by the CAMERA program. Color contour bands show the elevation of the surfaces. Picture 123 shows a landscape formed of short vectors with random color selection.

In Pictures 124 through 133 various elements have been added that enhance the surreal atmosphere of the pictures. These pictures were made by programs called PHOTO and GRAFIC. They have the capability of forming many multivalued objects in one picture, in contrast to the CAMERA program which can form only one single-valued object per picture.

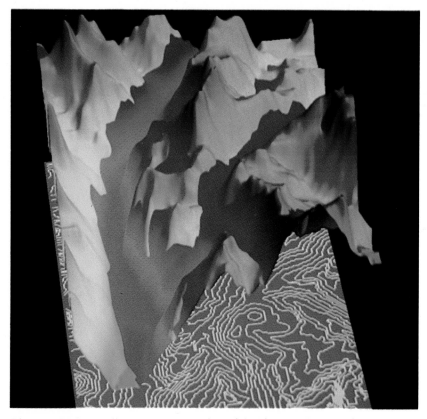

Picture 118 "Fall River Pass Quadrangle." The mountain and canyon scene superimposed over a topographical map was produced by Michael Potmesil of the Image Processing Laboratory, Rensselaer Polytechnic Institute. Indranil Chakravarty of Schlumberger - Doll Research aided in making the image.

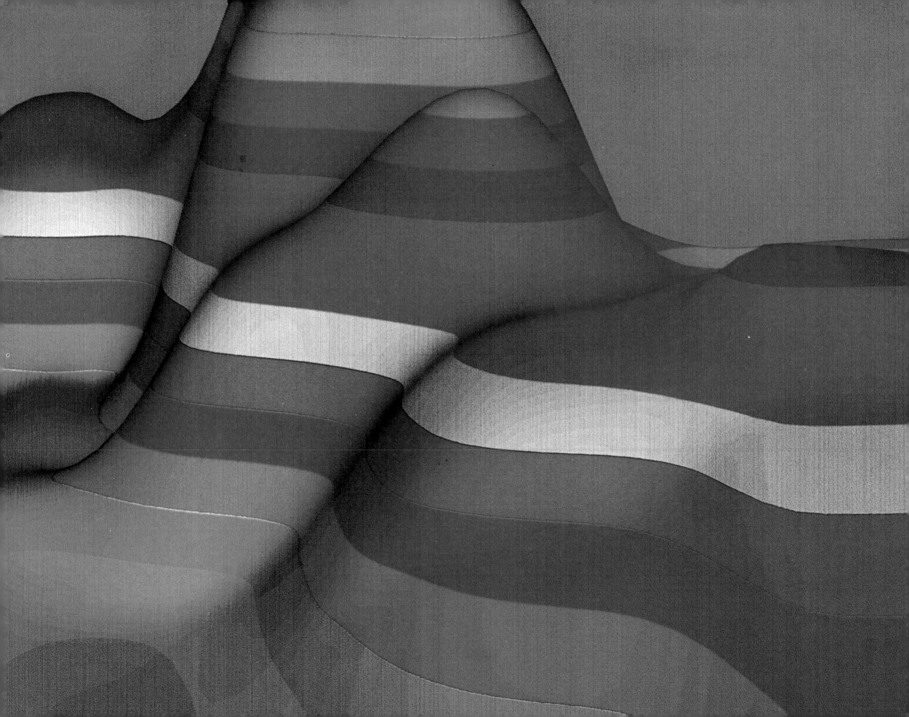

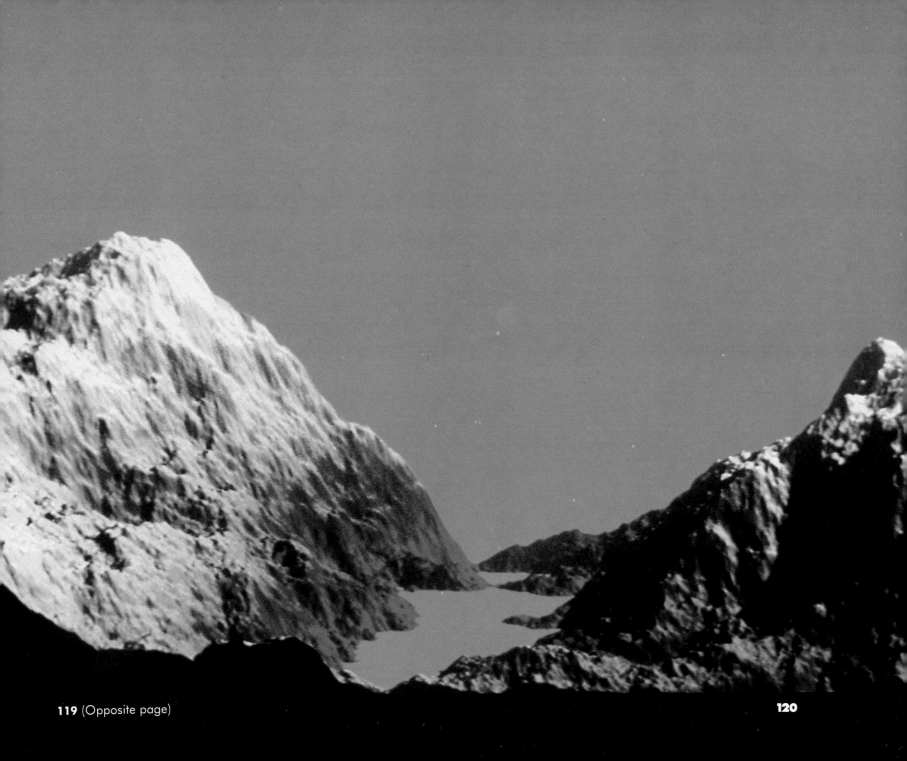

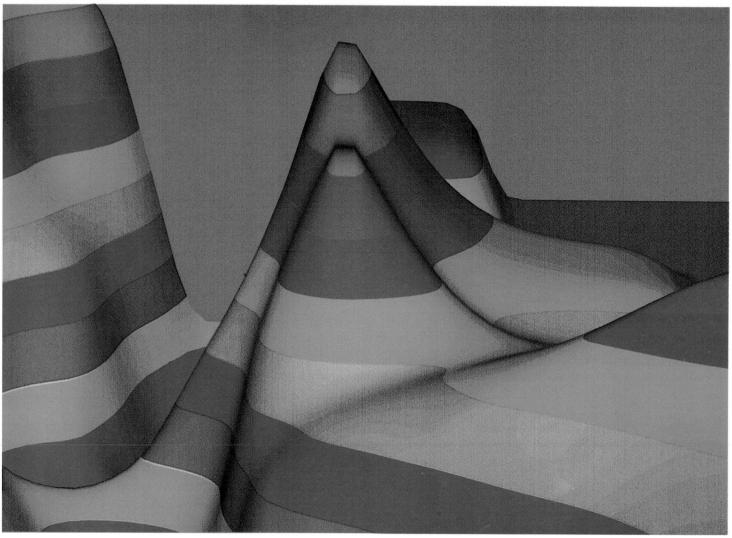

121

Picture 119 (Overleaf) Richard F. Voss used fractal geometry to produce a very realistic scene. (©1982 Benoit B. Mandelbrot, IBM Thomas J. Watson Research Center)

Picture 120 (Overleaf) "Blue Mountain." Color contours identify equal-altitude levels of the mountain and add to the aesthetics. (©1982 Melvin L. Prueitt)

Picture 121 "Math Land." (©1982 Melvin L. Prueitt)

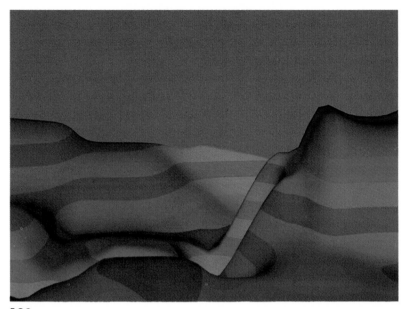

122

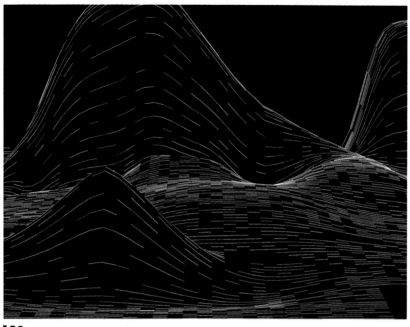

123

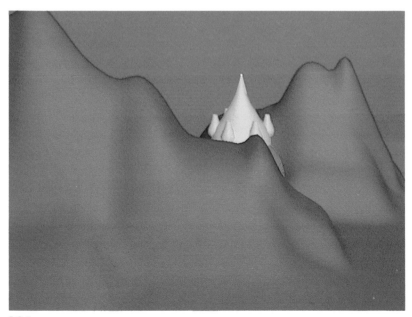

124

Picture 122 "Sunset Range." We can see from this how important lighting is to the mood of a scene. (©1982 Melvin L. Prueitt)

Picture 123 "Random Hills." To generate this landscape, random numbers were "plugged" into functions and the effects were added together. The colors of each line segment were also chosen randomly. (©1981 Melvin L. Prueitt)

Picture 124 "Hidden Castle." (©1982 Melvin L. Prueitt)

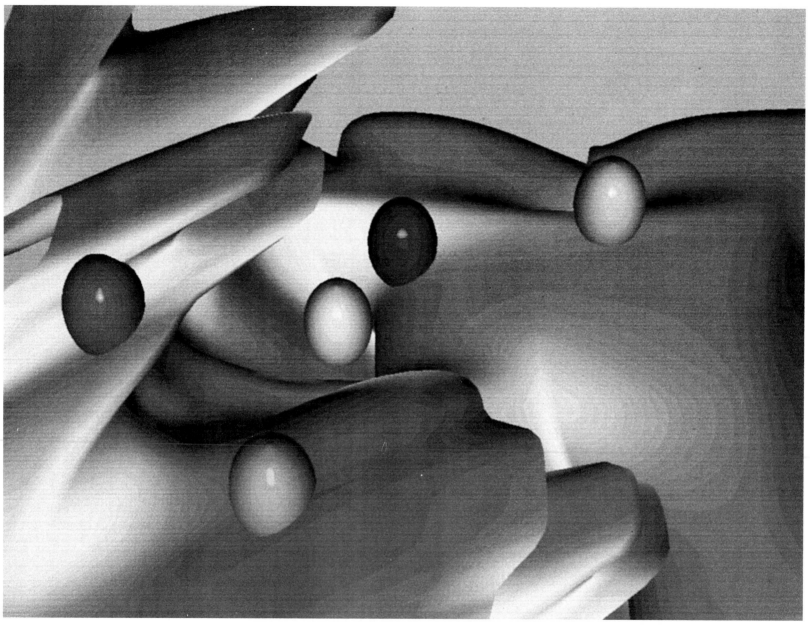

Picture 125 "Where the Wind Blows." The addition of objects on a landscape adds considerable interest and diversity to the picture. (©1983 Melvin L. Prueitt)

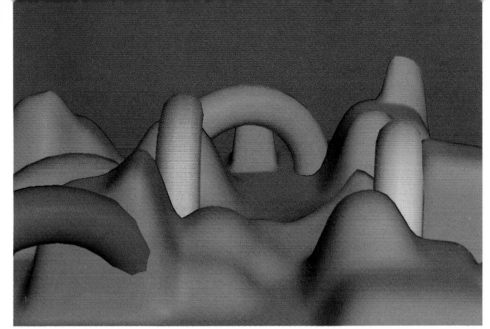

Picture 126 "Aerial Tunnels." Toroids can be interesting by themselves, but they become more fascinating when connected with some other geometry. (©1982 Melvin L. Prueitt)

Picture 127 "Floating Spheres." These spheres contribute to the surreal atmosphere of this magenta landscape. (©1982 Melvin L. Prueitt)

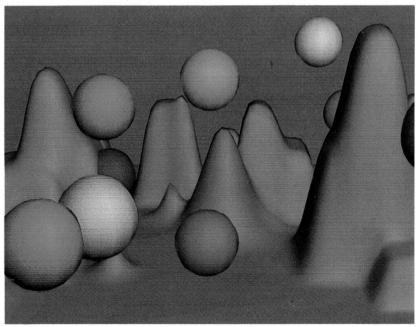

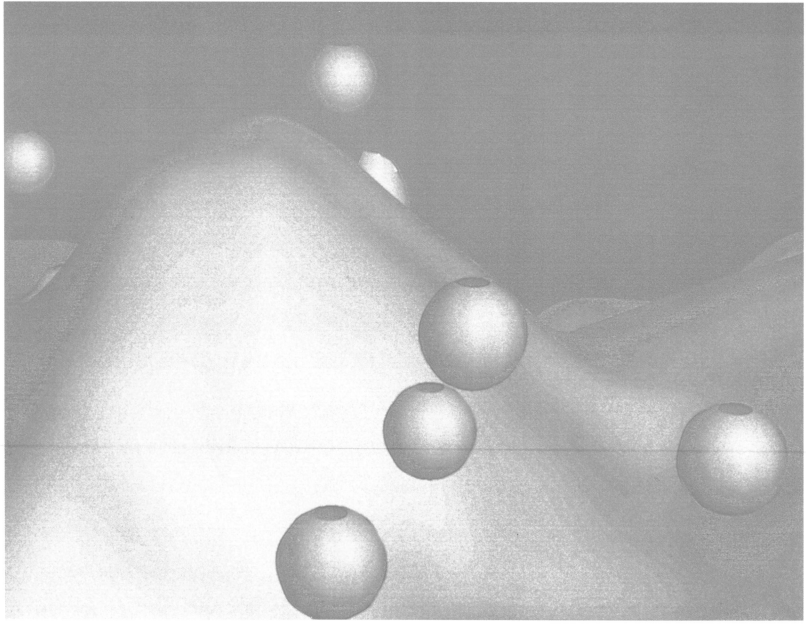

Picture 128 "Ghost Pottery." These pottery vessels seem to be drifting off into space. It is no problem for the computer to produce the effect since there is no gravity to contend with. (©1982 Melvin L. Prueitt)

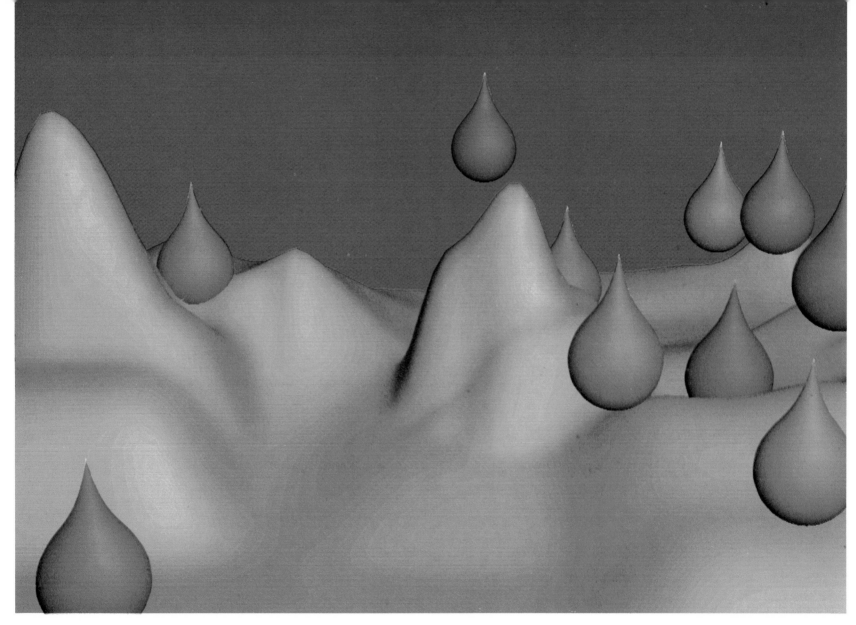

Picture 129 "Yellow Rain." A program called GRAFIC produces pictures like these. Each object in the scene is defined by a set of points, and the points are given to GRAFIC. The program does the rest. Teardrops are made by first forming spheres and then elevating some of the points near the top of the spheres. (©1982 Melvin L. Prueitt)

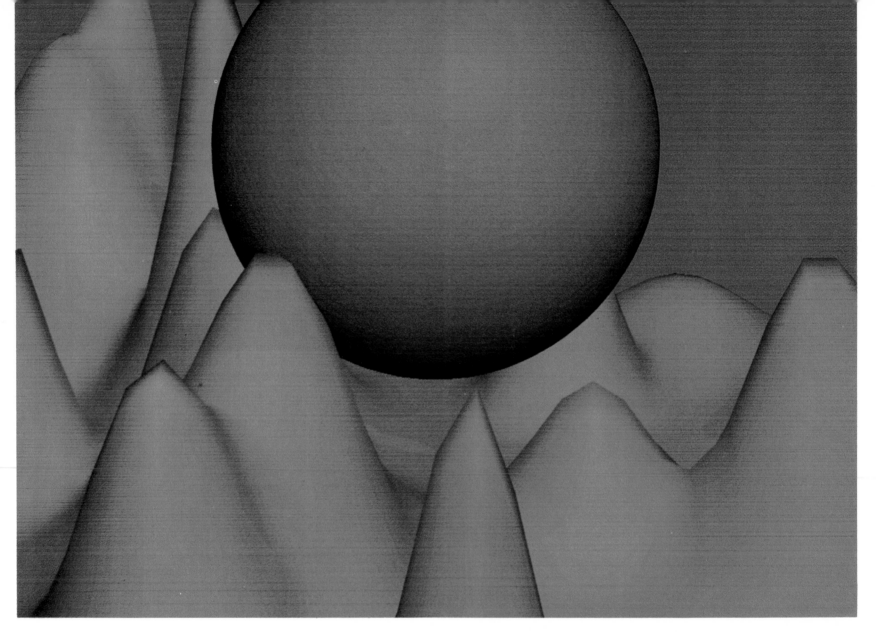

Picture 130 "The Sun Setting in the Mountains." (©1982 Melvin L. Prueitt)

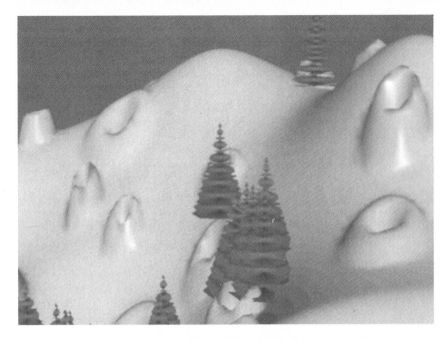

Picture 131 "Ascension." (©1983 Melvin L. Prueitt)

Picture 132 "Surreality." Parts of this image were defined to be black. The human visual system has no trouble defining the surfaces. (©1982 Melvin L. Prueitt)

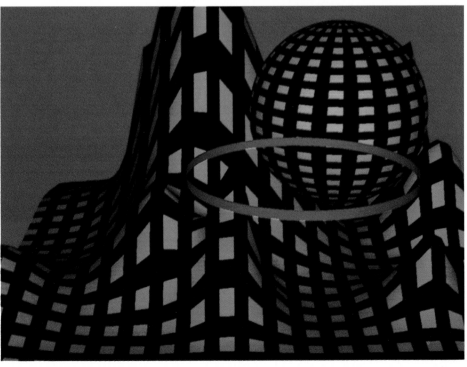

Picture 133 (Overleaf) "Rainbow Valley." The stripes in the rainbow actually consist of bent tubes. (©1982 Melvin L. Prueitt)

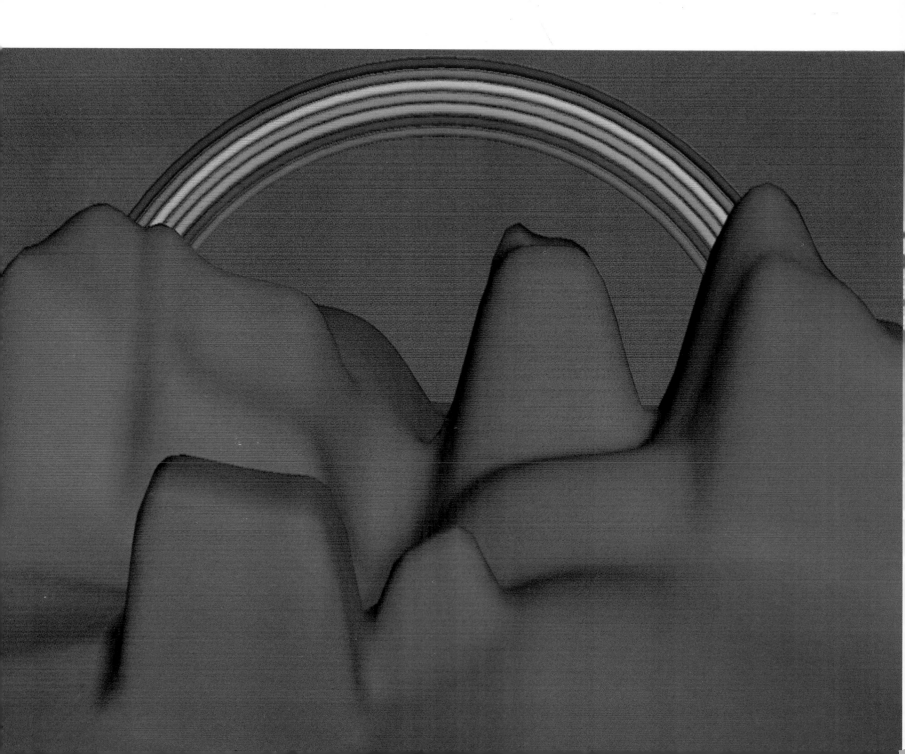

COMPUTER CAVERNS

It is a lot of work to write a program for designing a cave, but once the program is written, it can turn out innumerable caves, each with a different design, at the rate of one every few seconds. Of course, the process is more interesting if parameters are varied occasionally. Pictures 134 through 140 were produced by a program that used the CAMERA program for drawing the picture. Since CAMERA can handle only single-valued surfaces, it was called upon to make the bottom half and then the top. The stalactites were formed in the roof of the cave with exponential functions. Matching stalagmites were arranged on the floor, some of which were covered by water. The dark hole at the back, leading into unexplored regions, adds a bit of mystery to the scenes.

Picture 139 represents an ice cave. It is a single frame from a movie sequence in which the viewer is taken past the columns on a swerving journey through the cavern. During the trip, one can almost feel the icy draft of the cave's breath and hear the dripping water.

The light source was moved toward the rear in Picture 140, resulting in a strange glow surrounding the formations. A different program was used to draw the spiderwebby appearance of Picture 141.

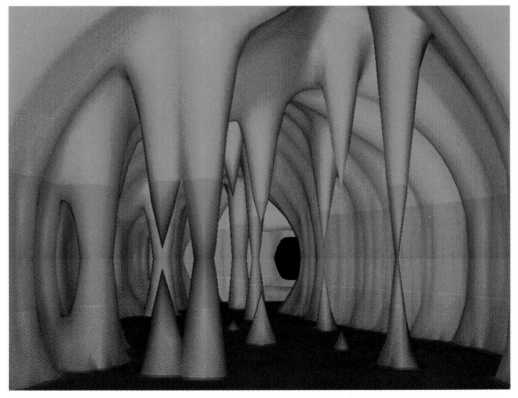

Picture 134 "Green Cavern." The CAMERA program produced this picture by drawing the bottom half and then drawing the top half. (©1981 Melvin L. Prueitt)

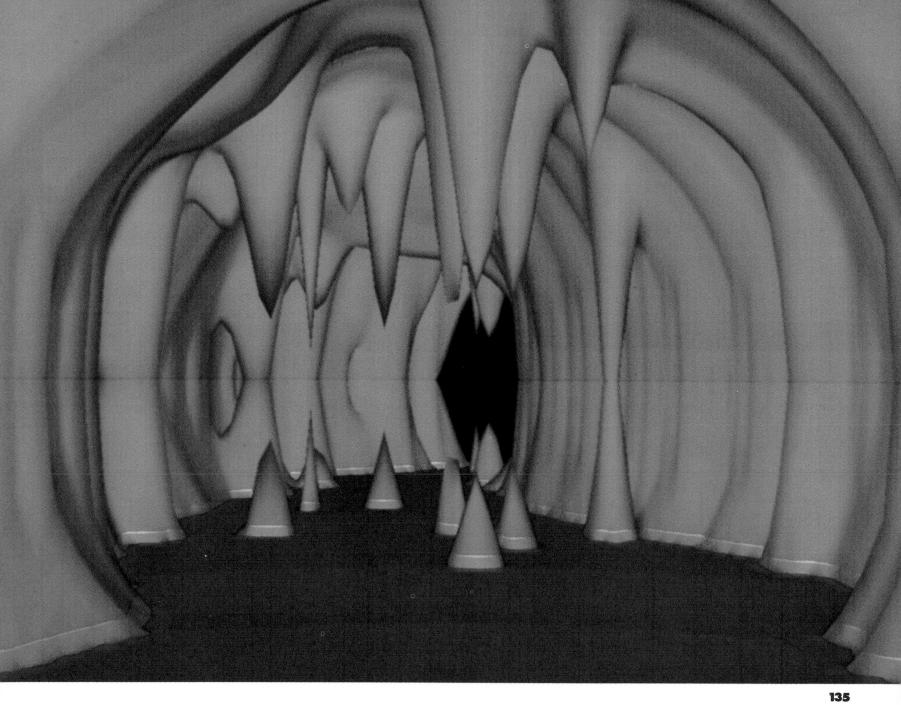

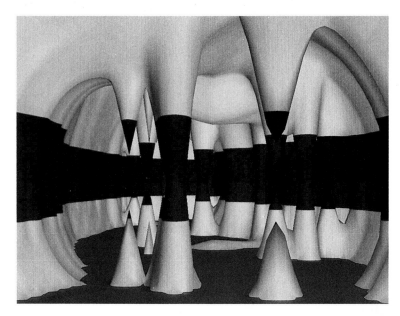

Picture 136 "Echo Cave." (©1981 Melvin L. Prueitt)

Picture 137 "Column Room." Several cave pictures are shown in this section to show the wide variety of designs that are possible with a single computer program. (©1982 Melvin L. Prueitt)

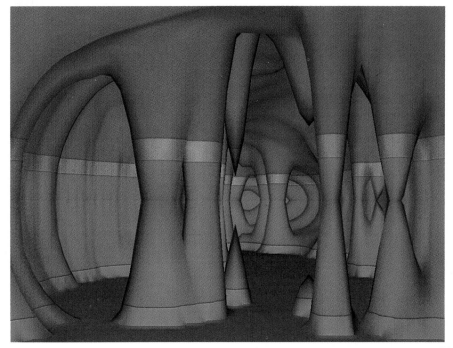

Picture 135 (Opposite page) "Mystery Cave." The title derives from the fact that we wonder what lies beyond the dark doorway. (©1981 Melvin L. Prueitt)

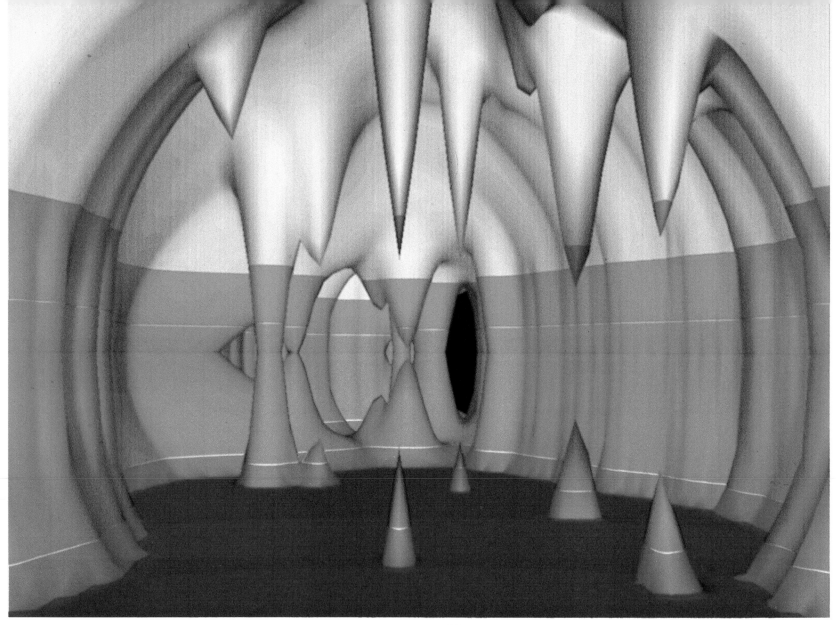

Picture 138 "Bright Cavern." The computer program was designed to cause the stalactites to line up with their corresponding stalagmites. You may note that some stalactites have no stalagmites directly below them. That is because some of the stalagmites are under water. (©1982 Melvin L. Prueitt)

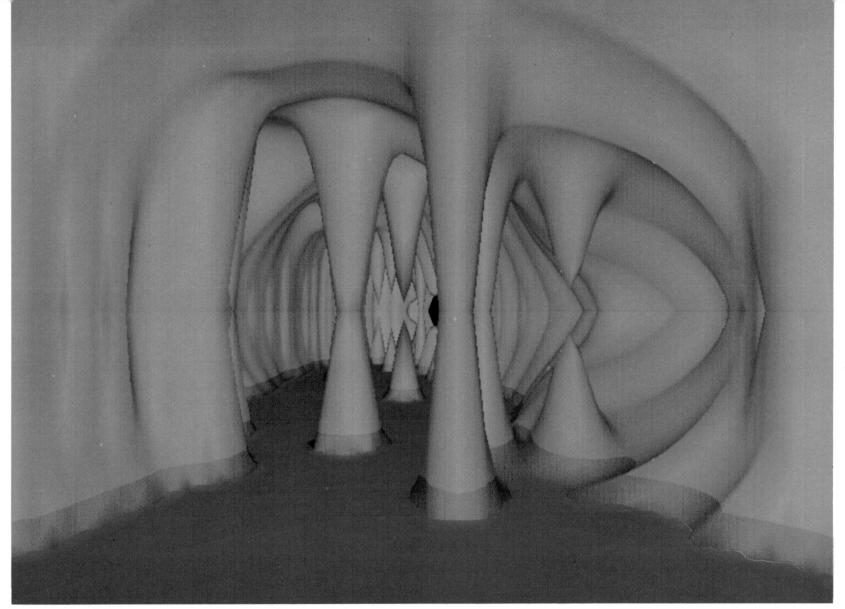

Picture 139 "Ice Cave." Coloring the walls cyan simulates ice quite well. (©1982 Melvin L. Prueitt)

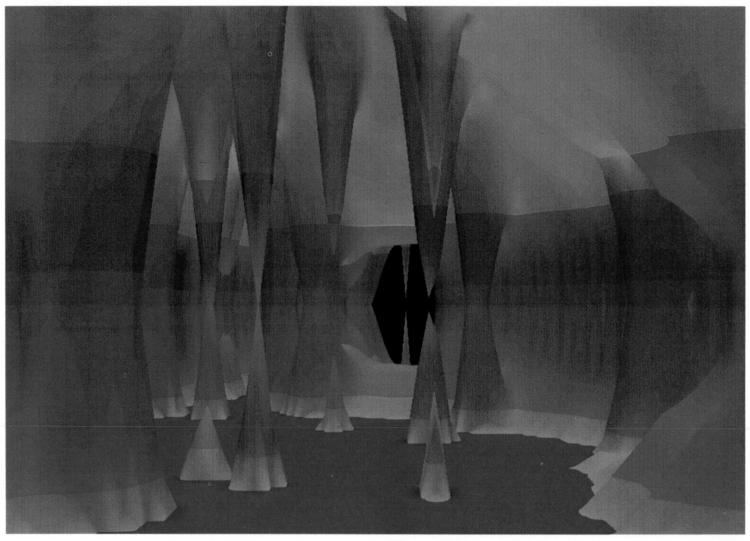

Picture 140 "Fantasy Cave." When the light source is moved toward the rear of the cave, the lighting effects become strange. (©1981 Melvin L. Prueitt)

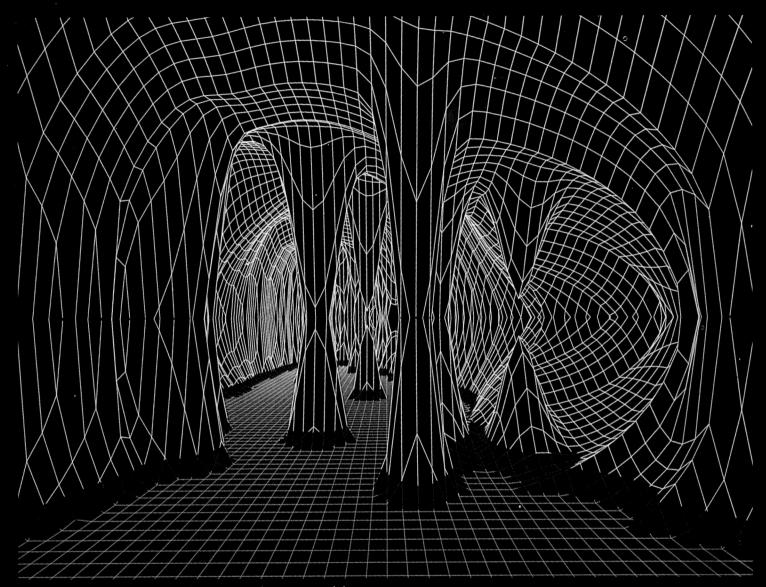

Picture 141 "Webb Cave." The program that generated the other pictures in this section also generated this one, but a different plotting subroutine was used. (©1982 Melvin L. Prueitt)

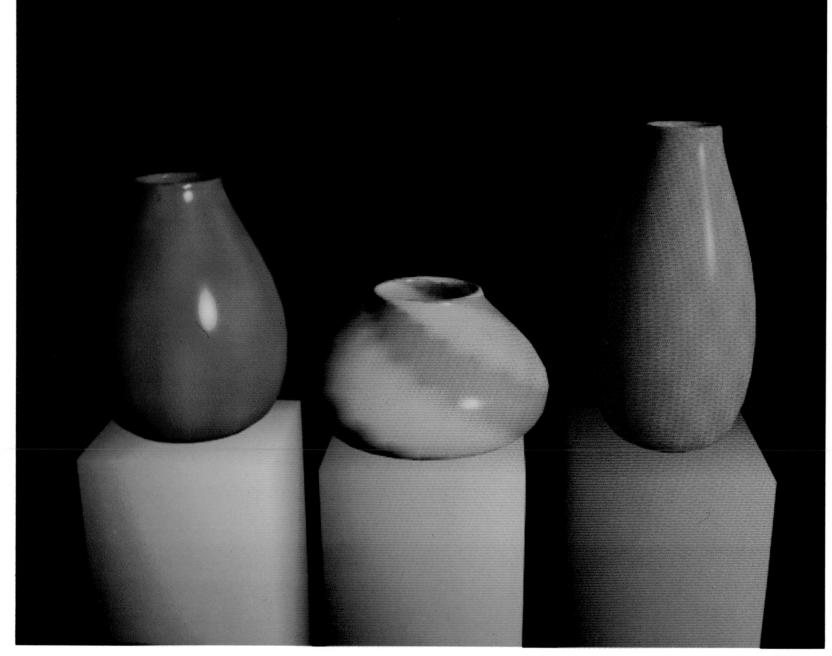

STILL LIFES

Michael Collery, at Cranston/Csuri Productions, has produced some fine examples of computer still lifes. Picture 142 shows glossy reflection and texturing of the surface. Transparency and reflection are beautifully done in Picture 143. We can see how effective transparency and specular reflection of the light sources can be in Picture 144 as we wonder if the shiny objects are glass, colored soap bubbles, or just computer fantasies. A different mood is achieved in Picture 145 by Harold Hedelman.

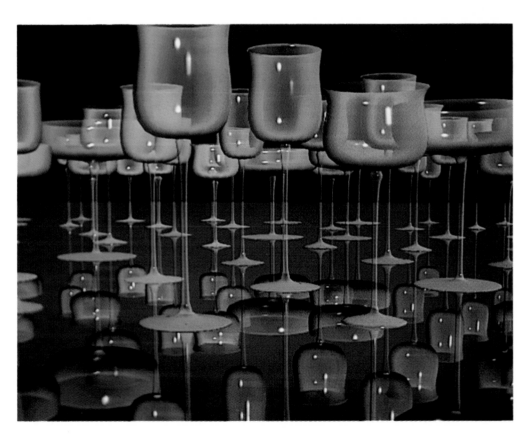

Picture 142 (Opposite page) This picture is a good example of surface texturing. The vases exhibit diffuse and specular reflection. (Image composed and created by Michael Collery; produced by Cranston/Csuri Productions; display software: Franklin Crow; display hardware: Marc Howard; data generation software: Wayne Carlson; software support: Julian Gomez, Hsuen-Chung Ho, and Robert Marshall)

Picture 143 This is an interesting study in reflection and transparency. (Michael Collery, Cranston/Csuri Productions; see Picture 142 for complete credits)

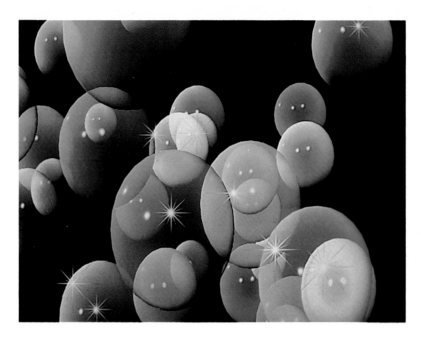

Picture 144 Not only do these bubbles have specular reflection but they have "sparkle." (Michael Collery, Cranston/Csuri Productions; see Picture 142 for complete credits)

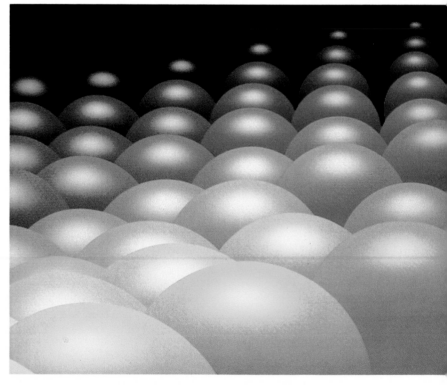

Picture 145 Harold Hedelman, Cornell University, discovered a nice arrangement for spheres. (©1982 Harold Hedelman)

Picture 146 "Cubes." Some simple geometries can be made exquisitely beautiful with appropriate reflection. Alan Barr of Raster Technologies, Inc. (North Billerica, Massachusetts) did that and added shadows.

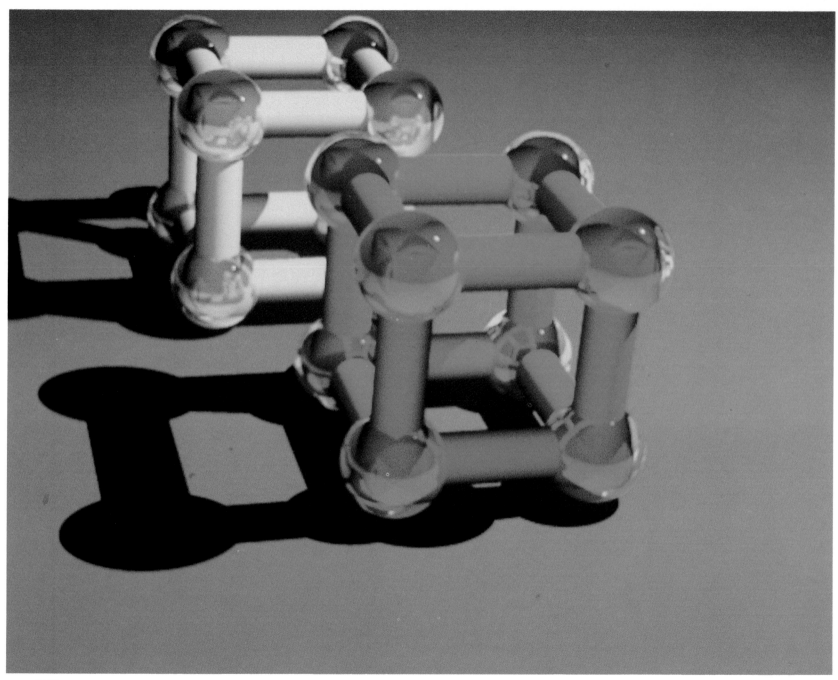

Reflection is taken to a delightful culmination by Alan Barr of Raster Technologies in Picture 146, where we can see the distorted reflected images of nearby objects in the spherical corners. Picture 147, produced by David Weimer and Turner Whitted at Bell Labs, demonstrates a computer simulation of fog.

Picture 147 "Foggy Chessmen." Adding fog to a scene is a sophisticated technique. (©1981 David Weimer and Turner Whitted, Bell Laboratories)

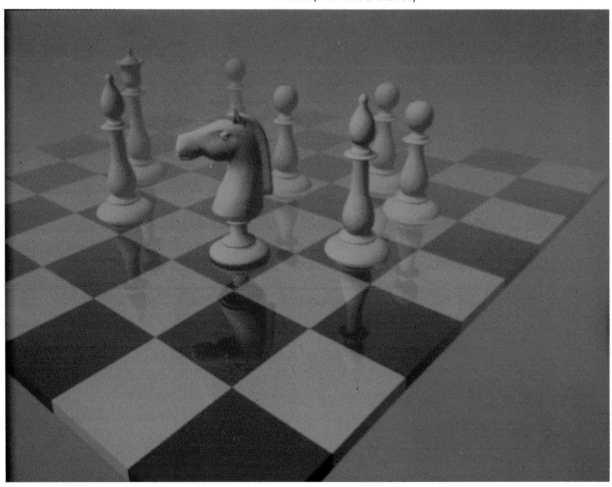

Picture 148, by C. Robert Hoffman, III, and Alan Greene, brings us not only interesting texturing on the walls but incongruous window scenes of Washington and Moscow.

Excellent detail and intriguing composition form the image in Picture 149, produced at Information International, Inc. Here we see computer-calculated shading, shadows, and reflection from two light sources. Can you tell where the light sources are?

Picture 148 "Great Northwest Talent." (C. Robert Hoffman, III, and Alan Greene, Digital Effects, Inc.)

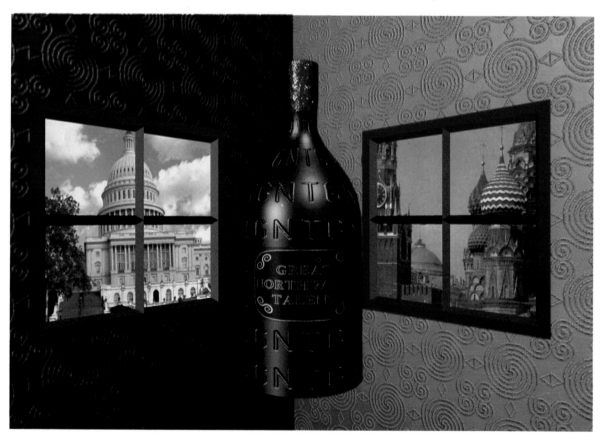

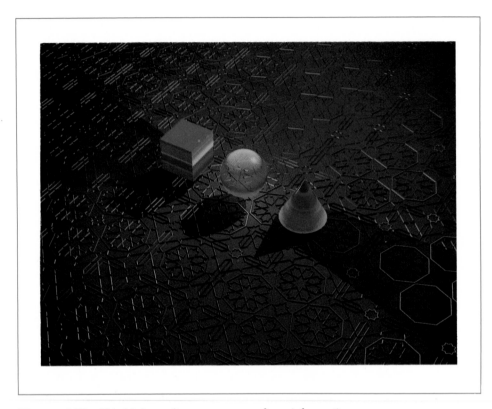

Picture 149 This high-quality scene comes from Information
International, Inc. (Art directors: Richard Taylor, Art Durinski, and
Larry Malone; technical director: Craig Reynolds) (©1981
Information International; all rights reserved)

COMPUTER SCULPTURES

Each computer artist contributes a different type of visual to the computer art field. Mike Marshall, however, is not limited to any one style, as can be seen from Pictures 150, 151, and other pictures in this book. Contrast these with Picture 152. The ability of computer programs to remove hidden surfaces and thus make objects look solid and opaque makes it possible to produce images of nonexistent sculptures. Pictures 153 through 162 illustrate some of the possibilities of three-dimensional geometries carved out of space by computers.

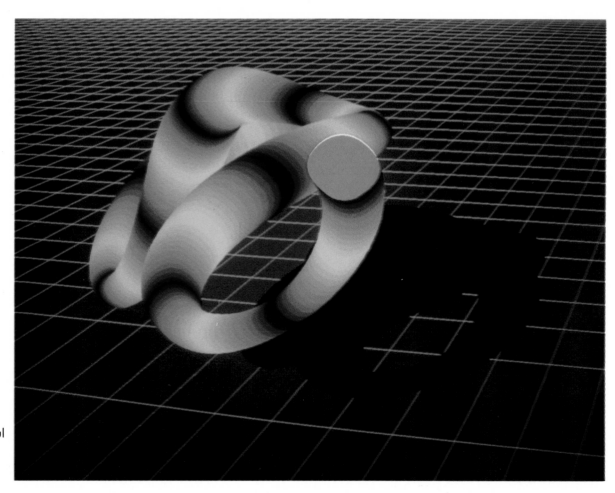

Picture 150 "Coil." By careful use of colors, Mike Marshall makes portions of his coil glow. (©1981 Mike Marshall)

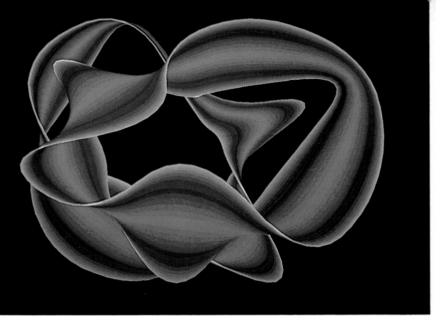

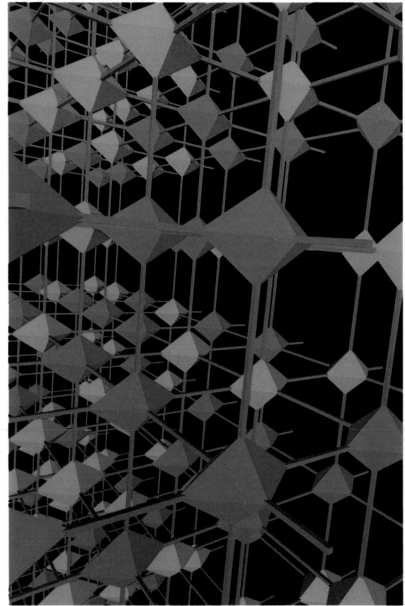

Picture 151 "Entwined." If you follow the outlines carefully, you will see that there are two separate ribbons here. (©1981 Mike Marshall)

Picture 152 "Broadcast Management Engineering 1981." The connecting links serve to determine the relative positions of the octahedra and accentuate the feeling of depth. (By Don Leich, Digital Effects, Inc.)

Picture 153 (Opposite page) "Spacecraft from Delta 5." Given an "impossible" geometry, the computer asks no questions and makes no excuses, but simply produces the picture if it has a proper program. (©1982 Melvin L. Prueitt)

152

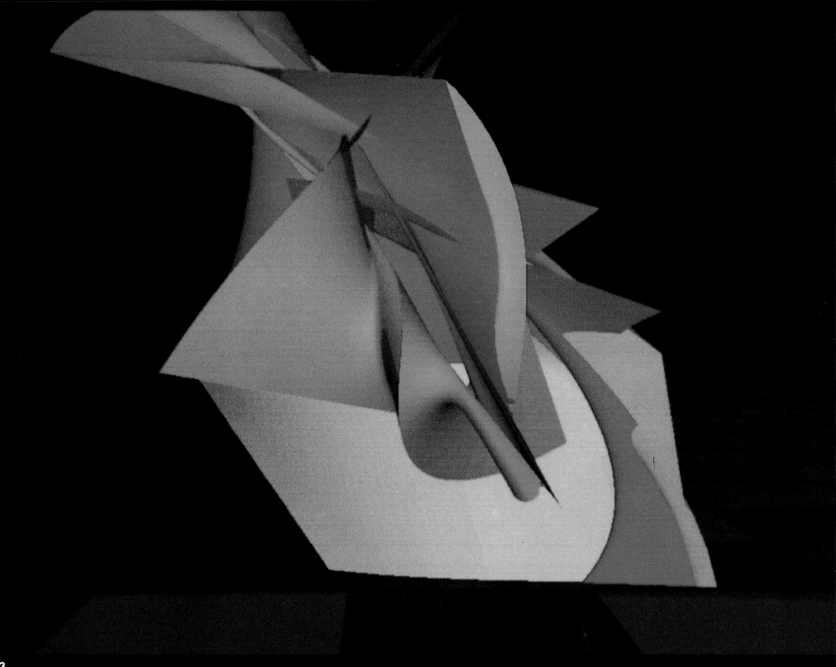

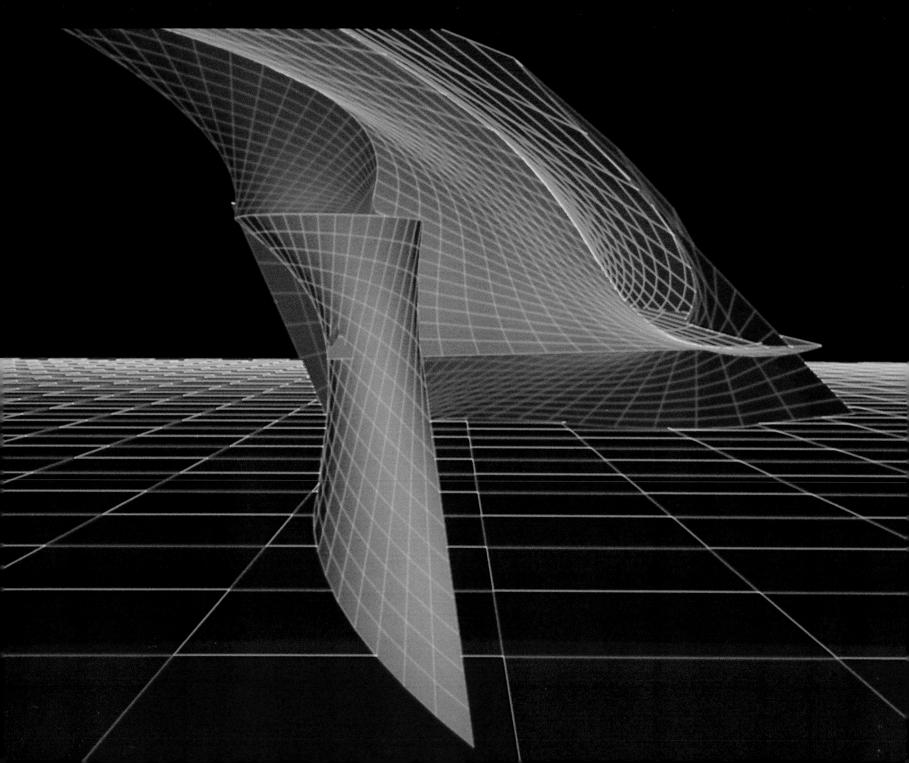

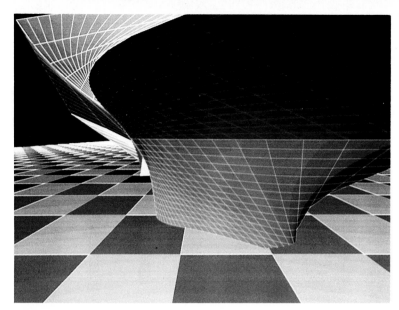

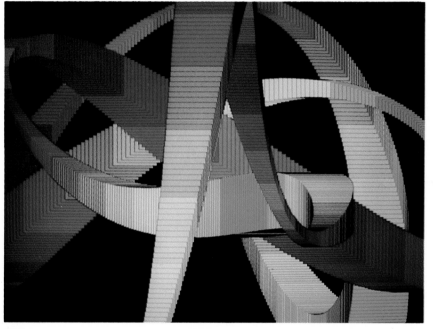

Picture 154 (Opposite page) "Gateway to Time." This image shows both shaded surfaces and the defining mesh lines. Coordinates are defined at the intersections of the mesh, thus defining the surface. (©1982 Melvin L. Prueitt)

Picture 155 (Above) "Windbreak." (©1982 Melvin L. Prueitt)

Picture 156 "Serpentine." If you follow these beams, can you determine how many beams are involved? (©1981 Mike Marshall)

156

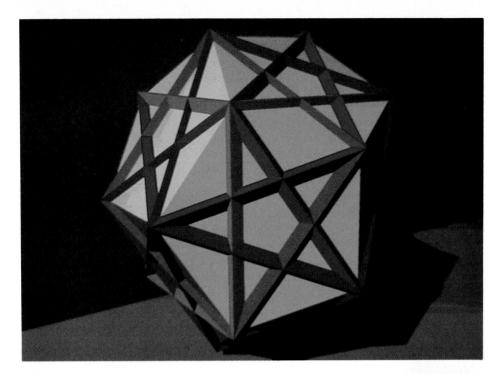

Picture 157 "Intersection of Five Cubes and One Dodecahedron." This picture is intriguing because of the lighting as well as the composition. (Professor Ronald Resch, Boston University; software credit: SynthaVision)

Picture 158 "Down the Drain." (©1983 Melvin L. Prueitt)

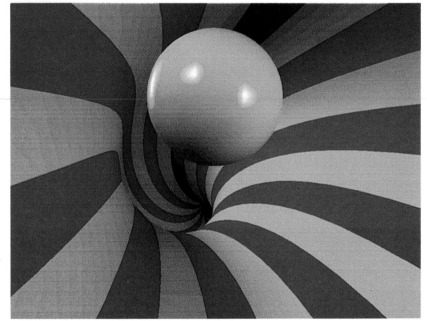

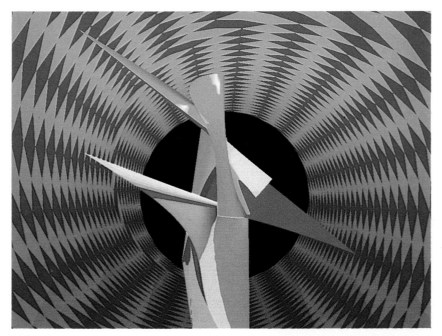

159

Picture 159 "Semaphore at Star Gate." Here we see a sculptured design in the center with the backdrop of a tunnel. (©1982 Melvin L. Prueitt)

Picture 160 "Transporter." (©1983 Melvin L. Prueitt)

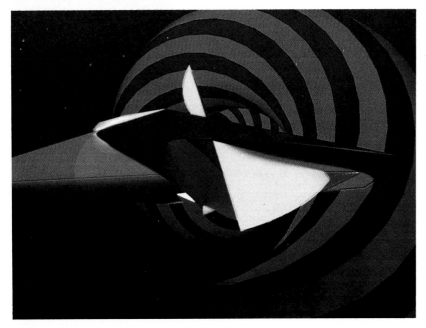

160

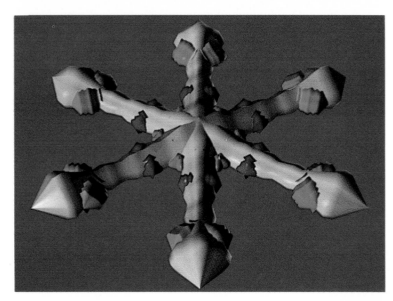

Picture 161 "Celestial Snowflake."
(©1983 Melvin L. Prueitt)

Picture 162 "Rounding the Bend." As a backdrop, tunnels can be straight, bent, spiralled, and distorted. In this case, it is bent to the left. The checkered pattern helps to define position and depth. The sphere seems to be moving through the tunnel. (©1983 Melvin L. Prueitt)

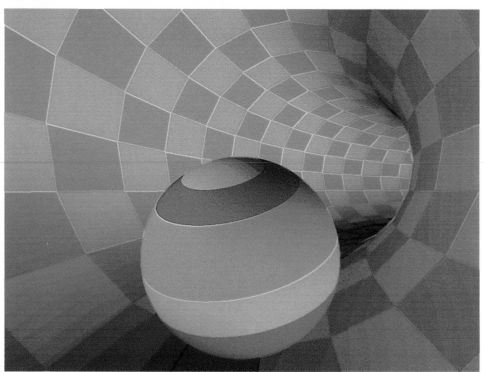

Picture 163 provides a variation on the theme by making parts of some surfaces totally transparent (that is, invisible). Mike Marshall's "Swirl" (Picture 164) seems to be unanchored in blackness, while Harold Hedelman's creation (Picture 165) is well cushioned from outer darkness. Duane M. Palyka relied on interesting texturing to define the surfaces of his sculptures in Picture 166.

Picture 163 "Vanishing Essence." The reason that these plates are effective in producing a pleasant picture is that our visual systems are able to connect them together into unified curving surfaces. (©1983 Melvin L. Prueitt)

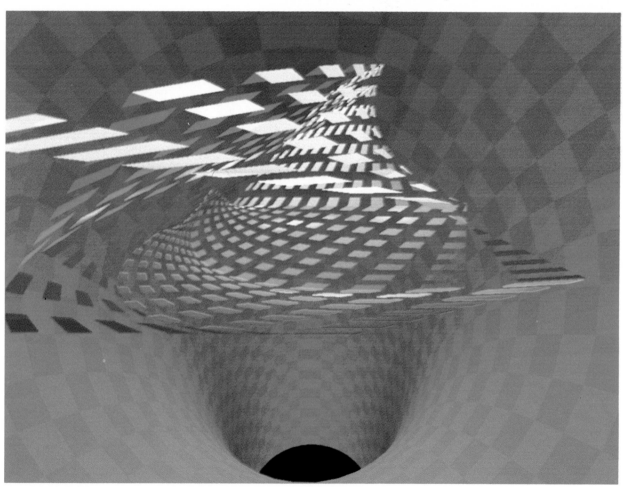

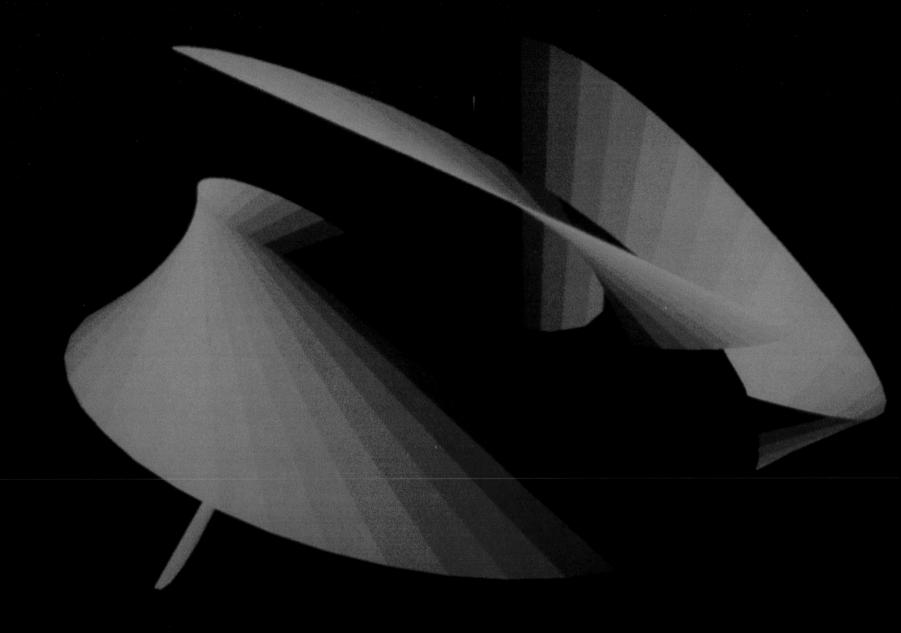

Picture 164. "Swirl." Deep shadows accentuate this design by Mike Marshall. (©1981 Mike Marshall)

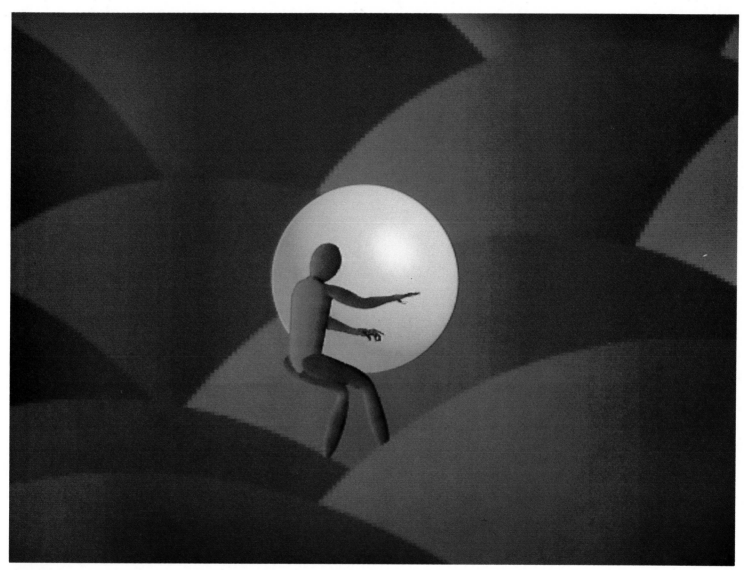

Picture 165 The bright sphere and the humanoid in the center bring this picture to life. (©1982 Harold Hedelman, Cornell University)

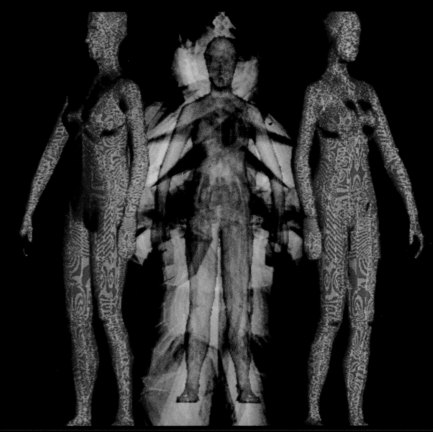

Picture 166 "Blue Figure with Orange Guards." Duane M.
Palyka adds extra interest to his sculptures by intricate texturing.
(Duane M. Palyka, NYIT Computer Graphics Lab)

OUTER SPACE

We wonder what is out there past the orbits of Neptune and Pluto; we dream of shining worlds and unaccountable apparitions roving across the Milky Way. The pictures in this section are scenes that we imagine we might encounter on an interstellar voyage. Picture 167 shows intuitively possible worlds of some far region of space, while Picture 168 contains signs that intelligent beings must live in the neighborhood.

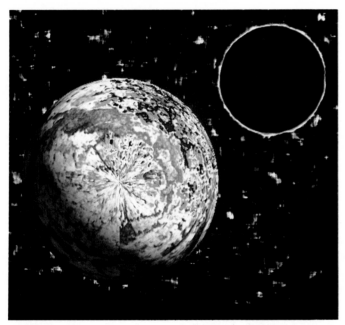

Picture 167 "Galaxy Far Far Away." LANDSAT imagery is mapped to the surface of this sphere. (Reid Judd, Gould, Inc., DeAnza Image and Graphics Division)

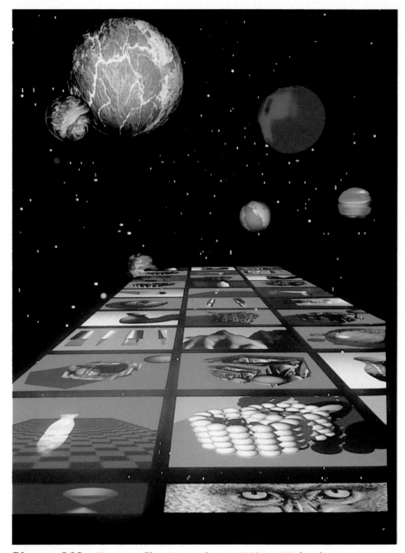

Picture 168 "Images Floating in Space." Here Michael Potmesil generated colorful planets and added some curious planes containing pictures. (Produced at the Image Processing Laboratory, Rensselaer Polytechnic Institute)

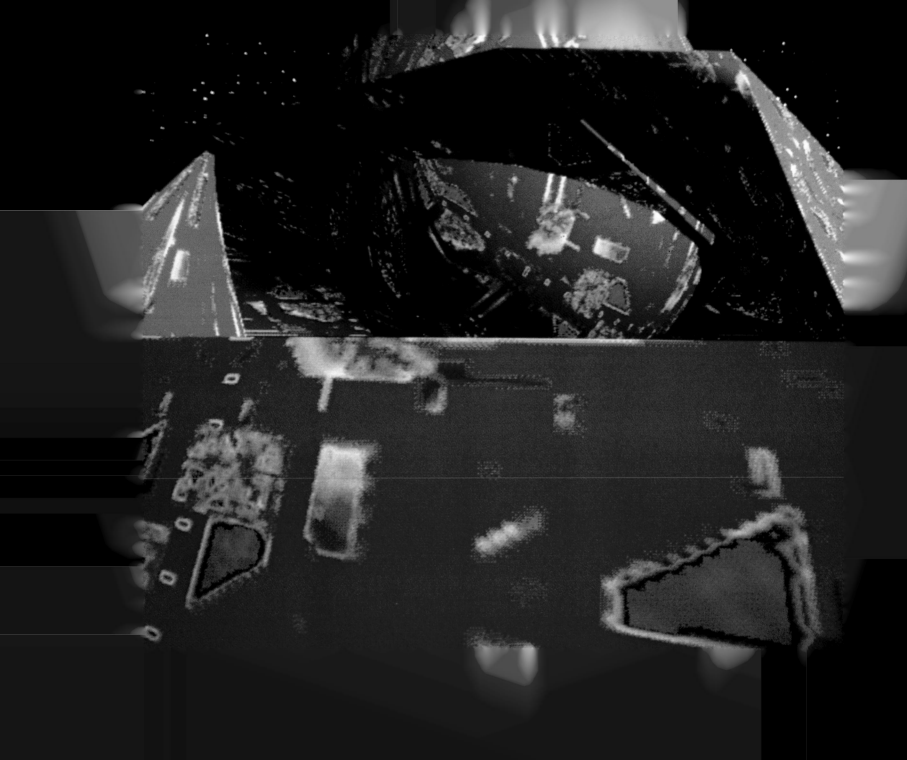

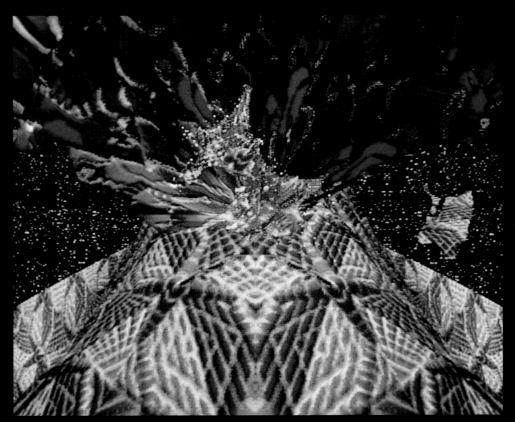

Picture 169 (Opposite page) "North Temple." We see massive structures that appear unearthly in origin. By providing a low viewpoint and strong perspective, David Em makes the objects appear large, rather than like models. (©1981 David Em)

Picture 170 (Above) "Volkan." For a volcano, this picture is rather fanciful but does have some interesting detail. (©1982 David Em)

David Em shows us some alien architecture in his "North Temple" as it might appear on an inhabited planet (Picture 169). The volcanoes on such a planet might be strange to our eyes, but it is difficult to believe that they could be as fanciful as that shown in Picture 170.

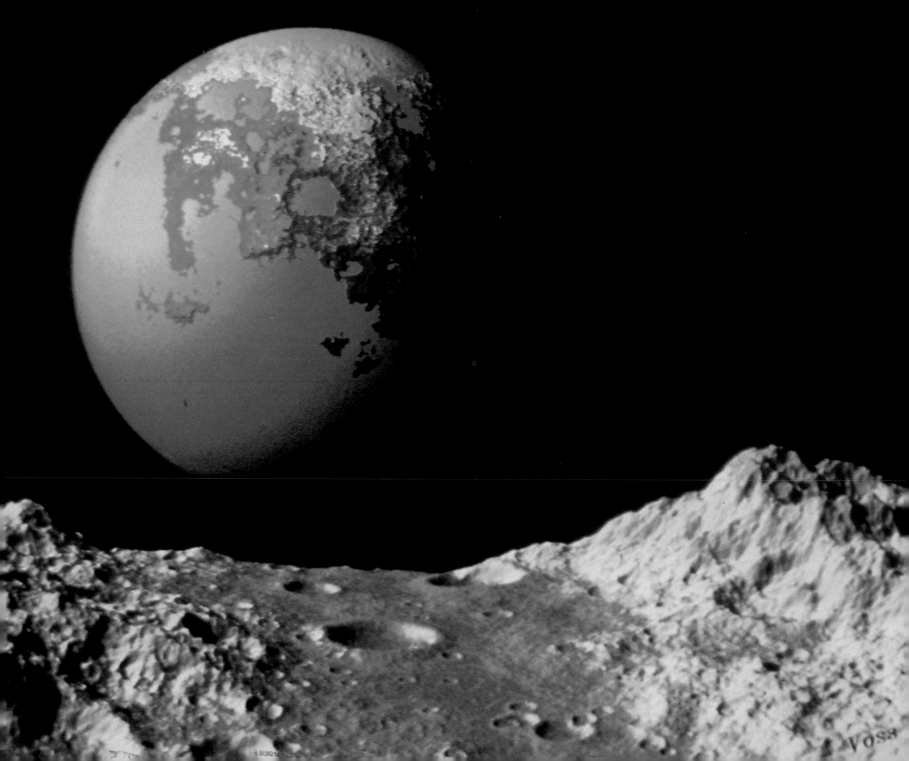

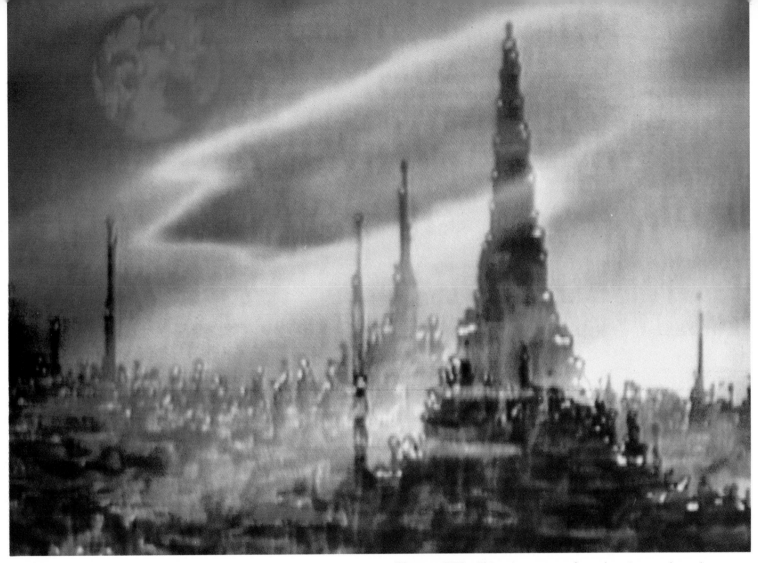

Picture 172 This misty scene of another time and another place is a freeze frame from VOYAGE, produced by Dean Winkler, Tom DeWitt, and Vibeke Sorensen at Telectronics. It was made with a Quantel Frame Store and a Grass Valley Switcher. (©1981 WTV)

Picture 171 (Opposite page) Richard Voss put fractal geometry to good use in producing this earthlike planet as viewed from a moon. The detail is outstanding, and the scene could almost be taken for real. (©1982 Benoit B. Mandelbrot, IBM Thomas J. Watson Rearch Center)

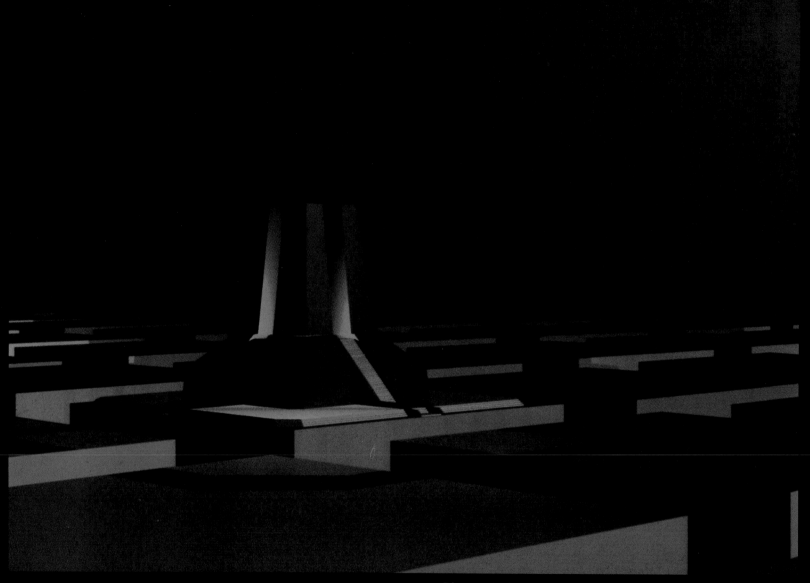

Picture 173 "The Cray Tower." Are there cities that look like this in some distant part of the Milky Way galaxy or perhaps in some other galaxy? Are the temples made of stone, titanium, or composites? Pictures like these give rise to questions that fade without resolution. (Digital Scene Simulation by Digital Productions, Los Angeles; ©1983; all rights reserved)

A much more believable scene is given by Richard Voss in the construction of a moon (foreground) and a planet with the use of fractal geometry (Picture 171). The planet in the black sky is not the earth, as one can quickly surmise by studying the continents. The planet looks green and inviting, and if we ventured in our spaceship from the foreground moon to the planet, we might find a city like that in Picture 172. A totally different city skyline appears in Picture 173. Picture 174 seems to depict a lonely uninhabited world.

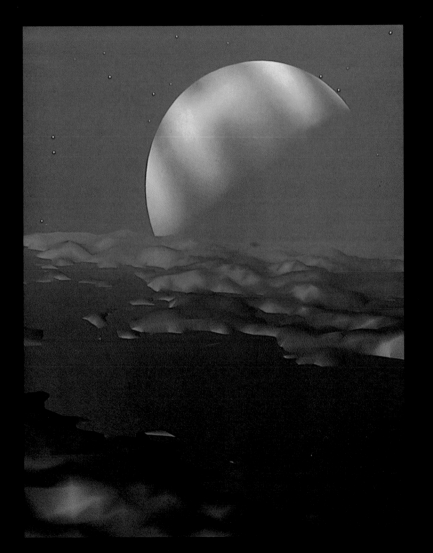

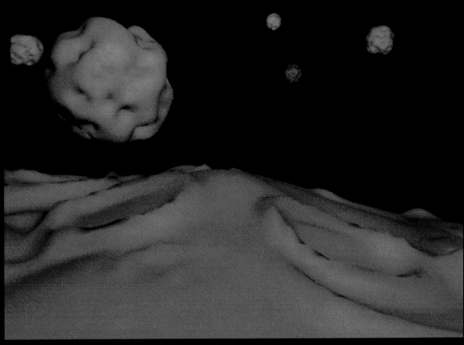

Picture 174 (Left) "Planet and Terrain." The planet in the background is rendered in soft colors blended together in a rainbow pattern to represent clouds. The terrain is modeled with a fractal package that produces random surface textures. (Digital Scene Simulation by Digital Productions, Los Angeles; ©1983; all rights reserved)

Picture 175 (Above) "Asteroids." This scene paints a grim picture of reality beyond the comforting blanket of the earth's atmosphere. There, merciless forces have disfigured and destroyed countless bodies that roll in silent darkness this side of Jupiter. (©1982 Melvin L. Prueitt)

Picture 175 gives a somewhat realistic picture of asteroids, the reefs of space travel. Picture 176 is a surreal view of a red sun, and Pictures 177(*a*) and 177(*b*) are symbolic pictures of a sun and a moon on a star background.

In the spiral of Picture 178, not only can we see stars that form the spiral, but upon close examination, we discover nearby dark hunks of rock hurtling to some unknown fate.

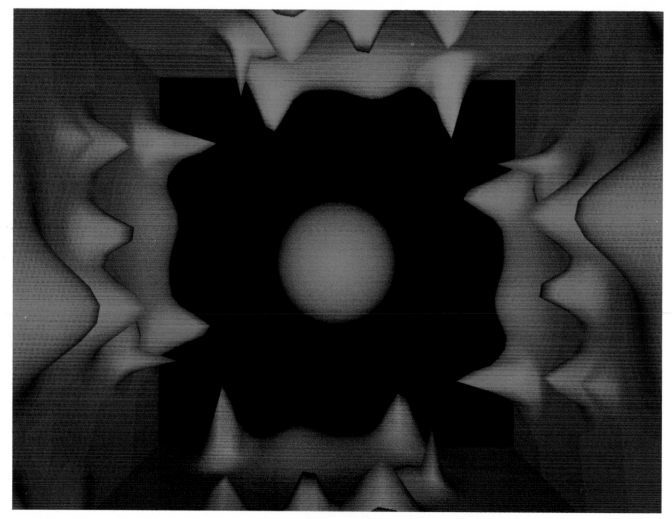

Picture 176 "Red Sun." (©1982 Melvin L. Prueitt)

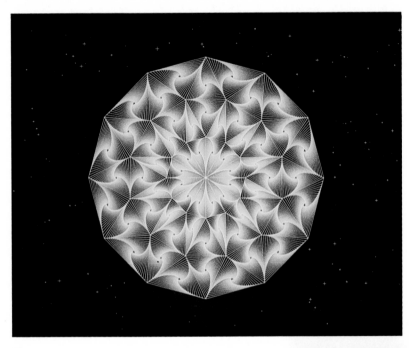

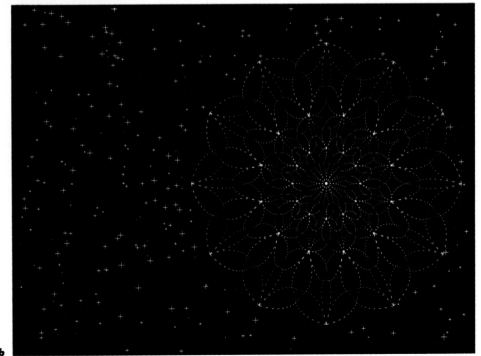

Picture 177 (*a*) "Symbolic Sun"; (*b*) "Symbolic Moon."
(©1982 Melvin L. Prueitt)

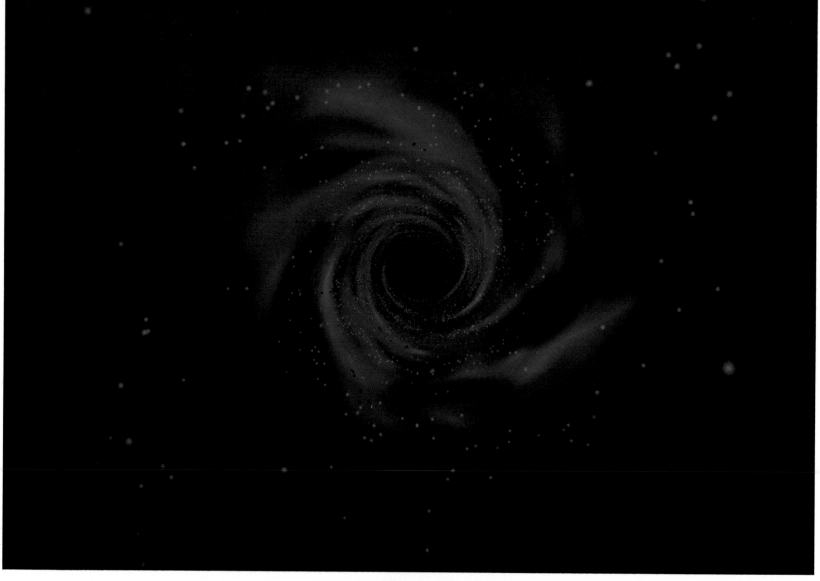

Picture 178 "Black Hole." Human beings may never see what a black hole looks like close up, but we can imagine. Here the gravitational fields are so intense that planets are torn apart; we see the debris of vanquished worlds falling into the nightmare of the cosmos. (Digitizing and design: Art Durinski and Gabriel Normandy; technical director: Gary Demos; ©1981 by Information International, Inc.; all rights reserved)

LIGHTING EFFECTS

Without light, we cannot see at all. Light intensities and light source positions have a profound effect on the appearance and mood of a scene. Ned Greene, at New York Institute of Technology, and Nelson Max, at Lawrence Livermore National Laboratory, demonstrate the effect of soft lighting with the scenes in Pictures 179 and 180, respectively. It is interesting to compare pictures of a scene with different lighting. Pictures 181 and 182 are identical scenes with different lighting. The first has a single white light source, while the latter has a red light source on the right and a green source at the left.

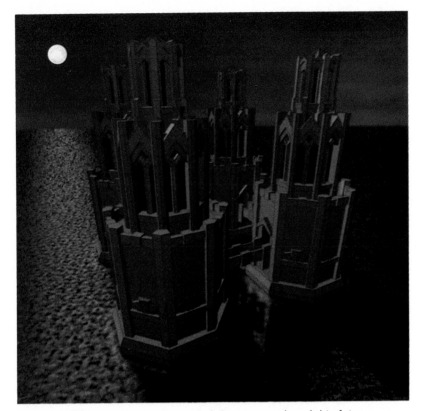

Picture 179 "Night Castles." Ned Greene produced this fairy tale castle with excellent lighting effects and reflection.(©1982 NYIT Computer Graphics Lab.)

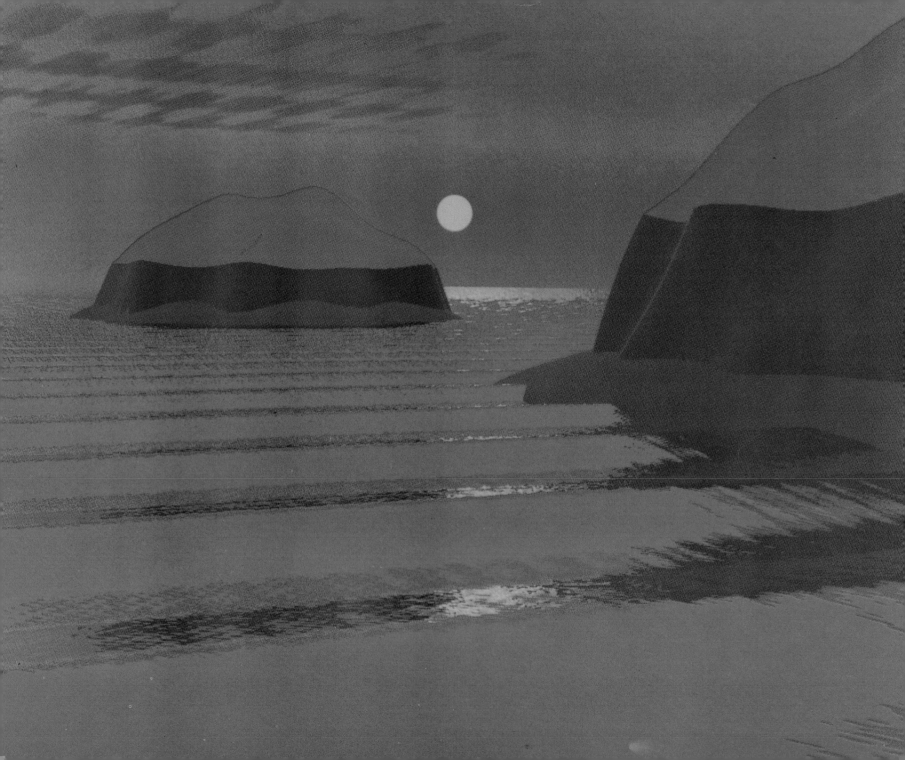

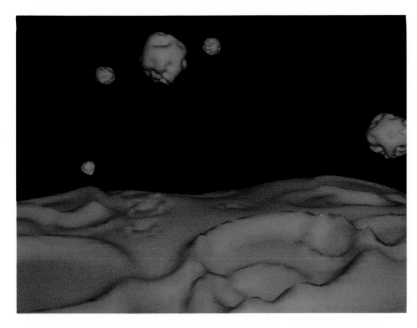

Picture 181 A single white light source at the viewer's position provides good illumination on these asteroids. (©1982 Melvin L. Prueitt)

Picture 180 (Opposite page) "Islands at Sunset." Reflection of the setting sun causes the water to look real. Nelson Max produced this picture with a ray-tracing and reflection algorithm on a Cray-1 computer and plotted it on a Dicomed D48 color film recorder. (©1981 Nelson L. Max, Lawrence Livermore National Laboratory)

Picture 182 This is the same scene as that of Picture 181, but the white light has been removed, and a green light now shines from the left while a red light shines from the right.(©1982 Melvin L. Prueitt)

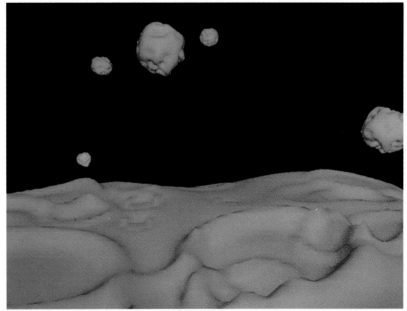

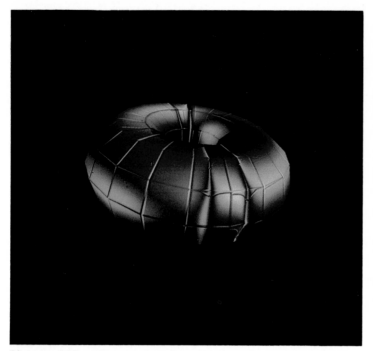

Picture 183 "Donut." C. Robert Hoffman, III, and Gene Miller designed this metallic toroid in space. Can you tell where the light sources are? (©1983 Digital Effects, Inc.)

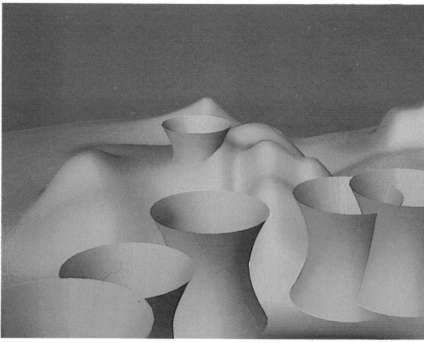

Picture 184 "Towers of Lyra." Green light emanates from the left and magenta light come from the right. (©1982 Melvin L. Prueitt)

C. Robert Hoffman, III, and Gene Miller used two colored light sources to produce metallic reflection in Picture 183. In Picture 184, all surfaces are white, but magenta light is coming from the right and green light is coming from the left. The same scene is not nearly so interesting with a single white light source. Pictures 185 through 187 have a green light on the left, a red light on the right, and a blue light at the viewer's position. Notice the subtle hues changing around the surfaces. Most of these pictures additionally have specular reflection on some surfaces. Compare these with Pictures 188 through 190, in which a single white light source is shining over the right shoulder of the viewer. In these pictures, ellipsoids (or "eggs") are effective in demonstrating the gradation of light over curved surfaces. Colored light sources make strange landscapes stranger and more interesting (Pictures 191 and 192).

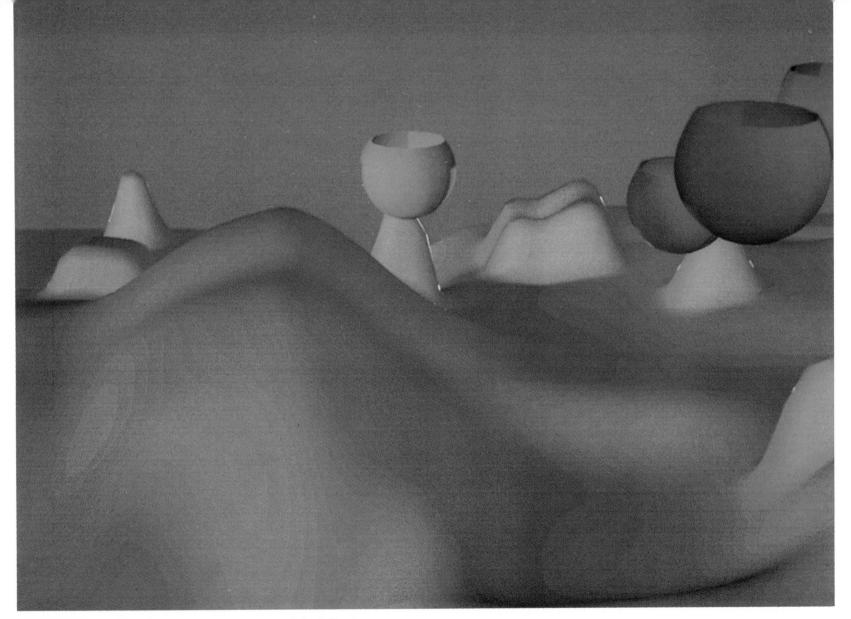

Picture 185 "Drifting Pottery." In this image and the following two pictures, green light comes from the left, red light comes from the right, and blue light comes from the viewpoint. (©1982 Melvin L. Prueitt)

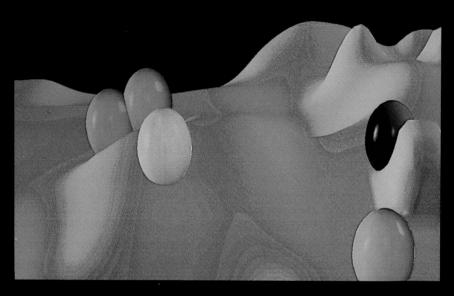

Picture 186 "Eggs of the Vegans." (©1982 Melvin L. Prueitt)

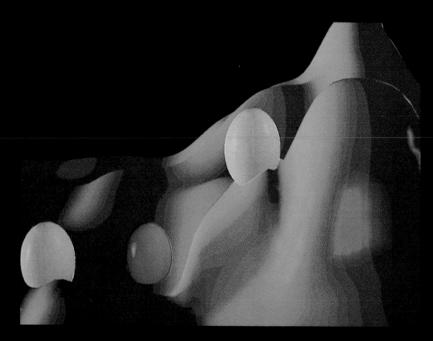

Picture 187 "Upland Nest." (©1982 Melvin L. Prueitt)

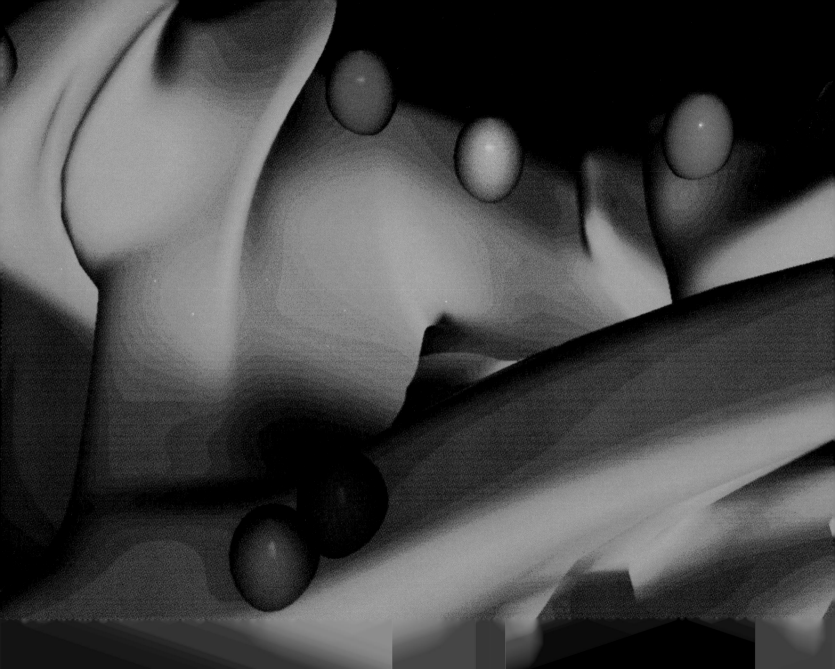

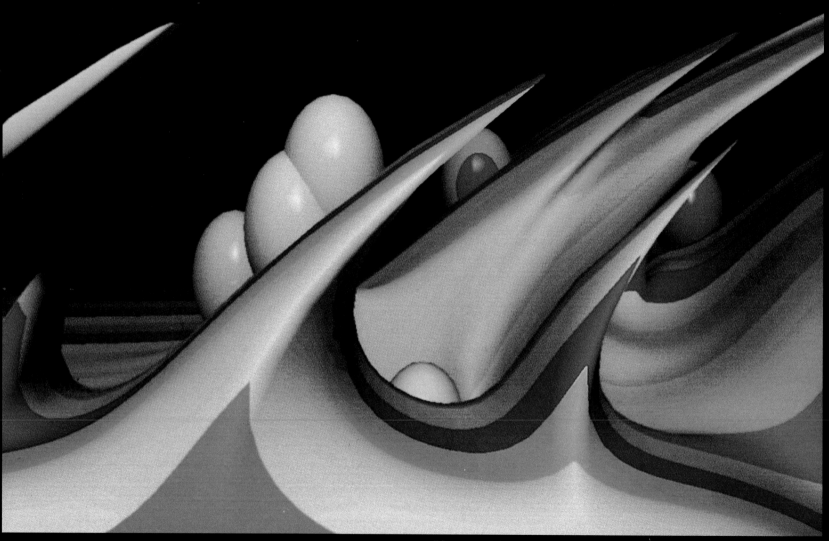

Picture 189 "Wind Sweep." Color stripes can produce interesting effects when the stripes follow the surface contours. Reducing light intensity as distance increases enhances the feeling of depth and highlights the foreground objects. (©1983 Melvin L. Prueitt)

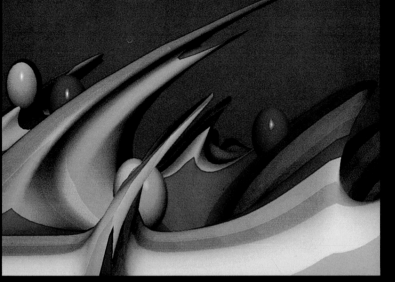

Roy Hall at Cornell University shows us the effect of a single light source shining on polished metals of different colors (Picture 193). Here we see shadows and multiple reflections of the light rays. Special treatment of the reflection make the surfaces look like metal rather than plastic.

Picture 194 was produced at Information International as a movie logo. There is a mathematical regularity in the waves, generated by the superposition of small waves on large waves. The light reflection is done well. The pyramid, as a source of spectrally dispersed light, gives the picture an "other world" appearance.

Picture 190 "Waves of Stone." (©1982 Melvin L. Prueitt)

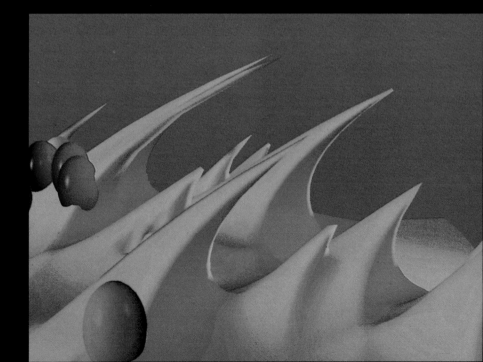

Picture 191 "Frozen Sand Dunes." (©1982 Melvin L. Prueitt)

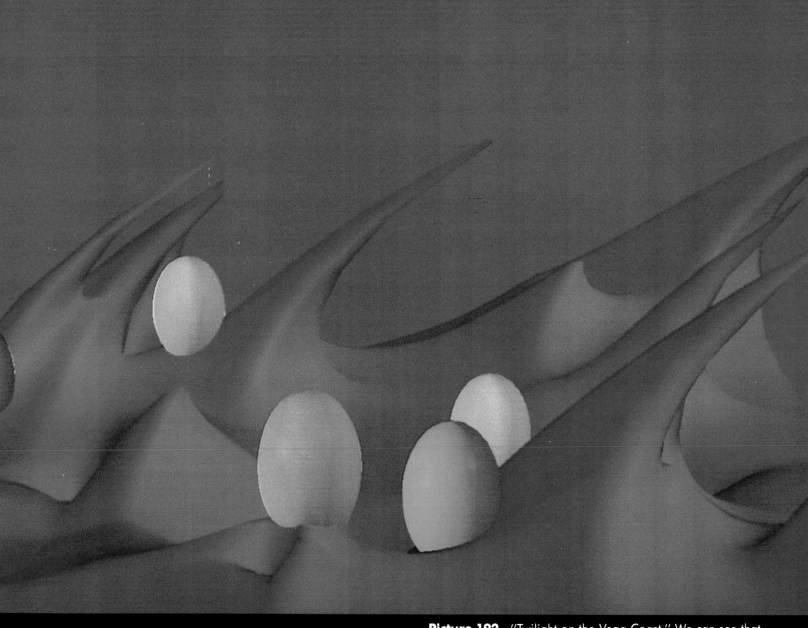

Picture 192 "Twilight on the Vega Coast." We can see that light sources can produced strange moods in a picture. (©1982 Melvin L. Prueitt)

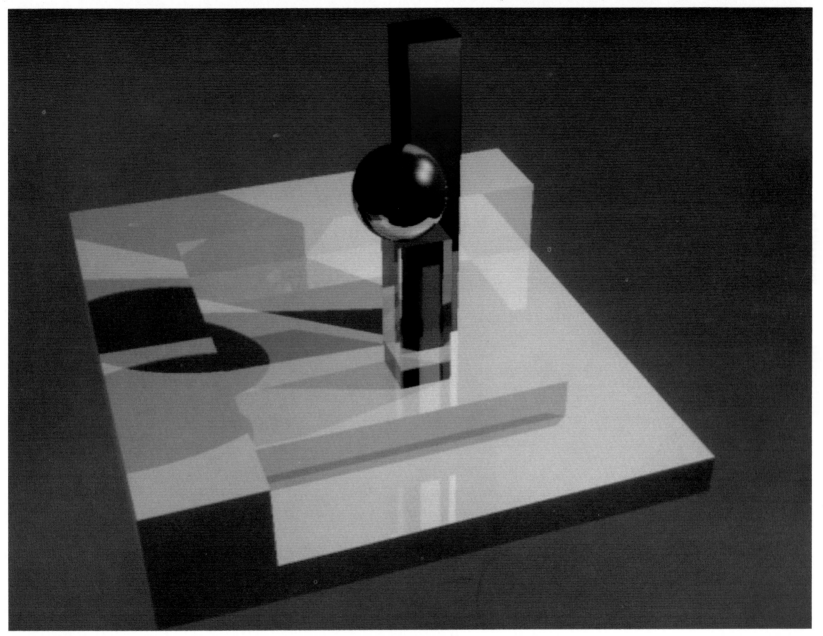

Picture 193 Not only is the light source important, but the manner of reflection must also be considered. Plastic reflects differently than polished metal. The computer program must be programmed to alter the color of the specularly reflected light for metals. (Roy Hall, Program of Computer Graphics, Cornell University)

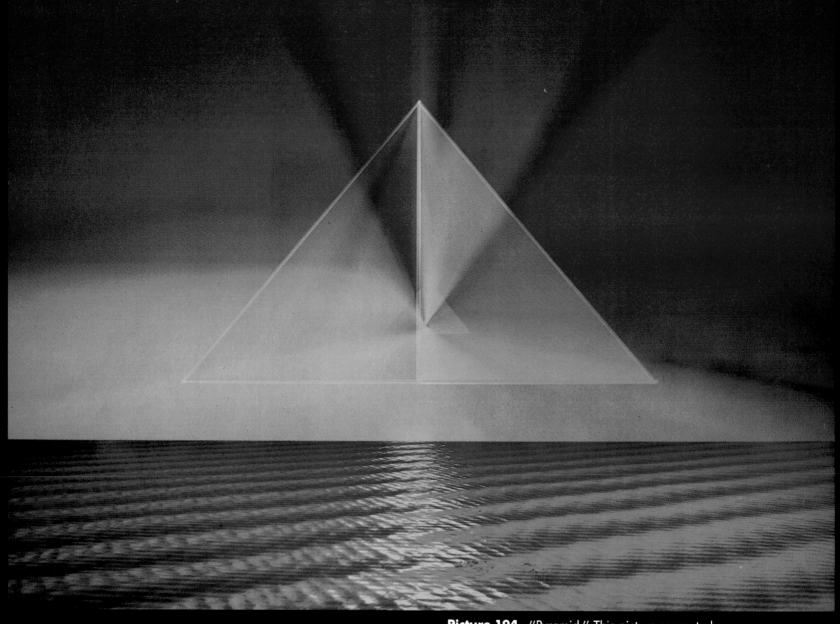

Picture 194 "Pyramid." This picture seems to have a multicolor light source at the center of the pyramid, but the light on the ocean comes from a different source. (Art directors: John Whitney, Jr., Joe Spencer, and Art Durinski; technical director: Gary Demos; ©1981 Information International, Inc.; all rights reserved)

ERRORS

Most people are ashamed of their errors and would prefer not to broadcast them. Computer programmers are no exception. Even though errors in computer graphics can produce visually startling results, the products usually end up in the wastepaper basket. Most of the pictures in this section are the consequence of human, not computer, error.

Picture 195, for example, was supposed to be a set of spheres in space, but a "bug" crept into the program. At another time, another bug cropped up in the same program, and Picture 196 was the result, a coven of alien eyes staring into space. The shading was working well, but the new bug caused the light intensity to be set at zero when it rose above a certain level. When *dimension* statements in FORTRAN programs were improperly specified, chaos reigned, as in Pictures 197 and 198. In the latter, normal shading turned into banding around the teardrops. An error in a shadowing algorithm caused the shadows to be misplaced in Figure 199. In Picture 200, I attempted to make a double-walled sphere, but the computer had other ideas. After correcting an error in the program, I got Picture 201: still wrong. On the third try, it worked, but of course the final picture does not belong in this section. Pictures 202 and 203 resulted from miscellaneous program errors. In Picture 204, the color of the landscape was not specified, so the computer obediently painted it black. Pictures 205 and 206 went awry because of hardware error—a plotter malfunctioned.

This selection represents only a small fraction of the erroneous results that are manufactured in the name of computer graphics. Perhaps there is some kind of a law that states that each new project must fill its quota of mistakes before worthwhile pictures are forthcoming.

Picture 195 "Oops." Errors can be interesting. But it is sometimes a lot of work to find the source of the error. (©1982 Melvin L. Prueitt)

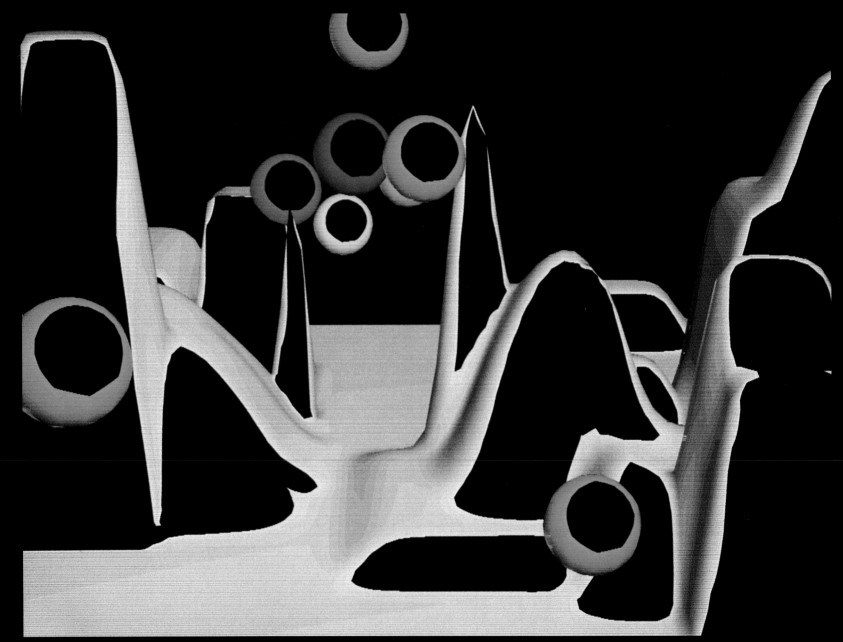

Picture 196 "Halloween on Neptune." (©1982 Melvin L. Prueitt)

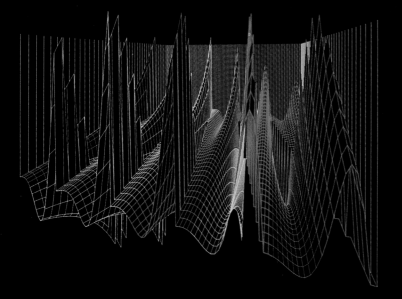

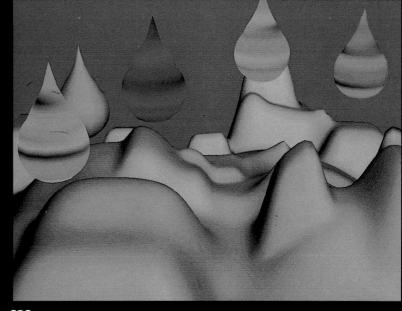

198

Picture 197 (Above) "Oh, No! What Did I Do Now?" This and the following picture resulted from an improper DIMENSION statement. (©1981 Melvin L. Prueitt)

Picture 198 "Acid Rain." (©1982 Melvin L. Prueitt)

Picture 199 "Look Ma, No Brains." Something went wrong during the development of a shadowing algorithm, and the computer did not know where to put the shadows. (©1982 Melvin L. Prueitt)

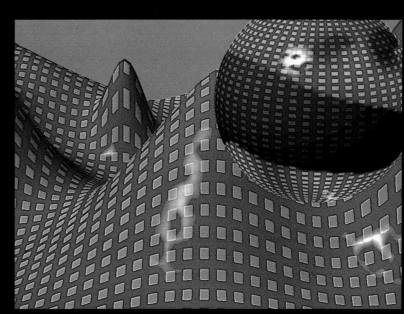

199

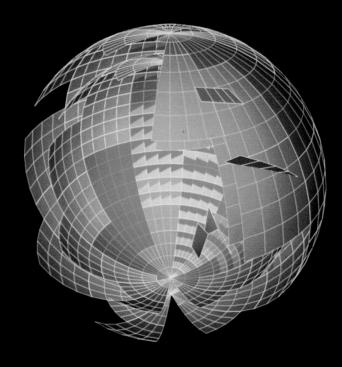

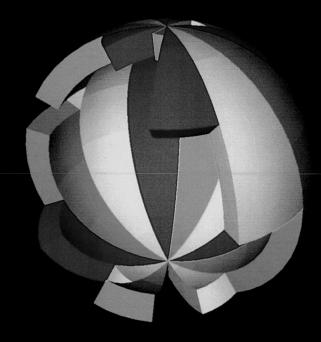

Picture 200 "Computer, Who Told You To Do That?" This was supposed to have been a double-walled sphere. The next picture is an improvement, but it is still not right. (© 1983 Melvin L. Pruiett)

Picture 201 "Where Is the Rest of It?" (©1983 Melvin L. Prueitt)

201

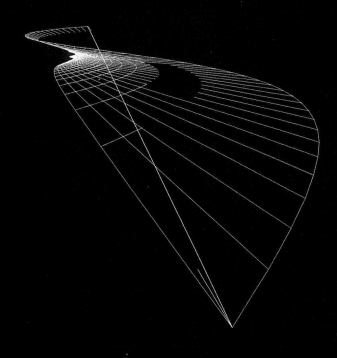

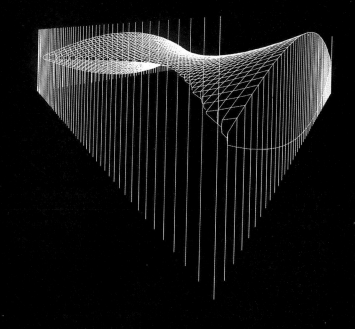

Picture 202 "Pothole in the Road." (©1970 Melvin L. Prueitt)

Picture 203 "Wing Structure for a Dodo Bird." (©1970 Melvin L. Prueitt)

203

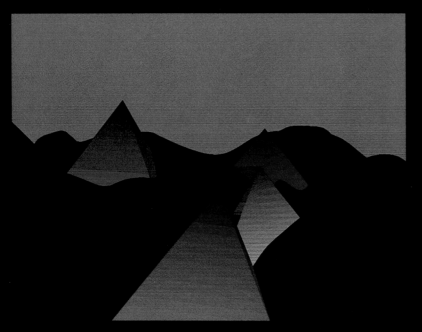

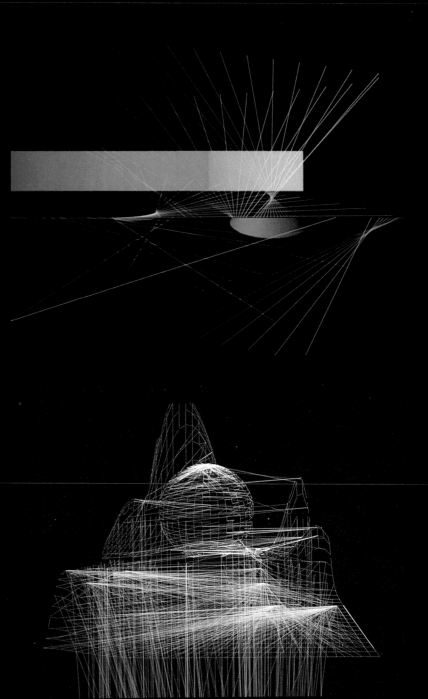

Picture 204 (Above) "Goof Number 7326.4." (©1982 Melvin L. Prueitt)

Picture 205 (Above right) "The Machine Did It." (©1982 Melvin L. Prueitt)

Picture 206 "Blown Fuse." (©1982 Melvin L. Prueitt)

HOME COMPUTERS

Although most people do not have access to expensive equipment, production of computer art is possible to a large segment of the population via home computers. Harry Vertelney and Lucia Grossberger provide us with some examples of home computer art in Pictures 207 and 208.

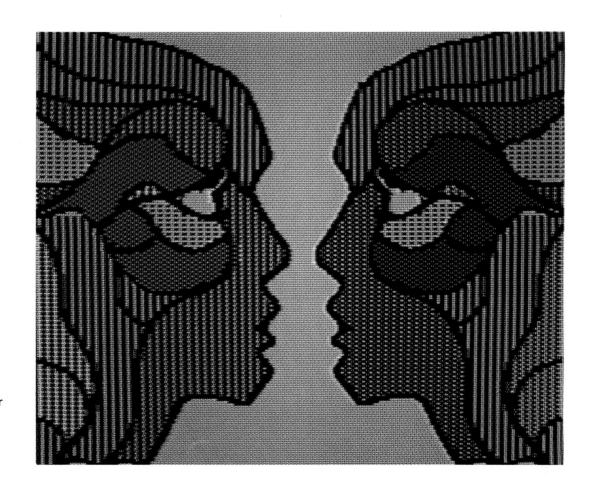

Picture 207 "Two Faces." Home computers are producing art all across the country. Harry Vertelney and Lucia Grossberger of Eclectic Electric created this picture on an Apple II computer and snapped the picture with a 35-mm camera.

Picture 208 "Change #11." (Harry Vertelney and Lucia Grossberger, Eclectic Electric)

Art software packages are available for home computers to make the creation of art easy for the nonprogrammer. But many people enjoy writing their own programs. John Fowler of Los Alamos wrote a program that removes hidden lines for his TRS-80 Color Computer. He used his pen plotter, which has color pens, to produce Picture 209, called "Pyramid City."

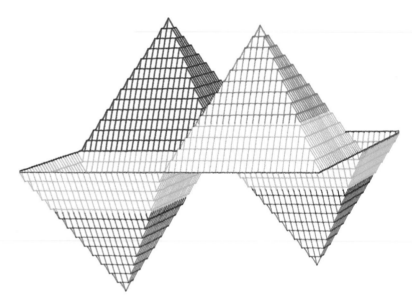

Picture 209 "Pyramid City." John Fowler in Los Alamos, New Mexico, wrote a program for his TRS-80 computer to remove hidden lines. This picture was plotted with his pen plotter. (©1983 John Fowler)

Picture 210 Vibeke Sorensen's computer graphics design class in the Department of Communication Arts and Design at the Virginia Commonwealth University found that home computers could produce colorful patterns.

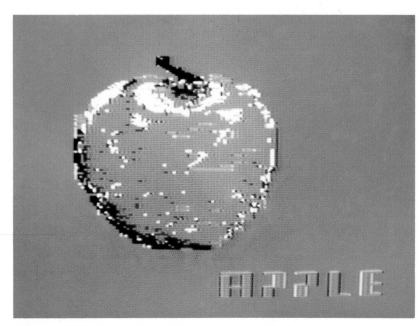

Picture 211 "Apple." (©1982 John Bonney, Virginia
Commonwealth University, using Apple Graphics Tablet)

Vibeke Sorensen's computer class, at Virginia Commonwealth University, generated Pictures 210 through 212 on an Apple computer.

I see a great future for home computer art. Each year, the equipment becomes more sophisticated. The computing power of home computers is comparable to that of the supercomputers of a few years ago. Before long, home computers will have the speed and capacity to do the massive jobs of intricate shading for the production of very high quality graphics.

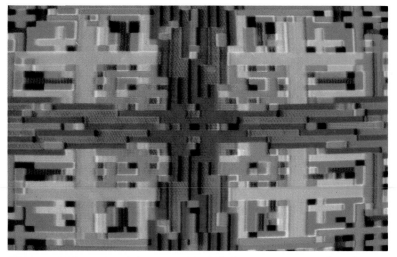

Picture 212 "Mandalas." (©1982 Vibeke Sorensen, produced
an Apple Graphics)

PICTURES FROM JAPAN

Yoichiro Kawaguchi has combined excellent computer graphics techniques with the sensitivity of an artist to produce some outstanding images. Some of his work suggests the growth of plant and animal forms. We see here spirals, branches, and segmentation typical of living organisms. Often he produces fascinating, unreal lighting effects by having each segment lighted the same regardless of orientation. This is quite obvious in Picture 214, in which each band seems to have its own light source. Note on the large "trunk" that each band is illuminated on the outer portion by orange light and on the inside by green light. In some of the pictures, he causes branches to grow on the main trunk and then smaller branches to grow onto the larger branches. This process is continued until the branches become too small to be seen. To make the pictures more interesting, he usually provides a varied background (see Pictures 213 through 223).

Pictures 224 through 227 were part of a movie produced by NHK, Japan Broadcasting Corporation. The lively, colorful images seem to represent very well the Japanese spirit in art.

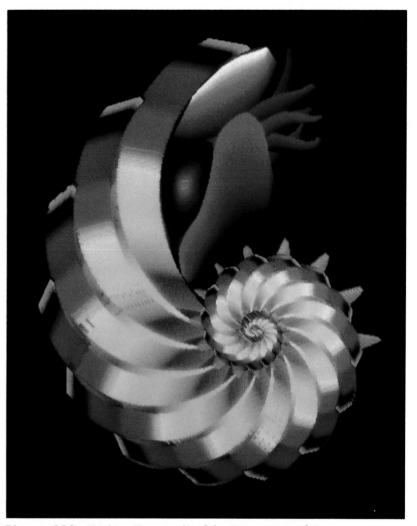

Picture 213 Yoichiro Kawaguchi of the Department of Art, Nippon Electronics College of Tokyo, has produced many excellent computer graphic images that simulate nature. We would expect to find this spiral form in the sea.

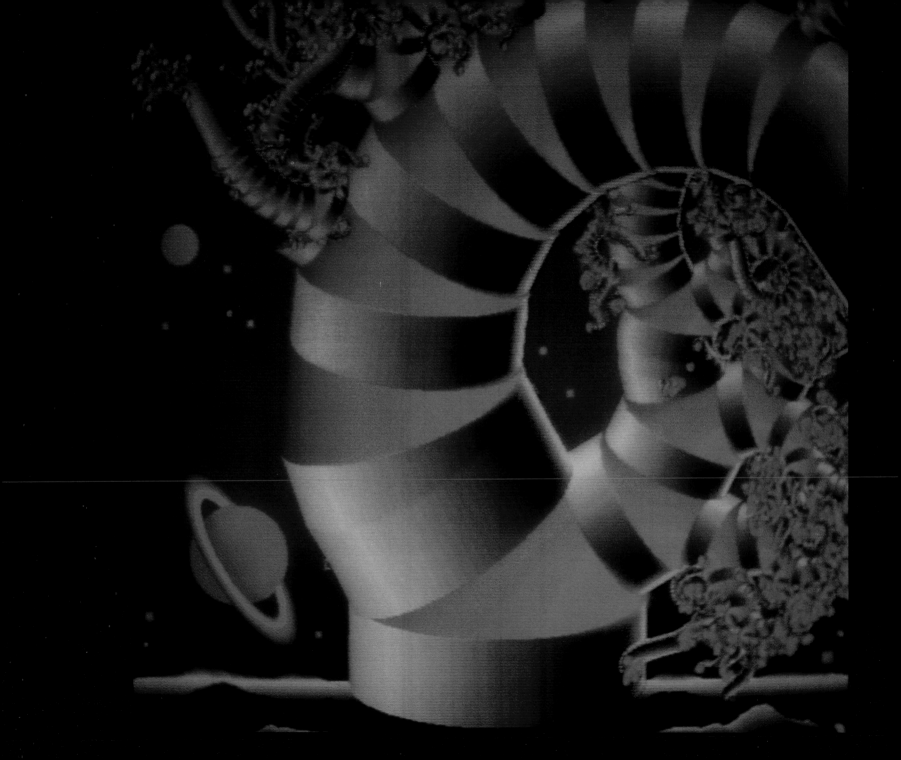

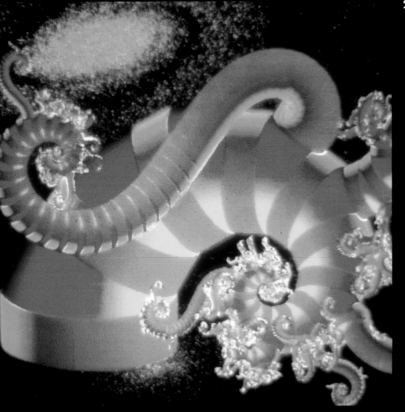

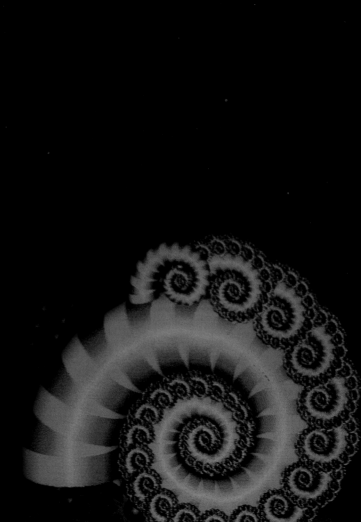

Picture 214 (Opposite page) Perhaps this picture represents some form of plant life on another world, but the manner in which branches grow on branches resembles plant life on earth. (Yoichiro Kawaguchi, Department of Art, Nippon Electronics College)

Picture 215 (Above) Note the backgrounds that are used in thes images to increase the quality and depth of the picture. (Yoichiro Kawaguchi, Department of Art, Nippon Electronics College)

Picture 216 "Spirals on Spirals." (Yoichiro Kawaguchi, Department of Art, Nippon Electronics College)

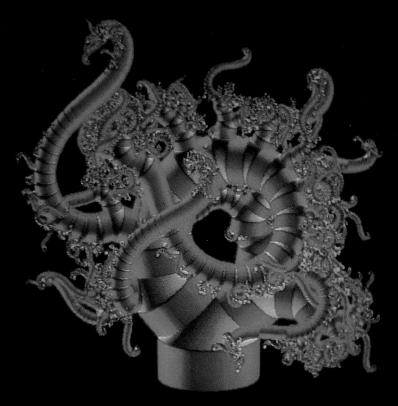

Picture 217 A totally black background brings this image out clearly. (Yoichiro Kawaguchi, Department of Art, Nippon Electronics College)

Picture 218 Using black in the foreground object increases the boldness of the object. (Yoichiro Kawaguchi, Department of Art, Nippon Electronics College)

218

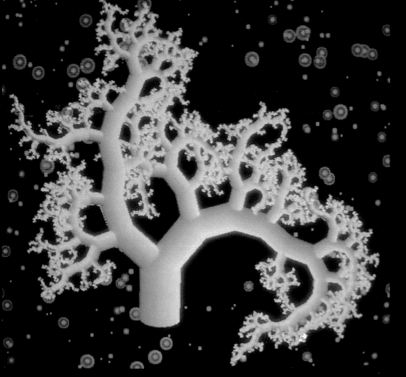

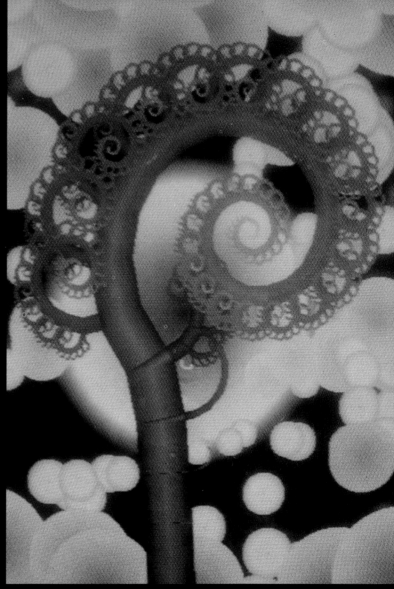

Picture 219 This picture changes the mood from that of the foregoing pictures. It appears to depict an underwater plant. (Yoichiro Kawaguchi, Department of Art, Nippon Electronics College)

Picture 220 (Yoichiro Kawaguchi, Department of Art, Nippon Electronics College)

220

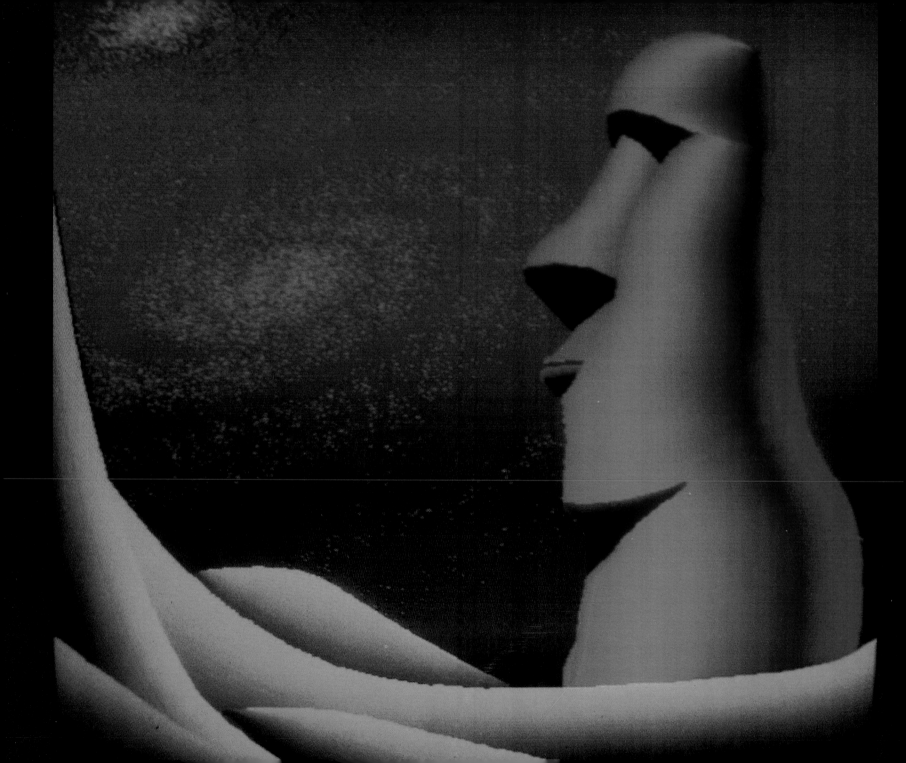

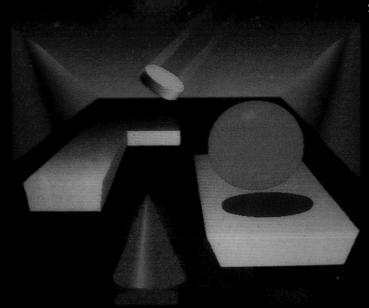

222

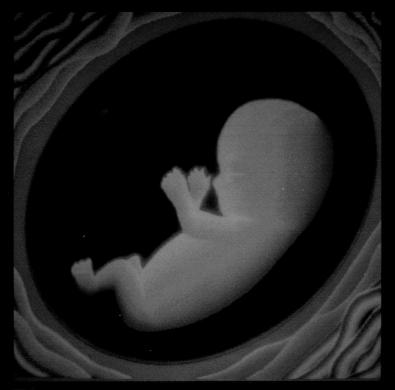

Picture 221 (Opposite page) The spiral plants are gone in the picture, but a spiral galaxy fills the background. (Yoichiro Kawaguchi, Department of Art, Nippon Electronics College)

Picture 222 These simple geometrical objects are easier to formulate in a computer than objects such as that in the previous picture. The streaks attached to the disk give it an appearance of motion. (Yoichiro Kawaguchi, Department of Art, Nippon Electronics College)

Picture 223 (Yoichiro Kawaguchi, Department of Art, Nippon Electronic College)

223

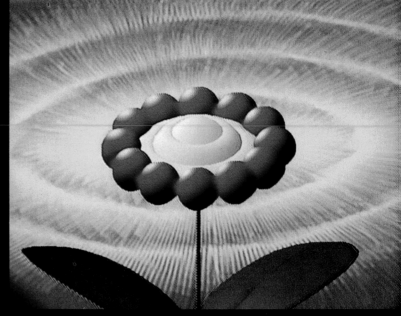

Picture 224 "Umbrellas." This and the following three figures are part of a movie (produced by NHK) called *Four Seasons of Japan.* (Director: Mayumi Yoshinari; technical director: Junnosuke Kutsuzawa, Kenji Kira, Hideo Noguchi, Kazuo Fukui, and Hiromichi Izawa; video technology: Shuichi Tamegaya and Kojiro Matsuzaki; sound mixing: Makoto Saito; photography: Minoru Iguchi; character design: Production Shirogumi; video and optical work: Far East Laboratories, Ltd; art director: Tatsuo Shimamura; ©NHK)

Picture 225 "Flower." (©NHK; see Picture 224 for complete credits)

225

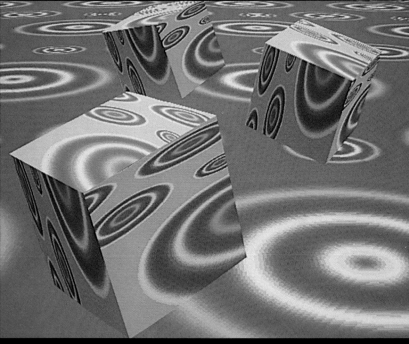

Picture 226 "Drifting Cubes." Note that the patterns on the cubes resemble those on the surface below. (©NHK; see Picture 224 for complete credits)

Picture 227 "Falling Spheres." These spheres have fascinating color patterns that blend smoothly and then change abruptly. (©NHK; see Picture 224 for complete credits)

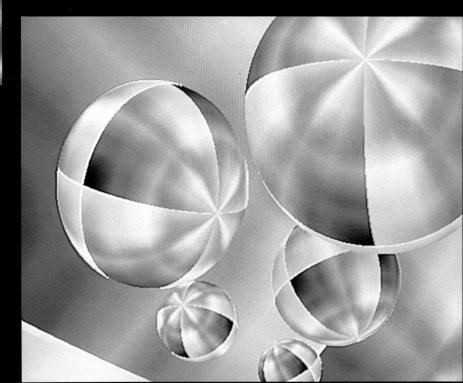

REALISM

Realism is important in some applications, such as flight simulators and computer-aided design. Evans and Sutherland Computer Corporation has hardware capable of producing realistic pictures that move in real time.[4] Picture 228 is one of the results of such simulations. In this picture, the simulation of atmospheric haze makes the background scene more realistic. Picture 229 is a simulation of a different sort and shows the versatility of the method.

[4]"Real time" refers to the production of pictures on the screen as fast as necessary to simulate motion that occurs at a natural rate.

Eihachiro Nakamae of Hiroshima University produced Picture 230, which is an architectural study utilizing shading and shadows. In much of computer graphics, the light sources are imaginary points that do not appear in the image. Here, however, we see light sources in the picture.

Computer graphics specialists are awestruck by the detail incorporated in Information International's X-Wing Fighter (Picture 231). Much work is involved in

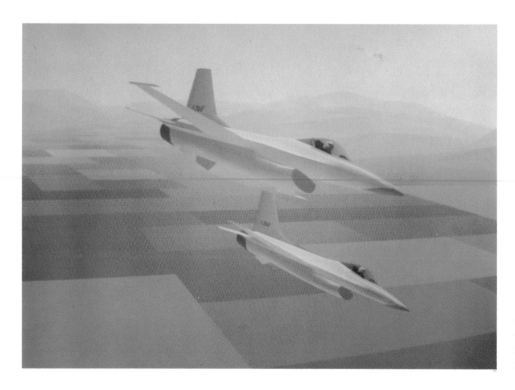

Picture 228 "F-16's." You can almost hear the scream of the jet engines. This picture was photographed directly from the Evans & Sutherland CT5 System. (©1980 Evans & Sutherland and Rediffusion Simulation)

setting up all the elements of such an object. This graphic suggests that computers will be doing a considerable amount of realistic animation for future movies.

Michael Collery did some detailed computer modeling to produce Pictures 232 and 233. Turner Whitted and David Weimer of Bell Laboratories did such fine work with Picture 234 that we could mistake it for a photograph. The picture, called "Boston," incorporates shading, shadows, and reflection. Picture 235, entitled "AT&T Long Lines," could also be mistaken for a photograph.

Designers who use computers to produce new designs want to see their creations as if the company machinist had built a model. Denise Archuleta at Sandia National Laboratories shows how a design can be taken apart before it is even built in Picture 236. The interplay of opacity and transparency aids in understanding the construction.

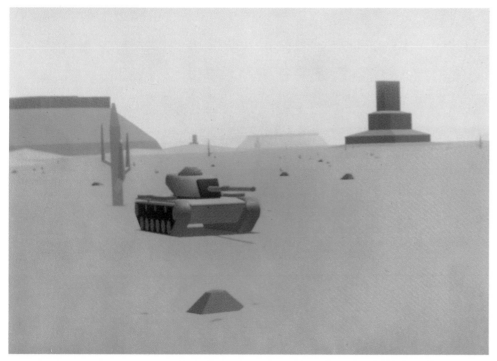

Picture 229 "Desert with Tank." This picture was also photographed directly from the Evans & Sutherland CT5 System. (©1982 Evans & Sutherland and Rediffusion Simulation)

Picture 230 "Night Light." Architects use computers to design and display proposed buildings. Thus they can see how the structures look without having to construct them. (Courtesy Eihachiro Nakamae, Faculty of Engineering, Electric Machinery Lab., Hiroshima University)

230

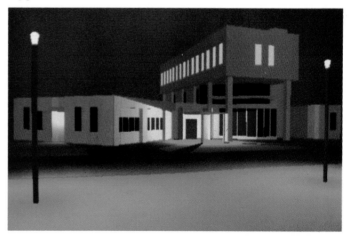

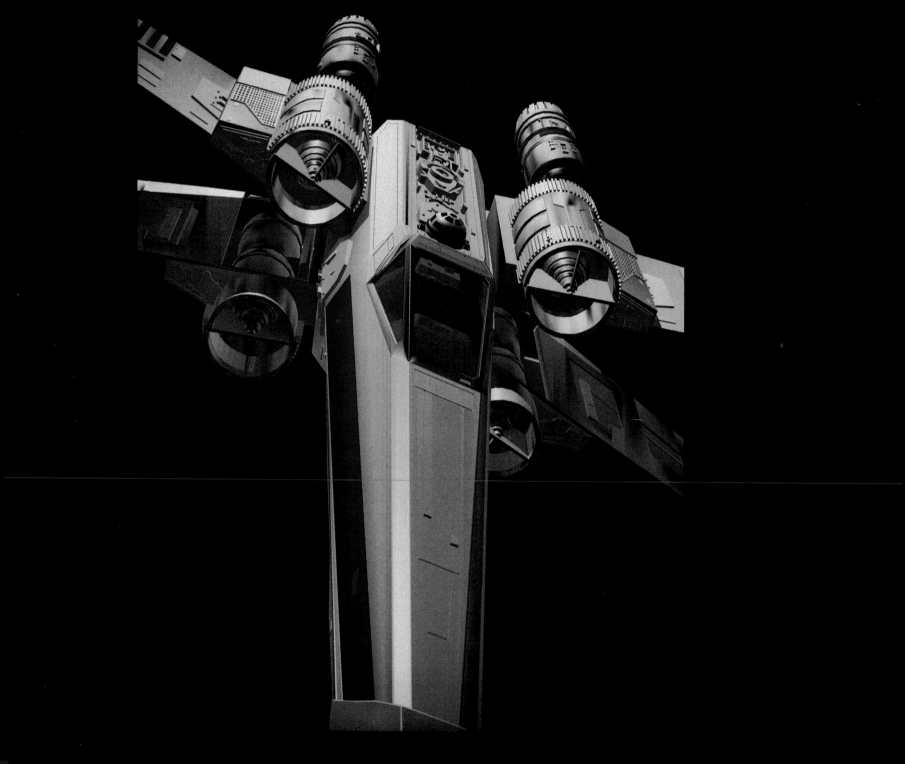

Picture 231 (Opposite page) "X-Wing." This is a fine example of intricate computer modeling. One can even see how the blue-tinted glass fits its molding. (Digitizing and design: Art Durinski; technical director: Gary Demos; ©1981 by Information International, Inc.; all rights reserved)

Picture 232 This is an interesting bit of realistic modeling by Michael Collery. (Image composed and created by Michael Collery; produced by Cranston/Csuri Productions; display software: Franklin Crow; display hardware: Marc Howard; data generation software: Wayne Carlson; software support: Julian Gomez, Hsuen-Chung Ho, and Robert Marshall)

Picture 233 It takes imagination to create interesting subjects for computer graphics, and then it takes much work to define the details of the picture. (Michael Collery et al.; see Picture 232 for complete credits)

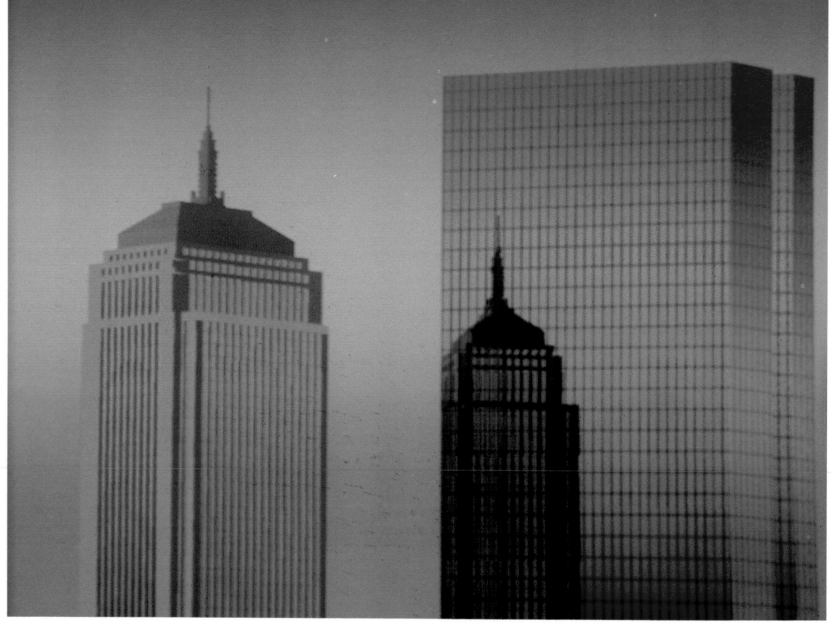

Picture 234 "Boston." (©1982 Turner Whitted and David Weimer, Bell Laboratories)

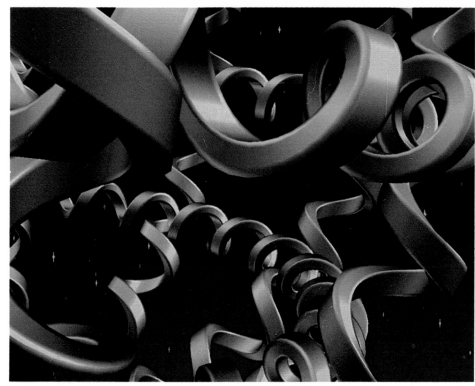

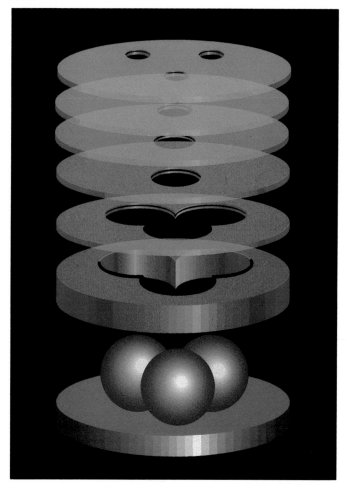

Picture 235 "AT&T Long Lines." (Produced by George Parker, Don Leich, and C. Robert Hoffman, III, Digital Effects, Inc.)

Picture 236 "Molecular Imaging." Denise Archuleta used a graphics tablet on a Genigraphics System to produce a schematic drawing of the process used to image organic molecules in the Field-Ion Tomographic microscope at Sandia National Laboratories, Albuquerque, New Mexico. (©1983 Sandia National Laboratories; all rights reserved)

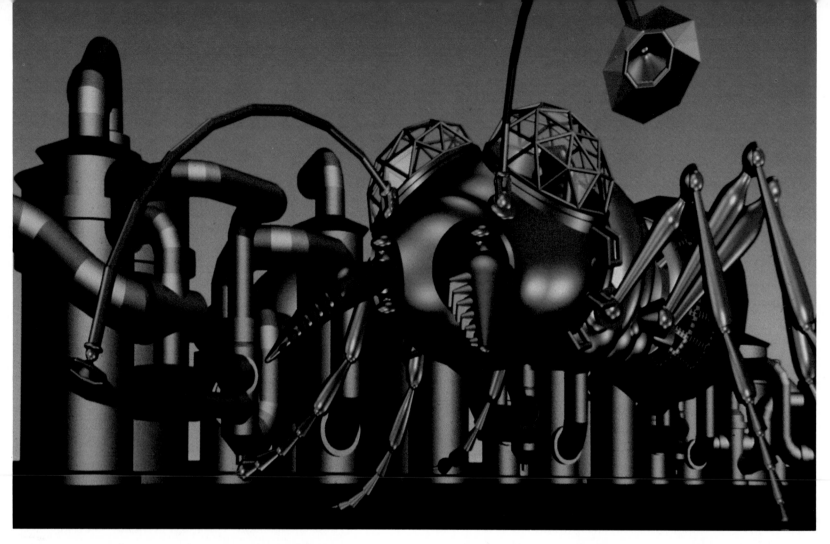

"The Ant," showing a beautiful mechanical monster, was created by Dick Lundin at the New York Institute of Technology Computer Graphics Lab (Picture 237). It is part of a movie called *The Works* that includes many outstanding computer creations. As one studies this image, it is difficult to imagine that all the parts, the light reflection, and the coloration are products of computer circuitry and software. In the movie, this complex machinery actually moves.

Picture 237 "Ant." This picture from the movie *The Works* was produced by Dick Lundin at the Computer Graphics Laboratory, New York Institute of Technology, and was plotted on a Matrix Model 4007 Color Graphics Recorder. (©1982 Dick Lundin, NYIT Computer Graphics Lab.)

PATTERNS AND DESIGNS

Human beings live in a world of surfaces: they walk on surfaces, they see surfaces, they feel surfaces, all in three dimensions. We have seen that computers can create images of complex surfaces to accommodate human vision. But computers might be more comfortable with the generation of patterns and two-dimensional designs.

Picture 238 Copper Giloth used a DATAMAX UV-1 Zgrass computer and some fine imagination to produce this picture. (©1981 Copper Giloth, Real Time Design, Inc.)

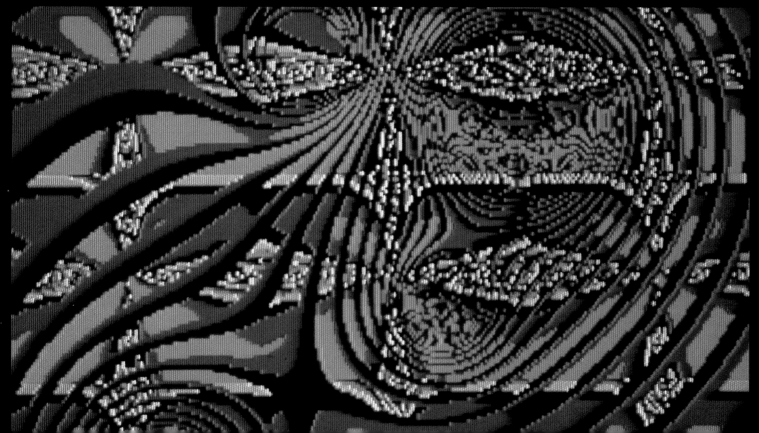

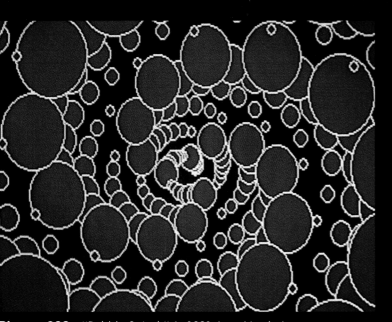

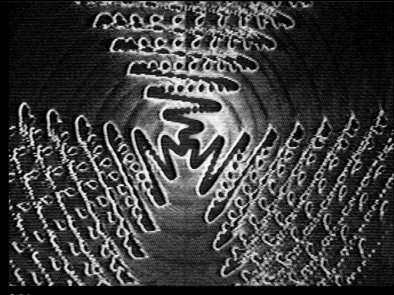

240

241

Picture 239 "Bubble Spiral." (©1981 Jane Veeder)

Picture 240 "Spiral PTL." This is a still frame from a video tape. Tom DeFanti, Dan Sandin, and Mimi Shevitz produced it with a PDP-11/45, Vector General Display device, and the Sandin Image processor. (©1980 Tom DeFanti, Dan Sandin, and Mimi Shevitz)

Picture 241 "Rug Design." This design was created by Steve Purcell at Advanced Color Technology on a Lexidata System 3400.

Picture 242 (Opposite page) "Gem '83." This intriguing design by James Squires on a Chromatics 7900 in the Fine Arts Department of UCLA has three-dimensional characteristics due to the shading.

The pictures in this section were created by artists using computers of various types. Pictures 238 through 240 show some interesting constructions that we might simply call "designs," while Picture 241 shows how the computer can design rug patterns. Imagine the saving of time and effort that is realized in producing a picture first without all the effort of making a real carpet. If the artist is not totally satisfied with the design, he or she can make alterations easily with the computer. When the design is finalized, the actual carpet can be woven.

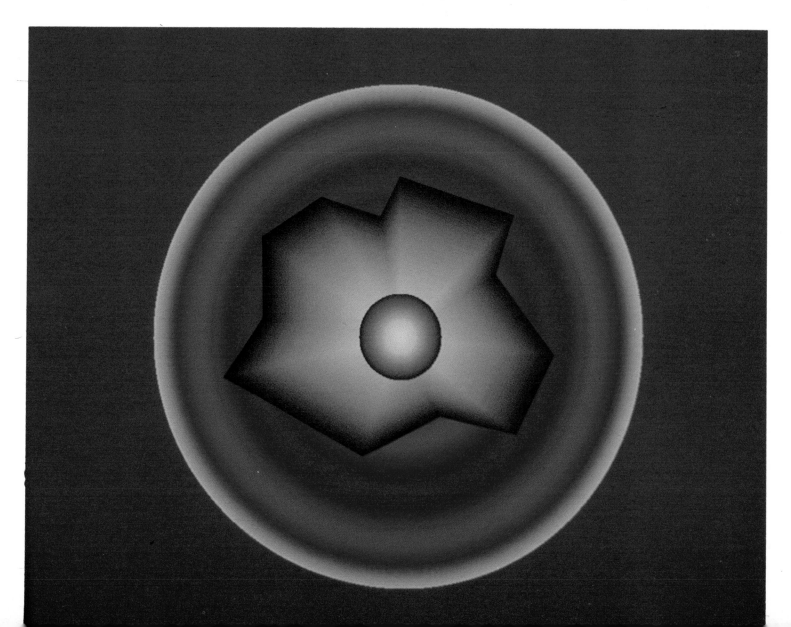

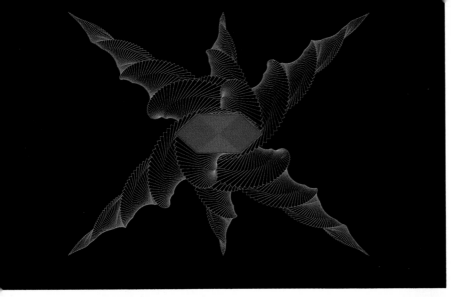

243

The other images (242 to 254) in this section should be of value to home computer users in stimulating ideas for different types of graphics that can be produced. One can see that various types of plotting devices were used in the production of these pictures; of course, home computer graphics output cannot yet match the line quality of some of these.

Picture 243 "Probe." Patrick J. Hodson ensures a three-dimensional appearance by removing hidden lines. (©1982 Patrick Hodson, Los Alamos National Laboratory)

Picture 244 "Spiral Out." (©1982 Patrick Hodson, Los Alamos National Laboratory)

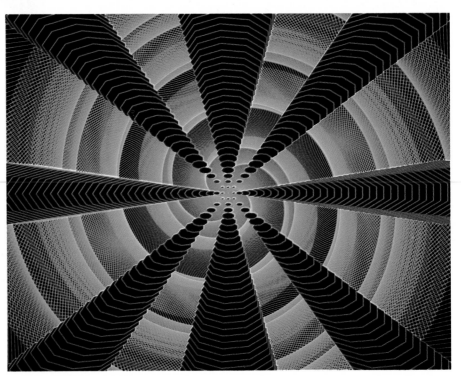

244

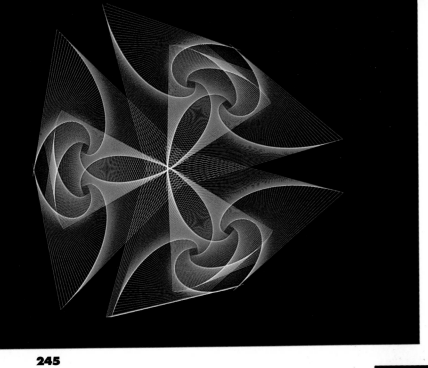

245

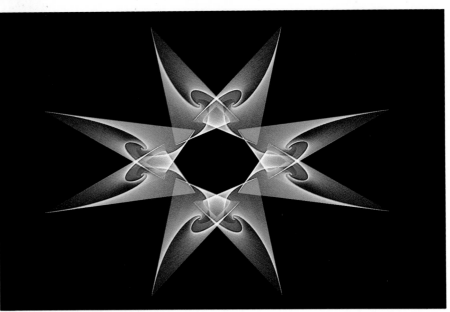

Picture 245 "Tri-Vail." (©1978 Melvin L. Prueitt)

Picture 246 "Corona." (©1979 Melvin L. Prueitt)

246

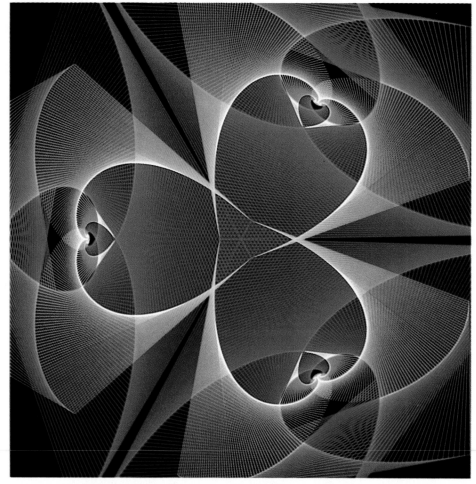

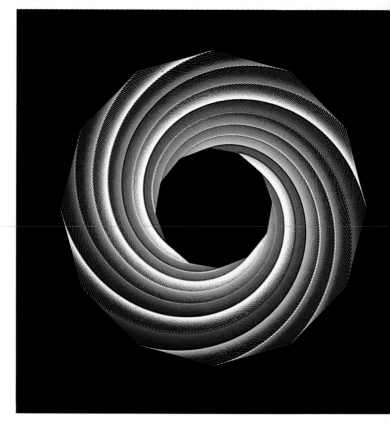

Picture 247 "Harmonic Heart." This image contains 15 heart-shaped designs. (©1979 Melvin L. Prueitt)

Picture 248 "Rainbow Black Hole." This design is made by placing 12 points on a circle and drawing lines between them. Then each point is advanced toward the following one a small distance. The connecting lines are redrawn. This process is repeated a number of times. Each set of lines is given a color. (©1980 Melvin L. Prueitt)

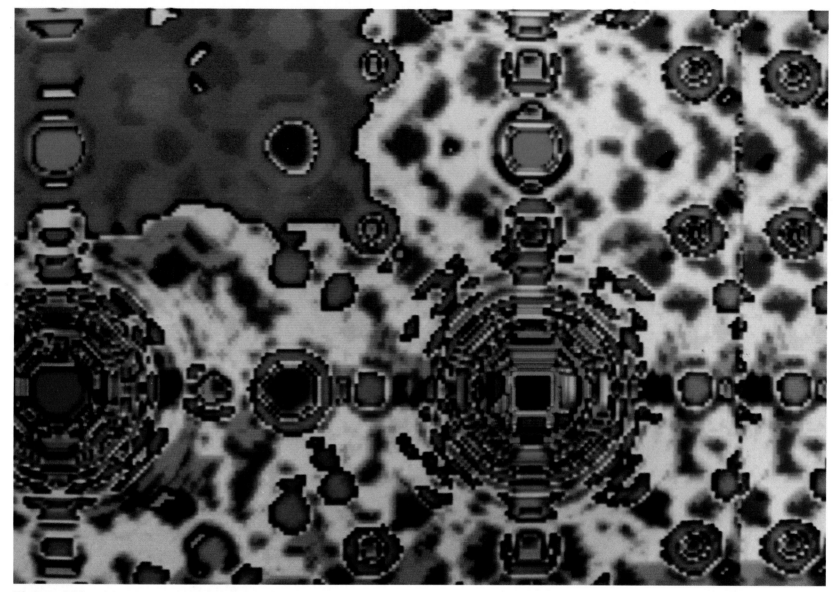

Picture 249 (Courtesy James Squires at the Fine Arts
Department, UCLA, using a Chromatics 7900)

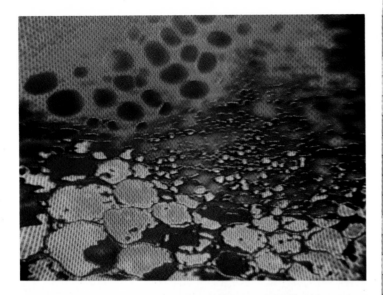

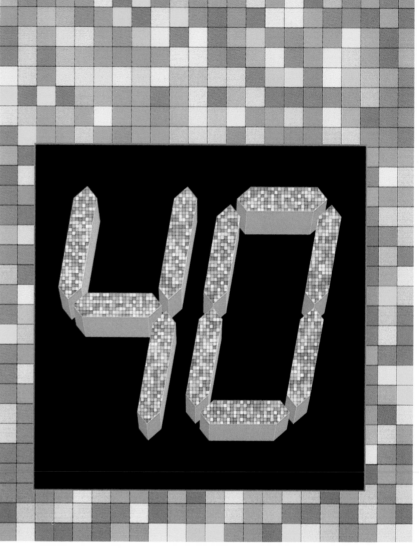

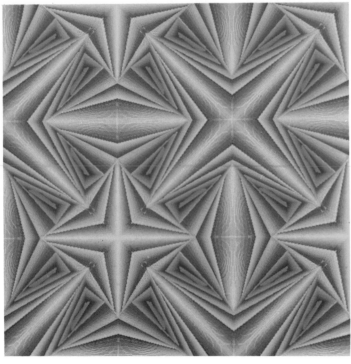

Picture 250 (Top left) Grant Johnson of Stimulus produced this image using analog processing equipment.

Picture 251 (Above) "40." Ron Griego built the number "40" by using computer "tiles." (©1982 Ron Griego, Los Alamos National Laboratory)

Picture 252 (Left) Paul Jablonka used his artistic skills to fit together these geometric designs. (©1982 Paul Jablonka)

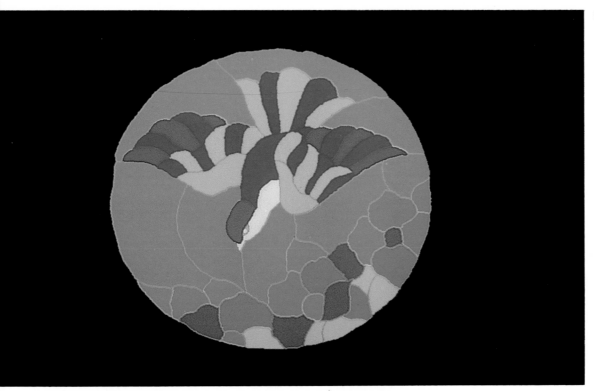

Picture 253 "Stained-Glass Bird." Here we have an unusual computer graphic. The spaces between the lines are filled in with constant color, like a stained-glass window. (Created by Donna Stwasser, color by Pete Harris, Jupiter Systems)

Picture 254 "Geometric Pattern for the Vergreville Pysanka." We see shades of Escher in this image by Professor Ronald Resch, Boston University. (Photo courtesy of Mike Milochik)

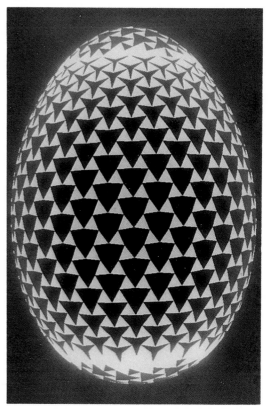

ABSTRACTIONS

Some people might feel that the majority of the pictures in this book are somewhat abstract. However, some pictures are more abstract than others. Hence we have here a small section devoted to abstract images. Darcy Gerbarg starts the section off with Pictures 255 and 256. It is not difficult for a computer to produce abstract designs, but it takes a real artist and a person who understands computers to make the designs interesting.

Harry Holland's "Fat City Blues," Picture 257, has a totally different spirit from Gerbarg's designs. Perhaps the three-dimensionality of it makes the difference. We see shadows that help to define shapes, but the mystery remains: What is it?

Some of these abstract designs have certain features that are duplicated a number of times throughout the image, but the duplications are made with variations in spacing, shape, color, and background to produce an interesting picture. Computers can readily repeat patterns, but they rely on human operators to direct them in the placement of the duplications. Pictures 258 through 264 provide a fascinating study of abstract art created by artists using computers.

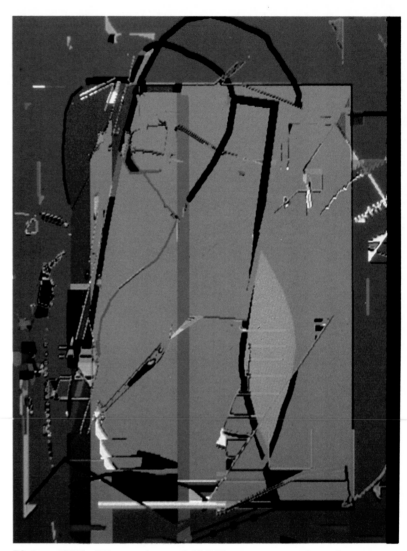

Picture 255 "Concession to Scifi." There are a number of ways to create abstract art with a computer. Darcy Gerbarg found a couple of ways in this and the following picture. (©1980 Darcy Gerbarg)

Picture 256 "Outer Space Scape." (©1980 Darcy Gerbarg)

Picture 257 "Fat City Blues." Professor Harry Holland, Department of Art, Carnegie-Mellon University, formed this picture on an AED-512 color terminal using an LSI-11 microprocessor. He used a system called the CMU Paint Program with software developed by Warren Wake.

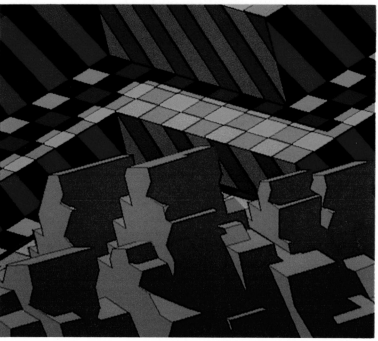

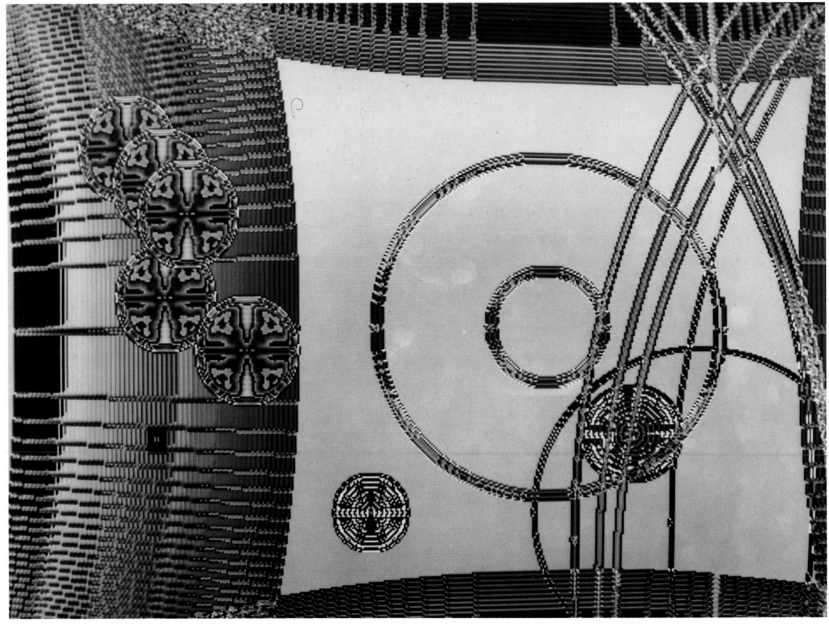

Picture 258 This was produced by James Squires as a graduate student using a Chromatics 7900 in the Fine Arts Department of UCLA.

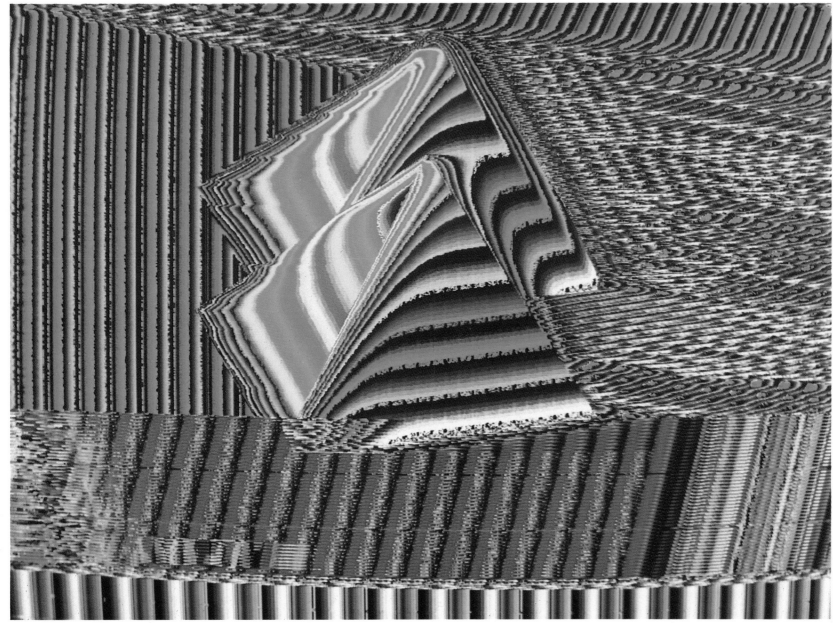

Picture 259 "Pyramids." This was also produced by James Squires.

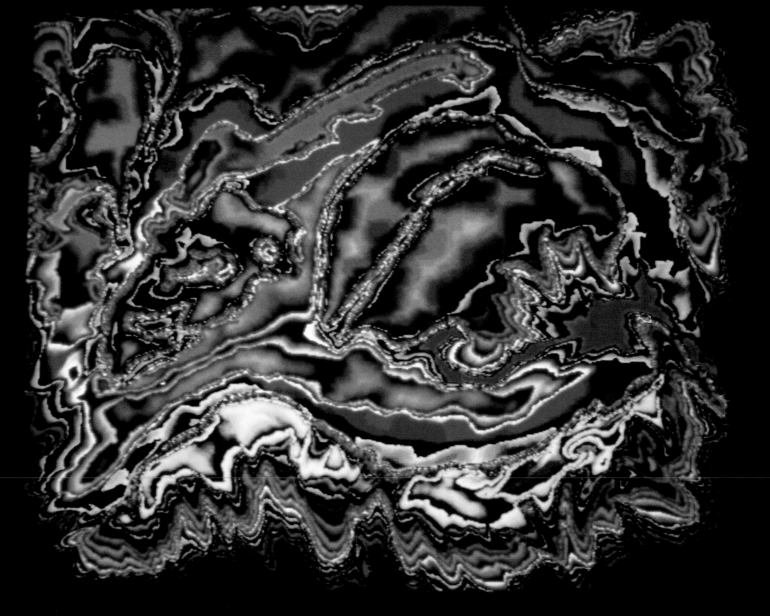

Picture 260 "Organism." Vibeke Sorensen used the Paint Program at the New York Institute of Technology to develop these vibrant colors and contours. (©1980 Vibeke Sorensen)

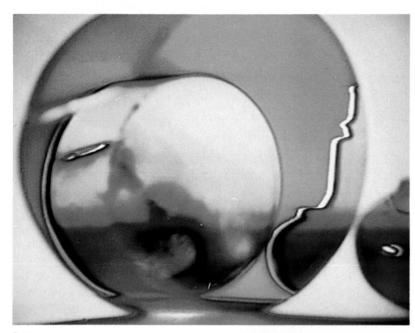

261

Picture 261 Connie Coleman and Alan Powell produced this image at the Experimental TV Center in Owego, New York. They primarily used analog devices such as oscillators, video keyers, and video colorizers.

Picture 262 Walter Wright uses a Cromenco Z2, two 48K image buffers, SDI graphics hardware, video digitizer, graphics tablet, and a Matrix Instruments camera. (©1982 Walter Wright)

262

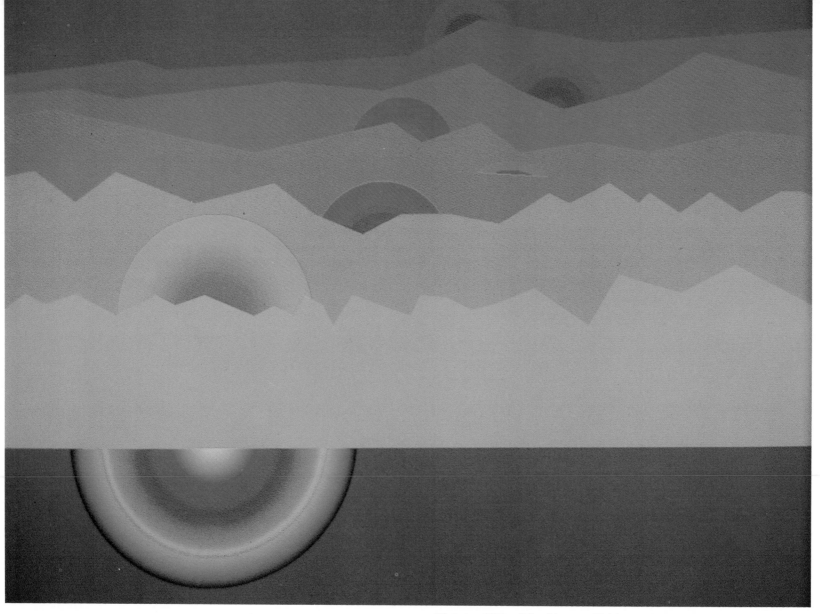

Picture 263 "The Moon's Children." (James Squires at the Fine Arts Department, UCLA, using a Chromatics 7900)

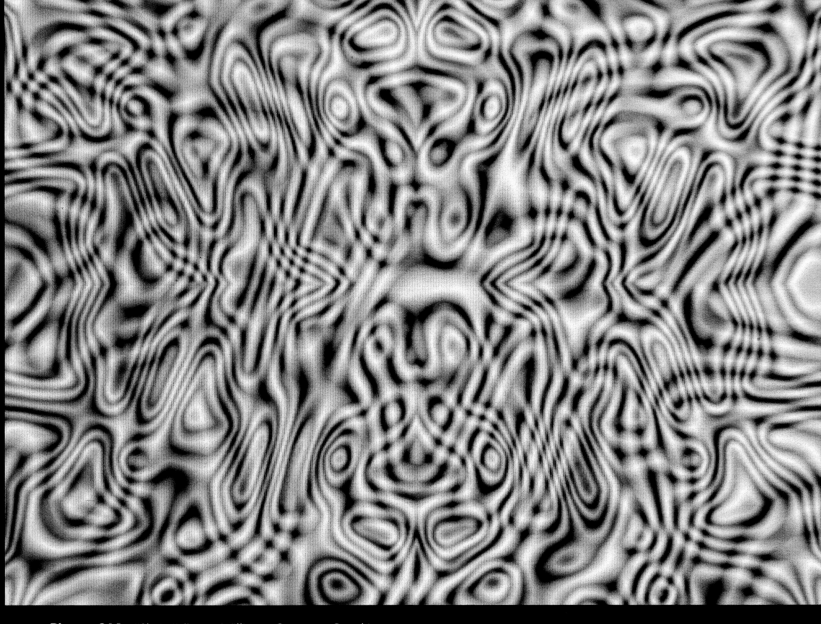

Picture 264 ''Skein.'' (Lance Williams, Computer Graphics
Laboratory, New York Institute of Technology; ©1980 NYIT)

EYE PIECES

Through our eyes, we perceive works of art. It is fitting, then, that we dedicate a section to computer-generated images of eyes.

I have not tried to count the number of eyes Lance Williams and a computer arranged in Picture 265, but I am sure he appreciated the help of the computer. Paul Heckbert approached the subject from a different angle —in fact, a number of different angles—in Picture 266. Copper Giloth had another idea about producing the eye with a computer and turned out a two-dimensional design (Picture 267). Pictures 268 through 270 show computer variations on a theme.

Dean Winkler, Thomas DeWitt, and Vibeke Sorensen provide a pleasant study of eyes in Pictures 271 and 272. Here we can see the rays of light symbolizing the sense of vision. These eyes seem to sparkle from their own light.

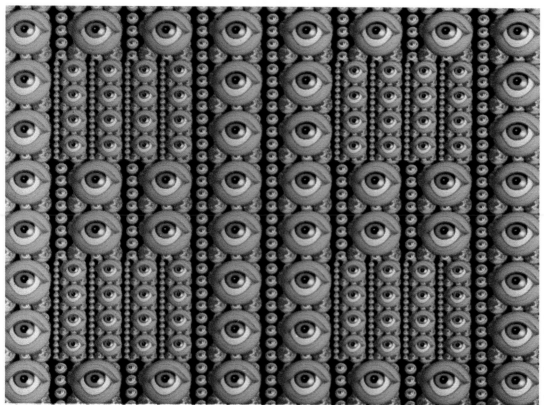

Picture 265 "Stareway." There are times when a computer is essential to producing a desired effect in art. It would be impossible to make these eyes identical by hand. (Lance Williams, Computer Graphics Laboratory, New York Institute of Technology; ©1980 NYIT)

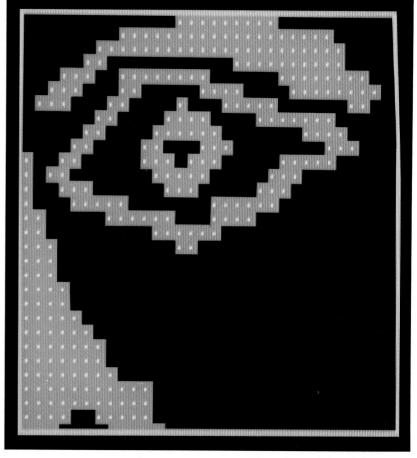

Picture 266 "Eyes." (Paul Heckbert, Computer Graphics Laboratory, New York Institute of Technology. Original eye image digitized by David Geshwind. ©1980 NYIT)

Picture 267 "Eye Module." Copper Giloth used a DATAMAX UV-1 Zgrass computer for this image. (©1980 Copper Giloth)

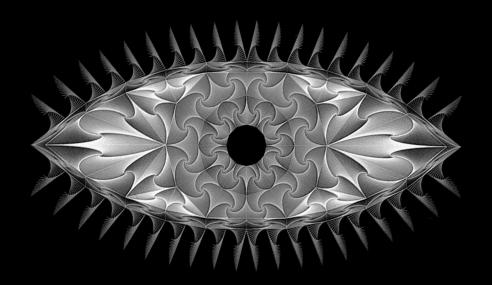

Picture 268 "Sculptured Eye." Instead of filling in areas with parallel lines, the computer can make pictures more interesting by filling in with lines that are oriented in some other manner. This gives the picture a structured look and provides form within the areas. This eye was drawn with many small filled-in areas. (©1982 Melvin L. Prueitt)

269 "Functional Iris." (©1982 Melvin L. Prueitt)

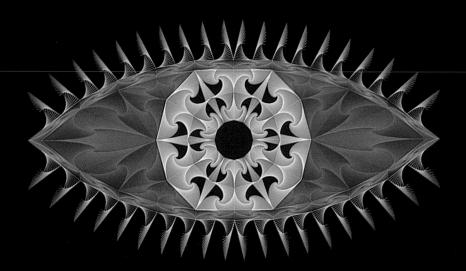

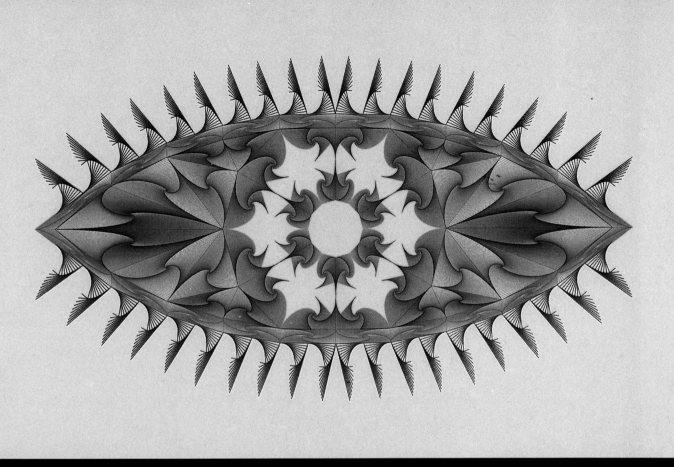

Picture 270 "Eye of the Imagination." (©1982 Melvin L. Prueitt)

Picture 272 This is another frame from the same sequence as
Picture 271 by Dean Winkler, Tom DeWitt, and Vibeke Sorensen.

ELECTRONIC FLOWERS

The world would not be the same without the presence of flowers. After the invention of the electronic computer, it did not take programmers long to learn that computers could create flower images. Picture 273 is a symbolic representation of a flower in three dimensions. Picture 274 is somewhat more abstract, but most people instinctively think "flower" when this picture is presented. The program CAMERA produced the open flower of Picture 275, reminiscent of some orchids or perhaps a pitcher plant. Possibly the picture could be improved by the placement of stamen in the center, but CAMERA could not handle that complexity. Another program, such as GRAFIC, could do the job. The top view of a flower that looks a bit mechanical is given in Picture 276. Picture 277 was constructed of a sphere and circular sine waves by GRAFIC. Petals that are functions of sine waves form the complex flower of Picture 278; Picture 279 is a newcomer to the flower kingdom, a spherical flower.

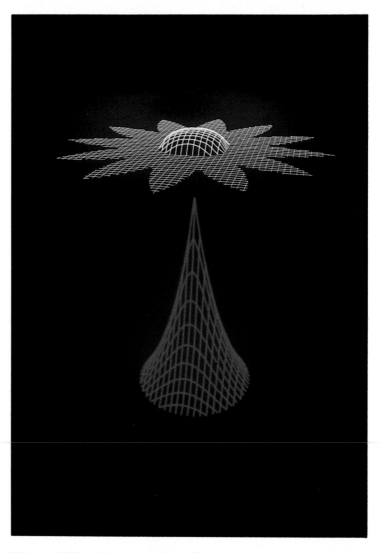

Picture 273 "Flower and Stem." There are as many ways to make flowers with a computer as there are varieties of flowers in the world. This section shows a few. (©1973 Melvin L. Prueitt)

Picture 274 (Opposite page) "Love's Flower." One can define a geometry and then reflect it about various axes and often end up with a flower. (©1982 Melvin L. Prueitt)

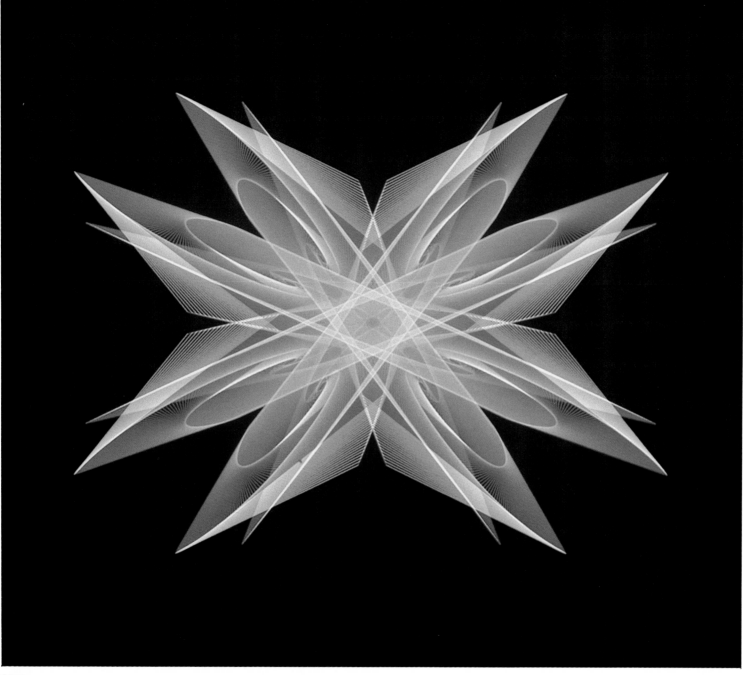

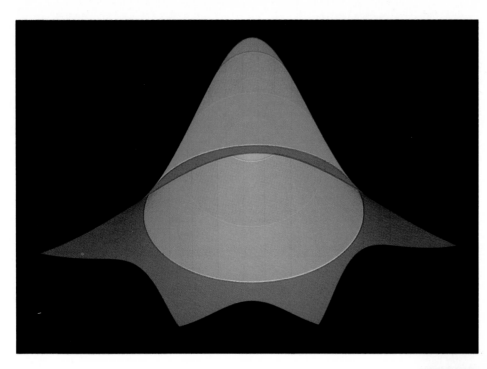

Picture 275 "Simplified Orchid." (©1982 Melvin L. Prueitt)

Picture 276 "Radiance." The top view of a design such as that of Picture 278 looks like this. (©1982 Melvin L. Prueitt)

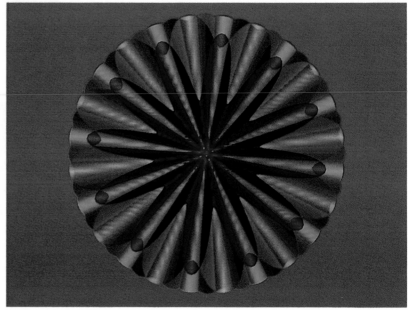

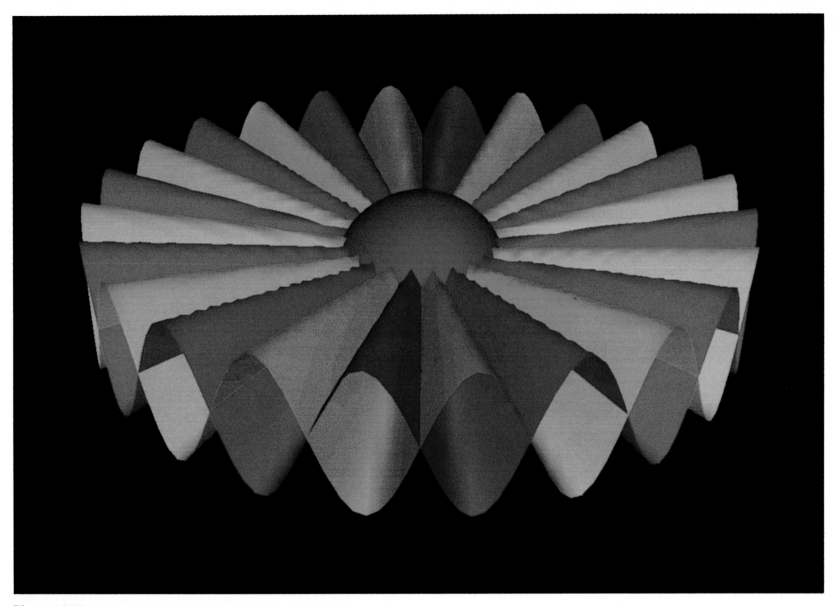

Picture 277 "Sine Blossom." A computer flower may consist simply of a sphere surrounded by two circular sine functions. (©1982 Melvin L. Prueitt)

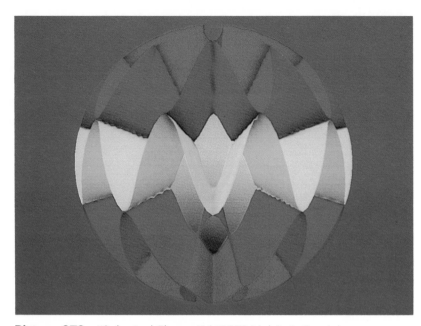

Picture 279 "Spherical Flower." (©1982 Melvin L. Prueitt)

Picture 278 "Complexion." (©1982 Melvin L. Prueitt)

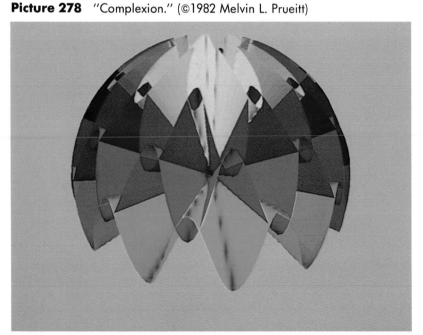

Picture 280 is a stylized version of a flower by Mike Marshall. Picture 281, a three-dimensional representation of a flower with a background plain of two-dimensional symbolic flowers, was created by NHK in Japan. A field of sunflowers is portrayed in Picture 282. In computer graphics jargon, people talk about the number of "edges" required to make a picture. That is, the polygons that make up the picture have edges that

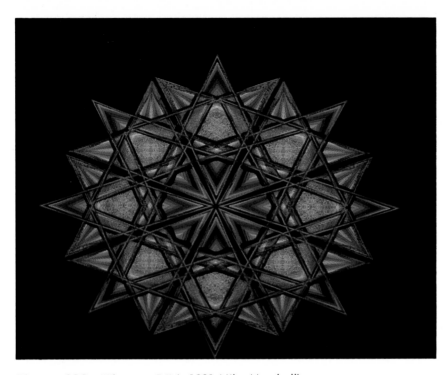

Picture 280 "Flower #5." (©1981 Mike Marshall)

Picture 281 Computers can create flowers that have no counterpart in the real world, but we recognize them as flowers nevertheless. (©NHK; see Picture 224 for complete credit)

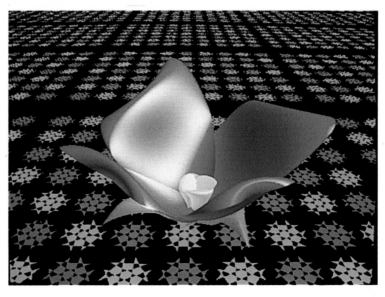

must be dealt with in hidden-surface removal programs. Over 55,000 edges are present in the objects that make up this image. The computer calculated the picture in about 7 seconds.

Finally, from Information International comes a sculptured bouquet consisting of flowers with glossy petals arranged with mathematical precision around the central stem.

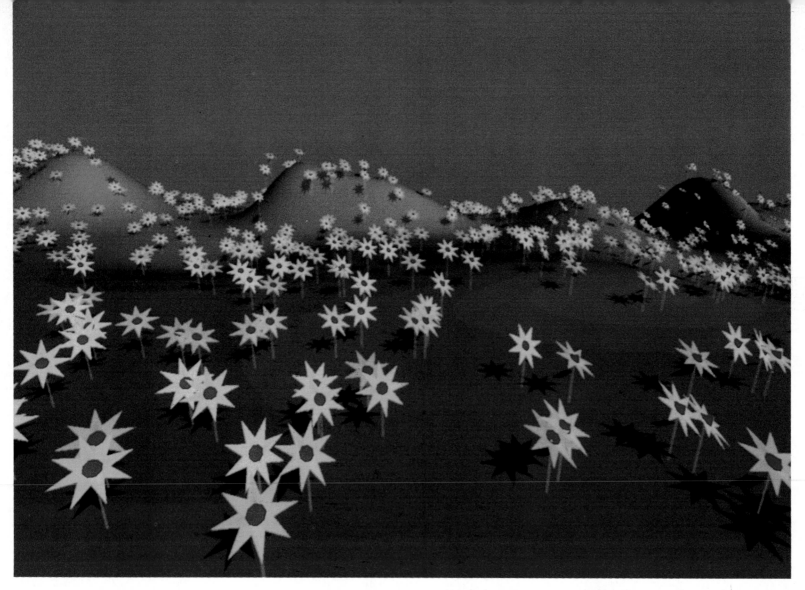

Picture 282 "Sunflowers Watching the Sun." Each flower has the same shape, but each is tilted at a slightly different angle within a narrow range of angles that point in the general direction of the sun. (©1983 Melvin L. Prueitt)

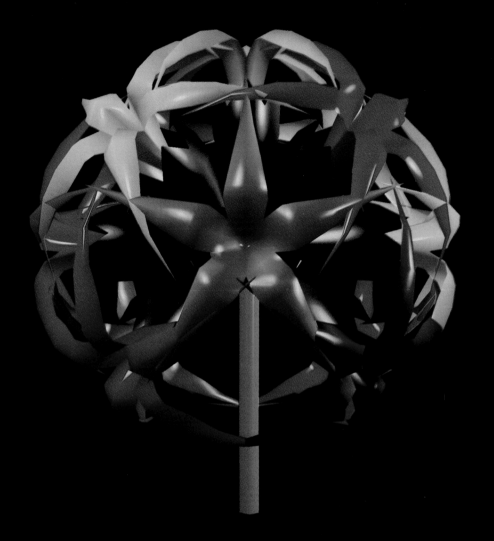

Picture 283 "Flowers." There is such lovely detail in this flower that we could wish to discover one beside a wooded path and pluck it up to take home. We could put it in a vase, and it would never wither. (Digitizing and design: Art Durinski; technical director: Gary Demos; ©1981 by Information International, Inc.; all rights reserved)

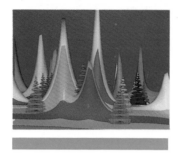

SUBJECT
INDEX

Abstract art, 220–227
Algorithm, 16, 23
Animation, 26
Anti-aliasing, 22
Art appreciation, 37–39
Art research, 31
Asteroids, 169–170, 175
Asymmetry, 78–82

Binocular vision, 7
Black hole, 172
Blind spot, 12–13

Cathode-ray tube, 4, 13
Caverns, 137–143
Color intervals, 31
COM devices, 4
Communication, 3–5
Computer-aided art, 28
Computer-aided design, 27, 204
Computer artist, 28, 30
Coordinator, 14, 16

Debugging, 14, 28
Depth buffer, 16
Depth of field, 23
Diffraction patterns, 85, 88–90
Diffuse reflection, 19–20

Erosion, 106–113
Errors, 13, 185–190
Eyes, 228–233

Flowers, 5, 234–241
Fractals, 119, 121–122, 125, 166, 169

Galaxy, 99
Geology, 92–93
Graphics tablet, 4, 26, 29

Hardware, 23, 204
Hemoglobin molecule, 85–86
Hidden-line removal, 16–17, 56
Hidden-surface removal, 16, 18, 34, 151
Home computer art, 29, 40, 191–194
Hue, 9–10

Ink jet plotter or printer, 4, 13
Interactive graphics, 4

Japan, 195–203, 205

Key frame, 26

Landscaper, 125–136
Laser, 85, 91
Laser printer, 4, 13
Lighting, 173–184, 204

Line drawings, 14, 15, 42–55
Loop, 14

Mantle, 92, 94
Menu, 4
Mesh photo, 56
Mie scattering, 85, 88
Mimas, 94–95
Motion pictures, 22, 28, 34, 37

Nonlinear systems, 118, 120
Nuclear spectra, 83, 85

Orion Nebula, 94, 96–98

Passive artist, 30
Pen plotter, 4, 13, 29
Perspective, 5, 7–8, 14, 16, 28, 56–63
Photons, 20, 85
Pixel, 16, 22
Plasma, 92
Plotter, 4, 13–14
Polygon, 16
Printer, 3
Program, 13–14, 34, 42, 137

Raster scan, 4, 22
Ray tracing, 20, 175

Realism, 204–210
Real time, 23, 204
Resolution, 5, 29
R Monoceros Nebula, 94, 98–99

Saturation, 10
Saturn, 94, 95
Scan line, 4, 16, 22
Shading, 7–8, 19–20, 149–150, 185, 205

Shadowing, 19–20, 149–150, 181, 185, 205
Sine waves, 115–116
Software, 23
Spectral hue, 9
Spectrum of light, 8
Specular reflection, 19–20, 145–148
Still lifes, 145
Symmetry, 65–76

Topography, 100–105

Vector graphics, 4, 22
Virus, 85, 87
Vision, 5, 8, 11, 38
Voice input, 5

Wavelength, 89

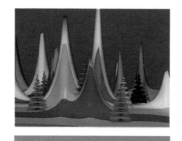

ARTIST
INDEX

Paula Adams, Los Alamos National Laboratory. Picture 75.

Denise Archuleta, Sandia National Laboratories. Picture 236.

Alan Barr, Raster Technologies, Inc. Pictures 10 and 146.

John Baumgardner, Department of Earth and Space Sciences, University of California at Los Angeles. Picture 79.

James F. Blinn, Jet Propulsion Laboratory. Pictures 80 and 81.

John Bonney, Virginia Commonwealth University. Picture 211.

Susan Bunker, Los Alamos National Laboratory. Picture 88.

Indranil Chakravarty, Schlumberger-Doll Research. Picture 118.

Connie Coleman, Experimental TV Center. Picture 261.

Michael Collery, Cranston/Csuri Productions. Pictures 142, 143, 144, 232, and 233.

Tom DeFanti, University of Illinois at Chicago. Picture 240.

Tom DeWitt, Image Processing Laboratory, Rensselaer Polytechnic Institute. Pictures 172, 271, and 272.

Art Durinski, Information International, Inc. Pictures 149, 178, 194, 231, and 283.

C. James Elliott, Los Alamos National Laboratory. Picture 75.

David Em, Independent Artist, Sierra Madre, California. Pictures 41, 56, 60, 61, 169, and 170.

Tom Ferrin, University of California at San Francisco. Picture 67.

John Fowler, Los Alamos, New Mexico. Picture 209.

Paul Frederickson, Los Alamos National Laboratory. Picture 79.

Curtis Fukuda, Gould, Inc., De Anza Imaging and Graphics Division. Picture 87.

Darcy Gerbarg, New York University and Pratt Computer Graphics Center. Pictures 255 and 256.

David Geshwind, Digital Video System, Inc. Picture 266.

Copper Giloth, Real Time Design, Inc. Pictures 238 and 267.

Alan Greene, Digital Effects, Inc. Picture 148.

Ned Greene, Computer Graphics Laboratory, New York Institute of Technology. Picture 179.

Ron Griego, Los Alamos National Laboratory. Picture 251.

Lucia Grossberger, Eclectic Electric. Pictures 207 and 208.

Roy Hall, Program of Computer Graphics, Cornell University. Picture 193.

Pete Harris, Jupiter Systems. Pictures 67 and 253.

Paul Heckbert, Computer Graphics Laboratory, New York Institute of Technology. Picture 266.

Harold Hendelman, Cornell University. Pictures 145 and 165.

Patrick J. Hodson, Los Alamos National Laboratory. Pictures 243 and 244.

C. Robert Hoffman, III, Digital Effects, Inc. Pictures 148, 183, and 235.

Harry Holland, Department of Art, College of Fine Arts, Carnegie-Mellon University. Picture 257.

Robert Hotchkiss, Los Alamos National Laboratory. Pictures 112 and 113.

Paul Jablonka, Tucson, Arizona. Picture 252.

Grant Johnson, Stimulus. Picture 250.

Reid Judd, Gould, Inc., De Anza Imaging and Graphics Division. Picture 167.

Yoichiro Kawaguchi, Department of Art, Nippon Electronics College. Pictures 213 through 223.

Don Leich, Digital Effects, Inc. Pictures 152 and 235.

Gordon Lind, Department of Physics, Utah

State University. Picture 65.

Douglas Lora, Los Alamos National Laboratory. Picture 78.

Dick Lundin, Computer Graphics Laboratory, New York Institute of Technology. Picture 237.

Larry Malone, Information International, Inc. Picture 149.

Benoit Mandelbrot, IBM Thomas J. Watson Research Center. Pictures 114 and 115.

Mike Marshall, Palo Alto, California. Pictures 28, 29, 150, 151, 156, 164, and 280.

Nelson Max, Lawrence Livermore National Laboratory. Pictures 68 and 180.

Gene Miller, Digital Effects, Inc. Picture 183.

Marvin Mueller, Los Alamos National Laboratory. Picture 74.

Eihachiro Nakamae, Faculty of Engineering, Electric Machinery Laboratory, Hiroshima University. Picture 230.

Gabriel Normandy, Information International, Inc. Picture 178.

Alan Norton, IBM Thomas J. Watson Research Center. Pictures 116 and 117.

Duane M. Palyka, Computer Graphics Laboratory, New York Institute of Technology. Picture 166.

George Parker, Digital Effects, Inc. Picture 235.

Michael Potmesil, Bell Laboratories. Pictures 118 and 168.

Alan Powell, Experimental TV Center. Picture 261.

Steve Purcell, Advanced Color Technology. Picture 241.

Ronald Resch, Computer Graphics Center, Boston University. Pictures 16, 157, and 254.

Dan Sandin, University of Illinois at Chicago. Picture 240.

Mary Schongar, Lexidata. Picture 15.

Melinda Shebell, Lexidata. Picture 12.

Mimi Shevitz, University of Illinois at Chicago. Picture 240.

Tatsuo Shimamura, NHK, Japan. Pictures 224 through 227 and 281.

Wayne Slattery, Los Alamos National Laboratory. Picture 76.

Vibeke Sorensen, Department of Communications Arts and Design, Virginia Commonwealth University. Pictures 172, 210, 212, 260, 271, and 272.

Joe Spencer, Information International, Inc. Picture 194.

James Squires, Fine Arts Department, University of California at Los Angeles, and Chromatics. Pictures 55, 242, 249, 258, 259, and 263.

Donna Stwasser, Jupiter Systems. Picture 253.

Richard Taylor, Information International, Inc. Picture 149.

Jane Veeder, Real Time Design, Inc. Picture 239.

Harry Vertelney, Eclectic Electric. Pictures 207 and 208.

Richard F. Voss, IBM Thomas J. Watson Research Center. Pictures 119 and 171.

David Weimer, Bell Laboratories. Pictures 147 and 234.

Billie Wheat, Los Alamos National Laboratory. Picture 77.

John Whitney, Jr., Information International, Inc. Picture 194.

Turner Whitted, Bell Laboratories. Pictures 11, 147, and 234.

Lance Williams, Computer Graphics Laboratory, New York Institute of Technology. Pictures 62, 264, and 265.

Dean Winker, Teletronics. Pictures 172, 271, and 272.

Walter Wright, William James College. Picture 262.

Mayumi Yoshinari, NHK Special Program Division, Japan. Pictures 224 through 227 and 281.